LIFE IS NOT A

Reality Show

LIFE IS NOT A
Reality Show

KEEPING IT REAL WITH THE

HOUSEWIFE WHO DOES IT ALL

Kyle Richards

HarperOne
An Imprint of HarperCollins*Publishers*

HarperOne

Product names and trademarks are used throughout this book to describe and inform the reader about various products that are owned by third parties. No endorsement of the information contained in this book is given by the owners of such products and trademarks, and no endorsement by the publisher is implied by the inclusion of products or trademarks in this book.

Photographs in the inserts for this book are used by permission of the family, with the exception of the photo of Kyle at age thirteen (on page 8 of insert 1), which is used by permission of Kathy Amerman, and the photo of the family (on page 16 of insert 2) all wearing white shirts, which is used by permission of Adam Bouska. Every effort has been made to obtain permission for all other photographs used. If any required acknowledgments have been omitted, or any rights overlooked, it is unintentional. Please notify the publishers of any omission, and it will be rectified in future editions.

FIRST EDITION

Designed by Ralph Fowler

Library of Congress Cataloging-in-Publication Data is available upon request.

ISBN 978–0–06–211348–1

12 13 14 15 16 RRD(H) 10 9 8 7 6 5 4 3 2 1

This book is dedicated to my mother,

Kathleen Richards,

who made me feel that I could accomplish

anything if I set my mind to it and who taught me

that there is nothing more important in

this world than being a mommy.

I love and miss you so much.

CONTENTS

LIFE IS NOT A

Reality
Show

Welcome to My World

Last night my husband, Mauricio, made a beautiful bubble bath for me. Don't get too excited, though; it's a rare occurrence! But it was nice. He even lit two of my favorite vanilla pillar candles. Very romantic.

I slipped into the water and was just starting to relax when my three-year-old daughter, Portia, came running into the bathroom squealing, "Yay! Bubbles!"

The next thing I knew there were all these Barbies and other dolls and ducks floating in the tub. I ended up taking my bubble bath with Ariel from *The Little Mermaid* and a couple of her friends. So much for romance!

Mauricio and I had to laugh. We laugh a lot around this house!

When you're a mother of four, you don't have a lot of time for yourself—or much of a chance to spend quiet, romantic moments with your husband (as he keeps reminding me).

And since I became one of the *Real Housewives of Beverly Hills,* my schedule has gotten even crazier. Filming all the time and traveling for the show, taking care of my kids and my husband, and trying to look good through it all just leaves me completely exhausted. Sometimes it feels like there's no time to even breathe! I look in the mirror and think, *Oh my God, this show is aging me!*

And then, again, I just have to laugh.

If you're a working mom, you know exactly what I'm talking about. I have it a lot easier than some mothers, of course. I really respect and admire women who have no choice but to work long hours away from their families, yet still manage to keep everyone and everything going, some without even the support of a husband.

I've always been fortunate. Anyone who watches *Real Housewives of Beverly Hills,* or just *Real Housewives,* as I refer to it, knows that my family lives a comfortable life. You might even assume that in *real* real life all of us who live here just sit around sipping

champagne and getting our hair done when we're not lunching or limo-ing, while the kids are off who-knows-where with the nannies.

But you would be wrong—about me at least. It's true that I grew up in this town and have lived here all my life. I'm Beverly Hills born and bred. But I am definitely not your typical Beverly Hills mom.

Can you believe I know some people who never set foot inside a grocery store? They literally never do the household shopping for their families! They send their housekeeper or nanny or assistant instead. But I do the grocery shopping for my family. It's just not the same if I don't; my kids always notice that something isn't quite right. (My oldest, Farrah, is twenty-three, through college, and has her own apartment now. But Alexia, who's fifteen, Sophia, who's almost twelve, and of course Portia are all still here with me.) I know exactly what they want and need.

You Know You Live in Beverly Hills When . . .

. . . You're the only mommy in the Mommy and Me group!

. . . You run into paparazzi at the grocery store.

. . . Men have wives who are younger than their kids.

. . . Women's engagement rings are the size of a small car.

Did you see our *Real Housewives* reunion special after season 1? Do you remember when Andy Cohen asked if any of the cast knew the price of a gallon of milk? I was the only one who raised my hand! And I was only twenty cents off, though I don't think he was accounting for the higher prices in Beverly Hills. At my house we go through three gallons of milk a week, the one-percent organic kind. Two I get during the weekly grocery shopping and then I usually have to run back for another before the week is over.

I've never had a nanny. I do have a housekeeper, but no nanny. As their mom, I understand and care about my daughters' needs more than anyone, and I want to be the one making their lunches and driving them to school. I want to spend every single minute I possibly can with my kids. Those are the most precious moments in the world to me.

As you may know, I'm opinionated. Ha! So this book is my chance to express my opinions about various aspects of my life, and the way I do things. People have been asking me for advice forever, it seems. Maybe it's something I got from my mom. She was known among my sisters and friends as "the guru" because she was so good at giving advice. Now that I have a higher profile because of the show, all sorts of people, not just friends or family but even complete strangers, ask me about my life—and for my input about theirs.

For one thing, I think people see that I have a good marriage, and they want that for themselves. I really do have a good marriage and I am grateful for that: Mauricio is a wonderful husband and a fantastic father. (And you may have noticed how *gorgeous* he is. A little side benefit there!) I love the life that we've built together. One question I'm often asked is, "What's the secret to a happy, lasting marriage?"

Look, I don't pretend to have a doctorate in wedded bliss! I'm not a marriage counselor, but I do know what has worked for me. Growing up with two older sisters in a house full of women, I received quite an education about men and how to play the game of love, and I'm always happy to share what I've learned. So I'll fill you in on some of the things I tell people when they come to me for advice. I'm amazed at the stupid moves we women sometimes make in our relationships, and I want to help you avoid them! I will also give you a few simple strategies to help you find the kind of man you want and build the kind of relationship you want. In other words, find him, catch him, keep him! Ha-ha!

I get other kinds of questions too—girlie questions about my hair and makeup. I *love* talking about that stuff; it's so fun! And maybe I do know more about those topics than some of the folks in my hometown, because, in contrast to the norm around here, I do my own hair and makeup most of the time. I don't want

to spend my whole life at the salon, and I don't want to be shelling out that kind of cash all the time either, so I typically do my hair and makeup myself. And you don't have to spend a lot of money to care for your looks. I'll point you to the products, most of which you can buy at the drugstore, that I totally swear by.

And fashion. How could I resist going there? You know I love it! Recently CNN and *InStyle* magazine both named me one of the most stylish TV housewives of all time! I can't even describe how flattered that makes me feel, because I'm really just trying to figure it out like everybody else! When it comes to dressing myself, I face the same kind of dilemmas you do, for example, how to draw attention away from certain parts of my body I don't really like. I've always had problem areas, and let me tell you, having four kids has not improved the situation! I understand the challenge of looking nice and put-together for your husband when you've been running around like a maniac all day.

Fortunately you don't have to spend a fortune on your wardrobe either. I've learned how to make some carefully chosen expensive pieces work together with a lot of inexpensive things. I'll tell you how I do it, and I'll give you all my theories about how to dress so you feel beautiful. Because you know if you *feel* beautiful, you'll look like it too!

Then there is the topic of money. A ver-r-r-y interest-

ing topic in this town. I want you to know that I am not made of money. Yes, Mauricio and I are very well-off. We have a beautiful house and beautiful things (we're not complaining!). But we have nowhere near the wealth of many of the people we know. We have three more girls to send to college, so we have to think seriously about how we spend our money. But that's okay with us.

Growing up in L.A. I've seen many people competing to have the nicest car and the biggest house and the most attitude. It's so ridiculous. I have friends who are having a hard time keeping food on the table right now, and friends who are billionaires, and everything in between. When Mauricio and I were first married, we didn't have much. And who knows? That may be true again. Things could always change. That's what I tell my girls: "You don't know what the future holds. You don't know what you'll have or what you won't." But it really doesn't matter. Someone can have millions of dollars and a twenty-five-thousand-square-foot home, but it doesn't make their life better than yours or mine. They may not have the husband I have or your fabulous kids. I've never felt intimidated by the overabundance of wealth in this town, and I sure never hold it over someone who has less than me. I treat everyone with respect, no matter where they come from or who they are or what they have. I certainly enjoy and

appreciate the nice things Mauricio and I have. We're blessed. But those monetary blessings aren't the most important things in my life.

What matters more than anything to me are relationships—my family, my friends, the ones I love. I think I have this persona now from *Real Housewives of Beverly Hills* that I'm this really strong girl, some kind of roaring tiger. The truth is I do have a lot of inner strength, but I'm also very emotional. I'm very sensitive—overly sensitive, maybe. I am touched easily and quite intensely by things, and sometimes I'm given to uncontrollable tears. I don't think it came across in season 1 that I'm not only passionate, but also *compassionate*. Hopefully in season 2 viewers saw me as not just a tiger but a pussycat sometimes too. (I suppose I *can* be fierce, but that's one aspect of my personality, not the majority of who I am.)

Mostly I'm a wife and a mother who puts her chil-

Pull It Together

I don't look paparazzi-ready every time I leave the house. But I do try to look pulled-together. It's not that hard, but I believe it entails four absolute musts:

1. Being fresh and clean.

2. Having my hair look decent, which for me means blow-drying it.

3. Wearing earrings. Gotta have 'em. I feel naked without them!

4. Putting on lip gloss. I just won't go without lip gloss—even in my own home!

dren at the absolute center of her world. So much of what I do and base my life on revolves around doing what's right for them. People often ask me about that too—about being a mom and juggling the demands of that role with the show and everything else. Well, get ready, because I *adore* talking about my kids! They're my favorite topic!

One of the most important things I try to pass on to my daughters is confidence. It's not always easy to be confident, but, as I like to say, when you're not feelin' it, you just have to fake it till you make it! This is one of my favorite expressions, and you'll hear me use it more than once in this book. It doesn't mean you should be someone you're not, but confidence lives inside you, even when you can't feel it. Faking it till you make it is just part of the process of finding that confidence and nurturing it and letting it come to the surface.

I believe confidence comes from being yourself. From watching *Real Housewives* some people might think that my life is all glamour. Ha! So untrue! When I entertain, though, I do want my guests to feel glamorous. You may know from the show that Mauricio and I love to throw a party! I can share some of my secrets to throwing a good one in record time—while keeping costs down too. Entertaining is a way to express yourself creatively, but it's also a way of celebrating family and friendship and fun. It's an expression of love. That's why I want my

guests not only feeling glamorous but also feeling comfortable. I want everyone to relax and be themselves.

Being myself is something I do well. And "myself" is not glamorous all the time! Believe me, life is not like the movies around here! It's funny. One night my daughter Alexia was at a party and I went to pick her up. I was the first mom to arrive, and I didn't want to go in to get her and embarrass her, so I texted her that I was outside. After a while still no Alexia, so I texted her again and said, "You better hurry and come out or I'm coming in to get you like this!"

And that would have *really* embarrassed her because I was in my pajamas! While I was waiting I took a picture of my slippers and tweeted it. I got so many comments from people laughing, saying, "Oh my God, I can't believe you pick up those kids yourself!"

"I can't believe you're actually wearing your slippers!"

"You're just like a normal person!"

That makes me laugh. I *am* a normal person! Of course I am! That's why I relate to you.

And why I want to share what's worked for me in my life.

So let's get started. Let's talk, girlfriend to girlfriend, and I'll tell you everything I know.

Mr. Right

People always ask my advice about relationships—my friends, my daughters, my daughters' friends, lately even people who simply walk up to me on the street! It's gotten to the point that I think I could do a "Dear Kyle" column.

I do have some expertise in this area, partly from growing up in a house full of girls and listening to my mom guide them through all their boyfriend issues. But I've also gained insights from my own experience and from great couples I know among my friends and family.

When people ask me, "What's the secret to lasting love?" I tell them that it's based on many factors, but one stands out above the rest. My absolute, number-one tip for creating a successful relationship is . . .

Pick the right guy.

Seriously. The quality of the people within a relationship is the greatest indicator of the quality of the relationship. Choosing a person who truly and deeply

Don't Kid Yourself

So you think he's the one? Really? *Really?* It's very easy to get carried away when you fall in love. You may feel certain you've found your ultimate dream guy because of this or that. For example:

- » We have great chemistry!
- » We have so much in common!
- » We have great sex!
- » We have such fun together!
- » He tells me he loves me!

I'm sorry, but these things do not guarantee he's the one you should spend your whole life with. And I know that last one, especially, is a bummer. But it's the most dangerous one! Keep your head! Don't get swept away by your feelings or his words. Instead . . .

Ask Yourself

When you find yourself dreaming of china patterns and the pitter-patter of little feet, it's time to get serious—with yourself. You have to be ruthlessly honest about determining whether the guy truly has the qualities you'll both need to build a lasting relationship. Answer these questions:

shares your values and goals will do far more to keep love alive than a whole closet of sexy lingerie!

Okay, this is where I imagine some people chiming in and saying, "Oh yeah, easy for you to say, married to

» How attentive is he to you? If a man doesn't make you feel adored and taken care of, he doesn't deserve you.

» What's his relationship with his mother? We're looking for respectful and kind here. Close—but not *too* close! Ha!

» What are his friends like? Let's hope they're wonderful, sweet, honest men who are good to the women in their lives.

» How does he get along with his family? If he has a good family life before you marry him, he'll likely be a good family man with you and your kids.

» How does he treat animals? When I see a single guy who owns a dog I usually assume he has at least some capacity for emotion and sensitivity, and the ability and desire to take care of something or someone other than himself. (My husband, though, never had a dog. Oh well, no one's perfect.)

» Last but not least is a real deal-breaker for me, though you may disagree. Does he obviously check out other women when he's with you? I think it's not only sleazy and disrespectful; it betrays a certain shallowness that I find totally unappealing. Disgusting!

such a great guy." I can't argue—I do have a wonderful husband. I'm not denying that fate and chance are part of what steers our lives. I was lucky to find Mauricio.

But I don't give luck all the credit. I had something to do with it—I picked a good one! I chose a man who I admired, someone who valued the same things in life that I did, had the same priorities, who treated me— and my daughter—well. Those qualities make up a big part of why I fell in love with him.

Or, to put it another way, I believe I made a very wise choice. And I believe that any woman can.

It's so easy for us to focus on how to please a man. Actually, I think it's even hardwired into us to some extent because it's part of our natural impulse to take care of people.

But being confident includes taking care of yourself and looking out for your own needs. Having a clear idea of who you are and what you really want is part of being comfortable with yourself.

Choosing a mate based on those considerations is the way to go.

Not to take all the romance out of it, but it might be helpful to think of dating as a hiring process. You're considering whether you want this guy in your life long-term, and it's a very important position to fill. You have to be clear-eyed in assessing whether he really fits the job. (You, of course, will also be competing for

the "job" of being a part of his life, but we'll cover that later!)

So, what kind of man are you looking to hire?

I have some friends who've always been drawn to bad boys—you know, the type who's charming and exciting but also a little dangerous. You can't always be sure of what they're doing or with whom! I was never attracted to the bad boys; I always wanted the nice ones, the kind ones, the good guys—even when I was very young. I said to a friend once, "You always go for the guy with the tattoos, and I'm looking for the one in a suit!" Not that you can't find a nice guy with tattoos or an ass in a suit. I'm just saying, if you're looking for a satisfying, stable, long-term relationship, bad boys may not be your best bet.

And the really hot guys aren't always your best bet either. When you're out there surveying your field of candidates, your eye may instantly go to the guy that is stunning and sexy and has an incredible body. Of course! But that doesn't mean your heart has to follow. I have a friend who's completely obsessed with a guy who works at her local coffee shop. "Oh, he's so hot!" she tells me. Okay, but what else? His character needs to match up. This friend has another guy who's been pursuing her. He's absolutely smitten; he sends her gifts and flowers and isn't afraid to show her that he wants to make her the most important person in his life. "I'm

sorry," I say, "but do you really have to analyze this?" Do you really want to be with the person whose looks are going to fade, who's going to make you worry, who may not return your phone calls? The one who's going to torture you? *Really?*

Don't spend your time looking for the hot guy and miss the one who's going to treat you like a princess and make you fall so in love with him that you can't imagine yourself with anyone else. It may take you longer to fall in love, but you'll have a much better life with the second guy. Believe me, in the community I live in, which as we all know tends to emphasize looks (and has more than its share of beautiful bad boys), I've seen it go both ways.

If you want a solid relationship, pick a solid guy. I'm not saying attraction isn't important. Of course you have to be attracted to a man to even consider spending your life with him! But don't, please, pick a man based on his looks.

I am fortunate, because I got the complete package in Mauricio. He's not only a good, loving person and a terrific father—totally solid—but he's also gorgeous, if I do say so myself. But that's just a little bonus, an area where I got lucky. I don't think he was as hot when I first met him; he's actually gotten better looking through the years! I used to think he was my little secret, but now the secret's out!

Remember that women's looks matter a lot to men. How could we ever forget it! Obviously, the way you look is what initially draws guys. It's the first thing they notice. Now ask yourself, what are you putting out there for them to notice? Think back to the job metaphor—you want to make sure you're advertising correctly for the position you have to fill and the kind of person you want to fill it.

For example, if you want to attract the guy who's into porn stars, or maybe the one who only thinks about sex, or perhaps the guy who's a cheater, then wear something that barely covers your ass and lets your boobs hang out.

If that's not your type, if you're looking for a man who is more interested in substance, then dress in something a little more substantial! Show a little less. A classy look will appeal to classy types of guys. Sure, it's possible that fewer men will look at you when you're walking through the restaurant. But the ones who *do* look at you are the ones you *want* looking at you! And once they come to talk to you, you can be pretty certain that they like what they see.

Which reminds me of a type of guy who spells trouble from the get-go—the guy who sees a pretty girl go by and swivels his neck around like he's in *The Exorcist* to watch her until she's out of sight. To me that is such a red flag. It shows complete lack of respect for the

Old-Fashioned Girl

I grew up with a lot of traditional values, especially when it comes to relationships between men and women. For example, the whole idea of going on a date with a guy and splitting the bill . . . that does not work for me. That would *never* work for me. I can't imagine it, because I was raised to think a gentleman should pay for a lady.

Even when we first started dating, Mauricio would never allow a woman to lay down money for a bill. I'll never forget one time when my friend handed him twenty dollars for something and it sat on the table while we were all talking. I kept staring at that $20 bill, thinking, "Oh my God, if he picks that up, it's gonna be over!" I couldn't even concentrate on the conversation.

Finally he picked up the bill and said, "Whose is this? Here, take it back," and he handed it back to her. I was so relieved! He passed the test!

For me, it's Dating 101: you should never, ever offer to pay the bill when you're dating. For one thing, it sets a precedent. And if a guy expects you to split a bill, I think it's an indication that he's cheap. I don't like cheap, and it has nothing to do with the amount of money someone has. You can be rich and cheap—believe me, I have seen plenty of that!

My girlfriends and I used to joke that when we see a guy happily going Dutch, it's like his wiener falls off!

Please don't think I'm saying that guys should be taking you out and treating you all the time if they can't afford it. If a guy doesn't have money, then tell him he doesn't have to take you to dinner! Suggest you do something else fun that doesn't cost a lot—have dinner at home, see a movie.

But if he asks you to dinner, he should pay. Then one

night, you can take him out to dinner and treat him, as a special occasion.

I know some people will consider me old-fashioned, but it's just the way I was brought up. The other night Mauricio and I were out with two other couples, and when I excused myself to go to the ladies' room, all three men stood up! Oh my God, when does that ever happen in this day and age? Three absolute gentlemen. I love that!

I also love it when my husband opens the car door for me. But only when we're leaving—not when we arrive at our destination. Then I open the door myself because it's too embarrassing to sit there waiting for him to come around and open my door. I mean, this isn't the 1940s!

woman he's with. My husband would never do that. If he did, he'd have no more eyeballs! They would be removed from the sockets and put in a box and locked away. Ha-ha!

Remember, you deserve to be treated with respect, and a guy who's good for the long haul will always treat you with respect. But not only you. A good person treats *everybody* with respect. That quality was something I found very attractive in Mauricio, and, I think, he in me. It's a lot of what draws us to the friends we have. We like to spend time with people who are genuine.

Mauricio is such a people person. Sometimes when we come out of a restaurant and the valet attendant brings the car around, he'll be chatting with him and

Do Something Nice

I really do think it's important for you to refrain from paying when you're on a date. But that doesn't mean you can't do something special for a man you're seeing. Maybe on his birthday you can take him to his favorite steak house. Or don't even wait for a special occasion. Just call him up and say, "I want to do something special for you, and I have a fun evening planned." You could get him tickets to a game. If he's a sports fanatic, he'll love you for that! Even now, in my marriage, long after the dating stage, I know that when I cook a big meal for Mauricio's entire family on a Jewish holiday, it makes him so happy and appreciative.

Bottom line: yes, let him pay on your dates, but now and then make a heartfelt and thoughtful gesture to let him know you care and that you appreciate him.

high-fiving him and exchanging phone numbers. "I'll call you!" he says on our way out. It doesn't matter who you are or where you came from or what you have, he treats everyone with kindness and respect. In this town, that's not always the way it goes. A lot of people *only* care about who you are, where you come from, or what you have. I can see those people a mile away, the social climbers who surround themselves with people with status or money and treat everybody else like dirt. You don't want a snob for a boyfriend, much less a husband.

So we want Mr. Right to be respectful to you and respectful of people in general, but what about the relationships in his life—the ones that existed before you came along? How does he get along with his parents and siblings? Is he good to his mother? How does he

Still a Hot Commodity

Men never lose that instinctive desire to be the hunter, even after they've caught their prey: you! You want to feed that instinct by making sure you remain a tasty morsel they'll lunge for, no matter how long you've been married. The best way to do that is to remain your own person after you're married—an independent being with your own interests. Your husband can't be expected to fulfill all your needs. Have your own life!

It's also important to nourish his sense of self. Tell him he's hot and fabulous. Build his confidence! Stroke his ego. And why not act like you are the hottest stuff going?

Nourish your own sense of self too. Carry yourself with pride. A woman who is comfortable with herself and not seeking approval all the time is much more alluring than one who puts herself down. But not so comfortable that you're digging ice cream out of the carton in stained sweatpants when he comes home!

And keep stoking those fires, baby. Mauricio and I call each other during the day just to say "I love you." We try to have as many date nights as possible.

Good Chemistry Matters

Chemistry in a relationship is not the same as sexual attraction. It's not being magnetically drawn to someone physically. Chemistry happens when you start talking.

When I met Mauricio, I could tell he was kind and sweet by the way he talked about his parents and how polite he was. He seemed the perfect combination of masculine and gentle. I loved that he spoke Spanish, was from Mexico, and was Jewish. That was the perfect combo! I've always wanted to go out with someone who spoke Spanish and to marry a Jewish man because I heard they made the best husbands.

Seriously, because so many of my friends growing up were Jewish, and because my mother never taught me much about our faith, in some ways I related more to Judaism than to Catholicism. I used to pretend that I was Jewish! On the weekends I would wear my friends' private school uniforms and a necklace with Hebrew writing on it that I'd gotten at my friend's bat mitzvah.

How embarrassing!

I think I mostly liked pretending that I went to school with my friends. I was a child actress, and when I was five, I was cast in *Little House on the Prairie*. I played Alicia Sanderson Edwards and appeared on and off through seven seasons. I remember riding horses on the set and catching guppies and playing near a pond with ducks. It was a good life, but definitely not a typical upbringing. I was tutored on set, and like all of the kids on the show I went to school right there where we shot, in one classroom, with one teacher.

It was fun, and it was all I knew. But I longed to have the same kind of life my friends had. My parents were divorced, and I looked at my friends whose parents were married and wanted that so badly. I thought they were the luckiest people in the world. The dad would come home to the mom and the kids with a briefcase in his hand. I was in complete awe! I decided that when I grew up I wanted a more traditional situation, a normal family with normal kids

who went to school in uniform and had parents who were married. (No coincidence that my daughters are enrolled in a Jewish school, to which they wear uniforms!)

When Mauricio came along, I was drawn to the fact that he'd grown up in a strong family.

On our first date we went to dinner, and he asked me out for lunch the next day. And at lunch, he asked me out to dinner that night. And from then on, we were together every single day and night. After four months, he said, "I'm in love with you and I can see myself spending the rest of my life with you." And then he said, "Would you ever be willing to convert to Judaism?"

I said, "Yes." To me, it was a big step toward that traditional life I wanted, to the sense of belonging that I'd always yearned for.

At first when Mauricio and I got serious, his parents were not wild about the idea. I don't blame them! I was divorced, not Jewish, and an actress. Does it get any worse? I understand how they felt. I wouldn't want that for my son.

After we got engaged his grandmother wouldn't even look at me. So I wrote her a letter and told her I knew how much she and his parents loved Mauricio. I said, "I just hope you know how much I love him too. And I want to be the best wife to him and the best mother to our children." I tried to explain that there was nothing more important to me than creating our family together with his family's support, because such a big part of what attracted me to Mauricio was his closeness to his family.

That letter seemed to change everything—along with a talk Mauricio had with his mother. He said, "Isn't it wonderful that I've had a chance to see what kind of mother Kyle will be? What a good mother she already is? How many men have that opportunity?"

If you ask me why I have such a successful marriage, I'll tell you that it's because Mauricio and I saw in each other attitudes and priorities and goals that we shared. Thank God we were both smart enough to recognize what we needed to go the distance.

treat kids? How does he treat animals? (I personally would be extremely wary of a man who wasn't nice to animals, even if he didn't particularly like them or want them as pets.)

One thing I really liked about Mauricio even from the very first night we met and started talking was the way he spoke of his parents. You could just tell that

A Really Bad Day

For me, trust is essential in a relationship, and especially in my marriage. Mauricio is not a fighter; in fact, sometimes I wish I could get him to fight a little. Ha! But we have had our issues.

One of the most difficult conflicts I've ever experienced with my husband was when I found out that he had been keeping a secret from me. I was devastated because I felt it violated our trust.

A friend of mine had gone to lunch with Mauricio and told him that she wanted to leave her husband. She also said that she'd been cheating on her husband, who was a friend of Mauricio's. But she asked him not to tell her husband or me any of it. And then one night at 2:00 A.M. when she had had a fight with her boyfriend she called Mauricio to come and get her, and pleaded with him not to say anything about it to her husband or me. That was when my mother was very ill and I was out of town taking care of her.

Mauricio is such a nice guy that it can get him into trouble. He doesn't know when to say no. He went to get her

he honored them. And he spoke of them affectionately too, which was a very good sign. Then, when we began going out, I saw that they played a big part in his life, which I loved.

Of course, it's possible to have too much of a good thing! If a man is so devoted to his parents—let's face it, usually his mother—that they're essentially running his

that night and honored her request to keep everything confidential. But keeping that secret from me was like bringing another person into our marriage. I was extremely hurt by that, and I let him know.

He finally told me all about it during a phone call one day. I was at home, and I really lost my temper. He said he hadn't wanted to bother me when I was out of town, and he was just trying to be a nice guy, but I felt he had violated the sanctity of our marriage.

You don't keep things from each other like that! Especially not when you're allying yourself with a friend of mine and the two of you are keeping a secret from me! I was so upset it's hard to describe. It was the worst day of our marriage.

I told him not to bother coming home that night. But he came home anyway. I threw a candle at him, and it hit the wall. Mauricio apologized profusely, but it took me a while to calm down. Later, we said "I love you" before we went to bed, but really getting over it took time and a lot of discussion about trust and keeping our bond intact. But we were ultimately successful because we do have trust in our relationship.

life, that can be a problem. Often it will resolve itself naturally; a young, single guy is likely to grow out of that kind of extreme attachment once he has his own family. But if you're dating someone whose focus on pleasing his parents is getting in the way of your relationship, you'll have to raise the issue with him—in a very gentle, sensitive way!—and try to help him shift his focus. You'll be treading on dangerous ground, though. You don't want to be seen as an interloper, so make it clear that you respect and embrace his family. If it continues to be a problem, decide how much it means to you. Is it worth ending the relationship over? I would much rather have a guy who's close to his parents than one who has no relationship with them at all.

Very early in my relationship with Mauricio, I learned that every Thursday was Umansky family dinner night no matter what. Even if there was some big party happening at the same time—and this is when we were still basically kids, remember—too bad. Thursday was family dinner night, period, end of story. What that told me is this: he prized family. He shared one of my deeply held values.

Mauricio also won me over by the way he behaved around my daughter. Some guys who are twenty-three years old would not have a clue about how to treat a five-year-old, and many of them would have no interest in finding out! But Mauricio was wonderful

Ambition Versus Opportunism

Beverly Hills is filled with ambitious men, but we've also got our share of opportunists.

You know—the fakers and the guys who are always looking to take advantage of people—which may include you! You have to be able to distinguish the two or you can get into a lot of trouble.

I can spot manipulators a mile away. An ambitious man wants the nice things in life and works his butt off to get them. An opportunist looks for ways to exploit other people. Here are some telltale signs you're dealing with the latter:

» He talks a lot about his money and possessions. (People who have a lot of money don't talk about it.)

» He always has something in the works, lots of exciting projects going on, big deals coming up. Yeah, yeah.

» He's often heard saying, "My cash is tied up right now . . ."

» He engages in over-the-top behavior designed to impress, like traveling with a bodyguard or driving a car that costs more than his house.

» He's always asking you to introduce him to high-profile people.

» He name-drops all the time.

» He's always forgetting his wallet! (In this case, run; do not walk! Ha!)

with Farrah, solicitous of her attention, bringing her presents, saying things like, "Why don't we all go to Disneyland!" and then piling us into his car. How can you not love a man who's so fabulous to your child, and sincerely so?

Pay attention to the people a man chooses to spend his time and share his life with. If they're bad news, then I'm afraid it's bad news for you. Birds of a feather, you know? And even if your guy is different from his friends, what does he see in them? What do they say about his judgment?

You can learn a lot about a man from the company he keeps.

Now that I think of it, all of Mauricio's friends are still with the same women they were with when we were dating. All these years later.

By the way, don't confuse the concept of a good guy with a boring guy. A lot of women do. Just because a man is respectful and nice and behaves well and doesn't hang out with players doesn't mean he's boring! Are you kidding? I would never put up with boring! It's extremely important that the man you marry is someone you have fun with, but you have to decide what kind of fun you want to have. Do you want to be a party girl who lives on the edge and likes the drama of an unreliable man? Do you want to have the excitement of an extended adolescence with a bad boy? Or do you

want to have a lasting relationship with someone you can count on *and* enjoy? It's possible to find a man who has both qualities. I know, because I did!

These tips can help you determine whether a guy is right for you (emphasis on the *for you*). I've told you what I value in a partner, and personally I think it has all turned out pretty well for me! But you have to figure out what you really want and need, and then do your due diligence before you make that hire. What's important to you? What are a man's attitudes toward work and providing for a family? Is there a place for spirituality in his life? What are his hopes and dreams? What are his plans for the future? Is he someone who will treat you the way you want to be treated for the rest of your life?

When I first met Mauricio, he did not have a lot of money, certainly by Beverly Hills standards. He was only twenty-three, just starting out in life, and making a modest salary in his parents' clothing business. He definitely wasn't a trust-fund baby! But he did have ambition. He had a drive to make his way in life and be successful. And I knew how well he treated me and what a good father he would be.

So I thought, in the best-case scenario, Mauricio would succeed, make money, and everything would be great. Worst-case scenario, he wouldn't—but I'm still in love with him. It's a win-win situation for me!

Of course, love is paramount. At least for me. Some people, especially in this town, may have other priorities—like women who hunt for big bank accounts, or men who only go out with models. I can't comment on those relationships.

I can only comment on my own relationship and the many relationships I've observed. Love is the essential ingredient in a successful union. But the best way to give love a chance to work its magic year in and year out is to make sure it's based on respect and shared values.

Those are the things that will carry you through life.

Learn the Language

As you now know, I grew up in a house packed with females. I wasn't around guys much when I was a child. I saw my father on weekends but didn't live with him, and I never had any brothers. You might think that would have left me clueless about men, but in fact, it gave me an excellent education about the male species. I have managed to put that education to good use in my own life—and I want you to benefit from it too!

Honestly, sometimes I feel like growing up in my house was like going to Dating University. I got to

learn so much about how the male mind works and, most important, how to apply that information. If I had to sum up all the knowledge I acquired at Dating U, it would boil down to this: to be successful with men—to attract a man, to encourage him to fall in love with you, to keep him once you get him!—you need to communicate on a level that men can understand.

It's almost like they speak an entirely different language than women. We women tend to think we're in love and want to have a guy's children the second we meet him. Right? It's funny, but you know it's true. "Oh, I could see myself marrying him; he's so cute! I like his laugh! He has a nice car! Whatever!" Guys don't think that way. It takes a lot longer for them to come around, and they often need a lot of encouragement along the way. But just the right kind of encouragement. You have to learn their language!

Let me explain how I got my master's in men, with a specialty in languages.

I am the youngest of three sisters. Kathy is ten years older than me and Kim is five years older. In addition to my real sisters, there were four other girls who lived off and on at my house: Sue, Roxanne, Tracy, and Wendy, all older than me. I thought of them as big sisters and still do; they continue to be very much a part of my family's life. Two of them were Kathy's best friends and two of them were the daughters of my

mother's best friend, who had passed away. My grandmother also lived with us. So I was surrounded by up to eight—eight!—women at any given time.

Having all those girls around meant that a lot of boy issues were discussed at my house, and my mother was the queen bee, dispensing advice left and right, especially at night after the girls would get home from dates. And I was listening in!

You see, I slept in my mother's bed until I was fifteen years old. That may sound weird, but when I was very little, I did some horror movies, including *Halloween I* and *II,* and they left me absolutely terrified of sleeping alone in the dark. I was so scared that someone would break into my room with a knife! So my mom let me sleep with her.

This is how it would go: late at night, one of the girls would come home from being out with a boy and tiptoe into my mother's room to see

The Best Advice I Ever Got from My Mom

» Carry yourself with confidence

» Speak your mind

» Never be intimidated by anyone

» Always act like a lady

» Play hard to get—but be smart about it

» Always put your children first

» Have a signature look

» Don't overpluck your eyebrows!

if she was awake. My mother would jump right up and turn the light on. "Oh, I'm not sleeping!" she'd say. "Okay, tell me everything from the time you got in the car." She didn't want to miss one detail.

When I was really young I would pretend to be asleep during the play-by-plays, but even then I'm sure I was soaking things up subliminally. As I got older, and especially when the conversation got juicy, I would pretend I was sleeping and listen to every scrumptious piece of information! It really was way too much information for my age, but it was priceless! And then when I got even older, I was allowed to openly listen in on some of it. I would sit there quietly creating a little checklist in my head. You don't do this; you don't do that; but you *do* do this. This is what works; this is what doesn't.

The stories would go on and on, and my mom would dole out her nuggets of wisdom. Sometimes one of the girls would come in crying about something, maybe upset because the guy she went out with didn't call her back. My mom would say, "That's because you were an idiot and didn't handle yourself properly!"

My mom had rules, like, "Never go too far; you have to be a lady," or "You don't let him do that on the first date," or "You only do such-and-such after you've gotten past the fifth date." It may seem like simple advice, the same kind of things moms have been telling their daughters forever. But the difference for me, and the

Top Ten Reasons Not to Let Your Daughter Star in a Horror Movie

10. Her friends can't go to the premiere without their parents getting upset.

9. She'll have psycho fans obsessed with horror films following her for her whole life.

8. She'll never let her own children watch scary movies.

7. You'll never let *her* watch her own scary movie.

6. She'll end up with anxiety disorders.

5. She'll have to obsessively check the back seat of her car every time she gets in it.

4. She'll be afraid of the dark for as long as she lives.

3. She won't want to sleep alone again until she's eighteen.

2. She'll have an unnatural fear of sharp objects.

And the number one reason never to let your daughter star in a horror movie:

1. She'll never trust a man in a Halloween mask.

reason I paid attention and filed everything away to put into practice later, was that I actually got to see it *in action*. I got to hear the real-life stories and saw what happened when the girls followed my mom's advice—or didn't.

And now I can see in my own life how valuable that advice has been. For example, my mom always said, "Don't sleep with him right away!" Of course she said it; wouldn't every mom? Yeah, for a reason! It's still just as good an idea today as it was thirty years ago. Because it's not about the sexual customs of the day, or about upholding strict standards of conduct based on morality—well, for some people it is, and that's fine. But even beyond that, it just makes good sense. It always has and it always will, because the basic natures of men and women don't change.

It's all about understanding the male brain, the big one in his head and his little brain too! Ha-ha! It's about *being fluent* in the language of men.

A man can sleep with you and enjoy himself and never think a thing about you again. That's just the way men are, whereas once we have sex with a man, we're likely to start dreaming about the next step and the next, all the way to love ever after. We're ready for him to just sweep us off to his castle already. But that's not the way sex translates to them. It just doesn't mean a lot in their language.

If you're looking for something more meaningful, more exclusive, more lasting—more like *love*—then you have to make him wait awhile. Instead of jumping into bed the minute he shows interest in you as a sexual partner, try to wait until he truly cares about

you as a person. Because if he doesn't care about you as a person, what reason does he have to come back to you—except for more sex? If he hasn't had a chance to get to know you, what is he going to miss? If his first experience of you is basically going to bed with you, don't be surprised if it's all over before it began. He's done, he moves on, and you've never had a chance to get under his skin.

I certainly made my husband wait a long, long time—months, which is an especially long time when you're seeing each other every day and every night. I'm sure some people wait a whole year, or even until they get married, to do the deed. I'm not saying you necessarily have to hold out that long, but at least let him get to know who you really are, so when he's not with you he'll think about you. He'll be thinking, yeah, I like her. I'm intrigued about her. I *miss* her. I want to know more.

I have a friend who never really bought the notion of waiting. She figured, hey, we're in a new era; it's not like the old days. Equality between the sexes! Women are allowed to express themselves sexually, just like men.

Well, sure we're allowed to express ourselves sexually! But that doesn't mean that doing so won't have consequences. Unfortunately, that hasn't changed. I'm not telling you that you're a bad person if you have sex right away. I know that some long-term relationships

have started that way. I'm just saying that if you really want to achieve a certain outcome, you want to be smart, which may mean delaying the big moment.

Now that friend of mine wishes she could go back and have some do-overs. She had a string of lovers and relationships that didn't go much farther than that. For a long time the situation suited her, but eventually she got to a point where she realized she wanted more. She looked back on her affairs and thought, *Oh my God! A couple of those guys were great. They're just the kind of men I could fall in love with. But I blew it when I had the chance!* She went through a real period of anguish, wishing she had done things differently. I felt so bad for her. Now she's decided to pull back and approach sex with a different attitude, and she tells me she just hopes it's not too late.

Many of the so-called rules that I learned growing up about how to look and act if you want to find a good man are based on the same principle: how you behave toward a man will affect the way he behaves toward you. The make-him-wait rule is a biggie, but there's an even more fundamental rule that I recommend you follow. It's so fundamental that it applies not just to men but to your whole life. Ready?

You *must* come across as confident. You must, must, must. Please!

Notice I didn't say "You must *be* confident!" I'm

very well aware that you can't be confident all the time (at least I can't!). Maybe there are people in the world who don't experience self-doubt, and if so I envy them, because I sure have my moments from time to time. People don't believe me when I tell them I have a very shy side. They say, "Oh yeah, hilarious!" But it's true. Being confident and outspoken didn't always come easily to me.

But I learned early on that when you feel insecure and totally lack confidence, you just have to fake it till you make it! If you *act* confident for long enough, even if you're just pretending, eventually you will actually *become* confident. I swear!

You want to come across as self-assured—certainly with men and ideally with everyone—because people will respond to you so much better if you do. People want to be around someone who feels good about herself, and they automatically avoid those who are desperate for validation. Only bullies and other controlling types are drawn to individuals who advertise their poor self-esteem.

When you're trying to appeal to a man, you do *not* want to look desperate for his attention and approval. That's a huge turn-off.

One day when I was filming, a stranger ran over to me. She said, "Can you give me some advice?" I was thinking, *Hmm, I bet she doesn't realize we're miked at*

all times! But of course, I was happy to help if I could. "I'm thirty-nine years old," she said, "and I'm going out with this guy. I just know that this is it. He's the one. I love him so much—but I get so insecure!"

I cut her off and practically shouted at her. "Well don't let him know that!"

The reasoning seems obvious to me: you'll be more attractive to a man if he doesn't think you're hanging on his every word and smile and invitation. You always want a man to think you have plenty going on in your life. In fact, you always want to *have* plenty going on in your life, period! You're not only more interesting to other people if you do, you'll be much more interesting to yourself.

Seriously, you never want the guy to think you're waiting around for him to call. I had lunch with one of my friends recently and she told me this guy she'd been dating wasn't calling her back. She said, "So I left a message saying, 'Why are you ignoring me?'"

Oh my God! "I don't even know if I can be your friend anymore!" I said. "Are you joking?" I would cut my finger off before I would ever call somebody in that situation. Okay, so you're feeling insecure. I get it. *Just don't let him know!*

You have to commit yourself to playing it cool when you're dating. If your guy wants to have a night out with the boys, just say, "Great, have fun!" You may

feel a little threatened—personally, I don't love guys' night out once you're married, or really even girls' night out, because I think nothing good can come from it— but don't let on. Don't tell him you'll just be at home waiting for him either. Don't say anything but "Have a good time!" Just let him think that you're totally fine with him going out to have a good time, because you'll probably be out having fun too.

Men are predatory animals, but that's not really as bad as it sounds. It's their biological nature; it just means that they like a challenge, a chase. That's the language they speak and understand. Make it clear that you're a prize worth fighting for. Don't just present yourself up on a plate and tell him you're available by room service twenty-four hours a day, seven days a week!

Let me use my own experience as an example. Mauricio and I first met at a nightclub in Beverly Hills called Bar One. We talked a lot that night and hit it off immediately, and he asked for my number.

But then he didn't call me for a whole week! He had actually gone to Mexico, but I didn't know that. So when he finally called me to ask me out, I had to make him wait a little. I had to say, "Oh, no, sorry. I can't do anything until . . . let's see, not until Thursday. I'm busy." I mean, really, how dare you wait a week to call me? No way I'm jumping and saying yes right away!

It's good to play a little bit hard-to-get, but don't be

obvious about it. I have a friend who told me one day, all proud and triumphant, "Oh, I was so good! I told him, 'I'm not going out with you tonight because you didn't give me the two-day warning!'"

I said, "What? Are you an idiot? You just defeated the whole purpose—and now you might as well sleep with him and get it over with!" Don't be afraid to pro-

Take It Up a Notch

If your man isn't moving things along as quickly as you like, you may have to help him a little bit. But you must do it with finesse. *Don't* just say, "Hey, we've been going out long enough now. When the hell are we going to get married?"

Right off I'm going to tell you that if the two of you aren't even monogamous yet, then forget about it! Forget him! Move on. That's an absolute rule. If you want more out of the relationship than just fooling around and having fun, take him off your list entirely. And I also don't believe in living together before you're married, or at least engaged. The old saying is true: Why buy a cow when you can get the milk for free?

Otherwise, if you want to take it to the next level, you have to be subtle. Plant seeds. Play with his nieces and nephews to show him how good you are with children. Cook dinner for his family so that he's more likely to see you as part of it. Get to know his parents. Get his mom to like you. (I went

vide a challenge to a guy you're interested in, but do it intelligently and *discreetly*.

Now, all this may seem like game playing to you, but in my mind it is just being smart. Playing the game is part of the mating ritual—especially if you're in your twenties or thirties. As we all know, men mature more slowly than women and they never really catch up! So

to a sculpting class with my future mother-in-law. I didn't care much about sculpting, but I wanted her to love me! I got more than I bargained for, though. We had nude male models, so there we were, the two of us, sculpting penises! Ha-ha!)

If the subtle approach doesn't work, you may have to resort to scaring him a little. Start to pull away from him a bit. Pull back emotionally, and don't be as quick to go out with him. "No, sorry, I'm just going out with my girlfriends tonight." Make him feel there might be a risk of losing you.

If that doesn't work, you're going to have to make some decisions. If the relationship doesn't move forward the way you want it to, are you willing to walk? If so, then you need to talk to him. Don't mention the word *marriage*. Just say, "Look, I don't know if this is going in a direction I'd like it to. I love you but I don't want to be wasting my time." And then you leave, and you stick with it. He may come running and he may not, but you stick with it.

young men are simply going to require a little more guidance.

If you're older than that, in your forties or fifties or whatever, you don't have to play as many games. At that point, most people are more mature and know what they want, but . . . you still have to play games a little bit. Because men and women are different creatures who speak different languages, and playing games helps you bridge that language barrier!

Of course, how you communicate when you're with a guy also matters—you know, actually talking! Conversing back and forth in English. It matters a lot.

My mother used to say that a girl should always be "sparkling" around a guy, outgoing, fun, funny, and smart. Obviously, those are qualities that are going to draw anyone toward you, male or female. Most human beings gravitate toward fun, upbeat people. I think maybe in my mother's day, though, girls and women felt obligated to be *so* upbeat and positive around their suitors that they almost couldn't be themselves. Or maybe that's just the way it seems to me, because things really have changed.

Now we tend to feel so comfortable with men, so casual, so let-it-all-hang-out, that I'm afraid we sometimes go a bit too far. Yes, you definitely want to be very good friends with the man in your life. But don't make the mistake of relating to him as if he were one of your girlfriends!

In other words, you don't have to tell him *every-thing*. You definitely don't want to complain about how you feel fat today, or just hate your hair and don't know what to do with it, or say, "Oh my God! My feet are disgusting! I am *so* overdue for a pedicure!"

First of all, this kind of talk makes you look insecure. Second, he doesn't want to hear those things. More important, you don't *want* him to hear them. Don't ever put yourself down in front of your man. Don't put those images or thoughts in his head—especially because, you know what? Most of the time he won't even notice! We might be convinced we look like Quasimodo on a bad day, but guys don't zero in on the flaws we see. They see you as more beautiful and less flawed than you do.

Sparkle!

Diamonds catch your eye because they sparkle, right? That's why you want to sparkle when you're with your man!

» Look like a million dollars!

» Flirt with him, even if you've been married decades.

» Be in an upbeat, happy mood.

» Make sure he feels loved and adored.

» Be affectionate.

» Once you're married, act like you're on a date.

One day I was wearing a Spanx under my outfit and my skirt flew up a little bit. Mauricio said, "What is that you're wearing underneath?"

I said, "Oh, those are running shorts, I just wanted

to make sure if the wind came up no one would see what they're not supposed to see!" I wasn't going to tell him I was wearing this newfangled kind of girdle because I needed it to suck all my chub in!

Even if you're not putting yourself down, you still have to be aware of what you're saying and the effect it has. Simply put, you do not want to bore a guy. Don't tell him every gruesome detail about shopping for shoes today. And don't provide a blow-by-blow story of what happened when one girlfriend said something to another, and then so-and-so said that, and now so-and-so's not talking to the other one, blah, blah, blah. I actually did this the other night; I started filling Mauricio in on a whole night of shooting *Real Housewives*. For a while he was like, "Oh really?" and, "Oh my God, what happened then?" But after about five minutes I knew he was about to start snoring, so I said to myself, *Cut!*

You can only go on about the mundane details for a couple of minutes before you've lost them. It's hard, girls, I know. One night my husband and I were out to dinner with some other couples and one of the wives said to me, "Oh, I love that lip gloss!"

I responded, "Oh! This is Trish McEvoy. It's called Irresistible. Isn't it great? Yeah, it does sparkle more than the others . . ." and so on and so on about the lip gloss, but then all of a sudden I thought, *What am*

I doing? If I had to sit through ten minutes of a man talking about his cologne I would say, "I'm leaving the table now!"

So even though I really do love lip gloss and I could talk about makeup all night (and also about how they just discontinued this other one I like!), I don't want to overdo it in front of my husband. It's something I prefer to save for lunch alone with my girlfriends.

Otherwise, it's like speaking Urdu to them for hours. They just don't get what we're talking about because it's not in their vocabulary.

There are plenty of things to talk about that he *will* be interested in—because you have all sorts of interests besides him in that busy life of yours, right? You want to make it clear that you're intelligent and have some depth. Maybe you can discuss spiritual topics, as long as you can do so without sounding like Shirley MacLaine. Or current events. Art, literature, music, culture.

Mauricio and I, of course, spend a lot of time discussing the kids and the house and family matters, and we talk to each other about our work too. I even try to talk about sports with my husband, which is amazing because I couldn't care less about sports! Believe me! I read the sports pages in the newspaper sometimes, and Mauricio is pleasantly surprised when I happen to know about so-and-so who got traded to

the Lakers. Ha! I like to ask my husband about golf too, because he loves the game and he always goes into a whole story about it. I don't know a birdie from a bogie from an eagle, but it makes Mauricio happy to talk about it!

I also believe it's important to pay attention to what's going on in the world so you can have intelligent discussions about it. I had my baby when I was nineteen and I didn't go to college. That's something that always bothered me, so I try to educate myself by reading as

First Love

By the time I met my first boyfriend I had absorbed some—but not all—of the love lessons I was exposed to growing up. I was thirteen—though I lied and said I was fourteen—and the boy was C. Thomas Howell, the actor who played Ponyboy in *The Outsiders*. Remember that movie? Tommy was so famous at the time we were dating that it was like dating Brad Pitt! I remember being with him once at Disneyland, where girls were literally screaming and throwing themselves at him. I was so immature and jealous that I was ready to rip every hair out of their heads—but I never let him know!

We were together for a long time, about four or five years. At one point Tommy was doing a movie called *Soul Man*, costarring with Rae Dawn Chong. He had begun acting kind of weird, and one day he called me and said

much as I can. If I hear about something and I don't know what it is, I do my research.

That way when it comes up again I can join in on the conversation. When you're up on the news and aware of the world outside your own little universe, that's when you can "sparkle." Men understand that kind of sparkle.

Now, before we end class for today, one more thing.

What if you're doing everything right but you're not getting the results you want? What if you're speaking his language, you're exuding confidence, you've got

he didn't want to be a cheater, so he had decided to be straight with me: he was curious about getting to know another girl. That was Rae Dawn Chong, who he eventually ended up marrying.

When he told me he wanted to date someone else, I was devastated. It just killed me. I was so upset that I couldn't hide it from him. I became hysterical. I got off the phone and ran to my mom's bedroom, and first I fainted, then I was just crying and crying. I thought I was going to die. He was my first love!

"Pull yourself together!" my mom barked at me. "You *never* let him know that you're affected this way."

Meanwhile I was hyperventilating. "I can't breathe! I can't breathe!" I laugh about it now!

I finally calmed down and by the end of it, I had learned my lesson. After that, I would never allow anyone to get to me like that again—and certainly never let him see me that way if I did.

your fabulous life going on, and you're not counting the hours and minutes and seconds before he calls? You're treating yourself with respect and insisting on the same from him, and you're not boring him with the saga of your favorite lip gloss. You haven't even given in to temptation and gone to bed with him, because

Keeping the Egos in Check

As you might imagine, egos grow amok in Beverly Hills. Oh yes.

Occasionally you might even find that someone you care about is letting her ego run wild. I'm not the kind of person who keeps things inside. If I feel something important about someone I care about, I talk to them. I'm not two-faced; if I'm going to complain to my husband about a friend's behavior, then I have to be willing to say the same things directly to my friend.

So if a friend of mine is acting out of control, I talk to her about it with as much kindness as possible. I'll say, "You know, I love and care about you, and that's why I'm talking to you about this. I hope I'm not hurting you by raising this with you, but I think perhaps you're not aware of how you've been acting lately and how it's affecting others."

No matter how nicely you say it, it doesn't always go over well. Some people are open to seeing their flaws and will appreciate your honesty and thank you for pointing things out to them. But some people really won't! Oh well. I hope my friends would do the same for me.

you're giving the two of you time to really get to know each other first. You're playing by the rules and you're playing smart, and yet he seems to be avoiding you. You're feeling some resistance from him, but surely that can't be true. You're just being paranoid, right?

Wrong. If you're sensing that the guy is putting distance between you, you're probably right. Don't try to make yourself feel better by dismissing your gut feeling. That's the moment to begin giving him some space. Give him some time to come around. If he wants you, he *will* come around.

And if he doesn't come around? Well then you don't want *him*. Why would you want someone who wasn't sure of his feelings for you? You think far too much of yourself for that.

You deserve someone who totally wants to be with you.

Sometimes it can be a struggle to come up with that kind of confidence. But remember: fake it till you make it!

Faking it till you make it is a great way to come across as the kind of self-assured, independent woman that men love to pursue. It's called the code of the jungle; you have to trigger a man's natural urge to chase you.

I'm a little nervous sharing my secrets like this, because I know my husband will read this book and I don't want him to find out all my little tricks. Ha-ha!

Maybe I'll just have to black out parts of it, because I definitely want you to have access to what I've learned.

For example . . . here's something I found out early on during my course of studies at Dating U: if you want to be conversant in the language of men, you have to realize that they are competitive by nature. They tend to want what other men want. It's just plain human, really. It's like the super-hot Christmas toy that kids have to have because all the other kids have to have it!

Sometimes men need to be gently reminded that you're a hot commodity—you're on other men's wanted lists! It's part of playing the game, communicating with them on a primal level that they comprehend deep down. It's not so much that you have to make them jealous. You just have to make them realize they're not the only lions in the jungle!

Once when I was quite young I resorted to sending myself flowers "from a secret admirer." Roses. Red roses! It's so ridiculous, but it worked. This trick is an oldie but a goodie!

It's different when you're married, though. Why would you want to make your husband jealous if you're married? I would never do anything to try and make Mauricio believe another man was interested in me. I think once you're in an exclusive, long-term relationship it's very sexy to a man to know that he's the *only* one you're interested in. (Not during the dating phase, girls! After they pop the question!)

But that doesn't mean I don't try to look my best when I go out with Mauricio so he's proud to have me on his arm. I try to be upbeat and have fun and be engaged with people. I might even dance extra sexy. I act like an attractive woman, and if there are men around who find me attractive and possibly even show it, well, it doesn't hurt!

I mentioned before that when Mauricio and I started dating, we spent almost every waking minute together. So I was very surprised when he said to me one day, "I have some friends coming to town, and I'm going to have to ignore you this weekend."

Uh, excuse me? Did you say ignore *me?*

Well, this is strange, I thought. *Why wouldn't I be invited to come along with his friends?* It didn't make sense, and I didn't like it.

So I called my ex-boyfriend, who was my good friend, and asked him out to dinner. And I suggested we go to The Gate, which was the hot club at the time and the one where Mauricio went almost all the time. I pretty much knew he would be there. And then I went out and bought the shortest, tightest, sexiest dress I could find. I took forever getting ready that night because I knew I had to look my absolute best. It was as important as my wedding day, as far as I was concerned. It's what was going to *get* me my wedding day! Ha-ha!

So my "date" for the evening and I went to dinner then went to The Gate and walked right past the table

where Mauricio was sitting with all his friends. His jaw dropped.

After a while he came over and said, "Hi, honey," very normally. But I said, "Hello," rather formally, then said, "Okay, well, have fun! I'll see you later." Like, skedaddle!

He could not stop looking over at my table. He couldn't concentrate. He was definitely not ignoring me! And then, lo and behold, I couldn't have scripted it better—my ex-fiancé walks into the club! He was the man I'd been seeing right before I met Mauricio. So I swung into action. I quickly jumped up and said to my date, "We have to go!" and dragged him along as I headed for the door. And I timed it perfectly so that we'd bump into my ex-fiancé right in front of Mauricio's table!

When my ex-fiancé saw me, he got upset, because the breakup had been hard on him. "How could you have done this to me?" he said. "Look at me—I'm a disaster!"

He started reaching for my hand, and the guy I was with, whom I'd known for years and who was really more like a friend, said, "I'm going to have to ask you to take your hand off her!" And that did it, they started fighting.

Then Mauricio jumped up and said, "Do you need any help?"

It was kind of hilarious! I waved my hands rather dramatically and said, "No, no, please! Let me handle

this!" I told them to stop, announced that I had to go, and marched out.

I had my date take me right home, because after that scene I figured I'd made my point, and I didn't want Mauricio to think I was ending up in someone else's bed.

Then I just waited. I estimated the phone would be ringing in about twenty minutes. Sure enough, tick tock tick tock, the phone rang, and it was Mauricio. "Are you okay?" he said.

"Oh, yes," I sighed. "It was just a very awkward situation, just terrible."

Then he explained to me that before he'd met me he'd been kind of seeing a girl in Mexico whose family was close to his parents. He'd invited her to L.A. before he met me and didn't know what to do about it. He told his mother, "I'm in love with Kyle and now I have this girl coming!"

She told him to be a man of honor and take her out with his friends and explain the truth to her.

So that's what he did. The girl was at his table that night.

I tortured him that night and the next day and then decided that was enough. The rest of the weekend I was with him and his friends again.

When you're dating, it's important for a man to understand that he hasn't *captured* you. He can't assume that you'll be waiting for him if he chooses to

ignore you. If you have to explain that to him in his language by showing up in a hot dress and walking right by him arm-in-arm with someone else, then so be it!

No matter what, make it clear that your life goes on, with or without him. And believe it yourself!

The Job's Not Over Once You're Hired

I always tell my husband that being married is like taking care of a plant. It has to be watered every day, and you cannot ignore it. My husband and I can't take each other for granted, and we both have to tend to our relationship every single day.

In other words, ladies, your work isn't done once he puts a ring on it!

As I told you earlier, my best tip for a success-

ful marriage is to make sure you get the right guy to the altar. But even with the greatest guy in the world, sustaining a marriage and making sure it grows and thrives and blossoms requires effort and devotion from both of you.

Later on I will speak to what he needs to do (since sometimes a little bit of instruction is necessary, especially if you marry very young). But before we get to that, I want to tell you what I've learned in my own marriage—actually in both of them—about how a woman can water that plant and make sure the romantic bonds stay healthy and strong. Sometimes you'll want to dig up the whole garden and stomp away, but stick with it!

Okay, enough with the plant metaphor. Now I want to go back to the idea that selecting a mate is a lot like hiring someone for a really important job. Earlier we concentrated mostly on your role as the hiring manager, but it's actually a mutual process. He's also deciding whether or not to hire you. Once you're married, congratulations—you got the job!

But the job's not over once you're hired. In many ways it has just begun.

I did not understand this in my first marriage. I was too young and immature at eighteen to even be married, frankly. I married a good man and a good father, and we're still very friendly. In fact, he and Mauricio even

became friends! But when I married him, I didn't understand the kind of commitment that was required of me. I thought, "Okay, I'm married, now everything will fall into place and I'll live happily ever after." No, marriage is work. The best work you can have, but still work! You have a lot to learn, and you have to apply that knowledge to your relationship. You have to commit to proving day after day that you're still the best one for the job!

Once I had my daughter Farrah, I learned right away that being a mom came very naturally to me, even at such a young age. But being a wife was extremely challenging. Every time something went wrong, I thought, *Oh, I'm outta here, done, finished.* Growing up with divorced parents made me think you could always just leave. I didn't have the tools to grasp the point of marriage—that no matter what, you're in this for life. You're building a family. You stick together.

I was bored at times too. My husband was quiet and shy and liked to play golf, and I found myself living the life of an older person, though I was just a kid. All my friends were starting college and here I was home nursing a baby. I didn't even know how to make meals for someone. I thought, *Do I have to do this every day?* Oh my God, about the only dish I could come up with was tuna fish sandwiches!

What I eventually learned was that not only do you

have to choose a good partner; you also have to be ready to step up and *be* a good partner yourself. You have to embrace commitment. It's the most vital part of a real union and essential for creating a family.

A big part of that commitment is providing support and encouragement to your spouse. Everyone needs to be nurtured, and I believe it's important to build up your husband as much as you can. I'm always reminding Mauricio how smart he is and how proud of him I am. It's important for him to have that confidence to succeed in life. I see so many mistakes in marriages when women—and men—don't support one another or work hard to build each other up.

And it does go both ways—your man should be your biggest cheerleader. I really needed that from Mauricio after my mom died. She was a very big support system for me; she made my sisters and me feel that we could do anything in the world. After she died and I lost that, I was suddenly going, "Wait. Hello! Somebody tell me I'm wonderful!" Mauricio did come through for me, but I didn't leave it to chance. I told him what I needed.

You can't expect your husband to magically figure out what you're thinking. Don't get mad if he doesn't read your mind or divine your emotions. Sometimes you just have to tell him. I have said to my husband, "You know, sometimes I need you to acknowledge more of what I do as a mom, juggling four kids and trying to keep it all together, trying to look good." When I'm

explicit about what I need, I give him a fighting chance to supply it! Remember, men don't have the same kind of emotional intuition that women do, the sensitivity that comes along with our natural roles as mothers and caregivers. So work with him to help him understand what you need and what will make you happy.

Clear communication may not be easy. When I first married Mauricio, it was a real struggle to help him better understand me. In any marriage couples have to go through a period of learning about each other and about themselves, and it can be rough at first. For us, our youth made it particularly difficult. When we married, he was suddenly not just a husband but also a father to Farrah, and soon after that, we had a child together, Alexia. So it was the two of us, a seven-year-old, and a newborn in a two-bedroom apartment—and Mauricio was only twenty-six.

Sharing chores was a very challenging part of our

He Said, She Hears

I've noticed that we women often have our own interpretations of what men say. For example:

» He says, "I'm falling for you." She hears, "Will you marry me?"

» He says, "I can't see you tonight. I'm going out with the guys." She hears, "I'm dumping you and going out to pick up women!"

» He says, "Why don't you go out and buy a little something?" She hears, "Max out the credit card!"

relationship in the beginning, and he took a long time to learn. I had to tell him, "Excuse me, you need to be here helping me. I cannot do this all by myself!"

I vividly remember one day when I was pregnant with Sophia and could not stop throwing up. I literally had my head in the toilet and the other two kids were waiting for me to make lunch. My husband came in and rubbed me on the head and said, "I feel so bad for you, honey. You must feel awful. If you need anything, call me. I'm going to the golf course!"

Oh. My. God. I said, "If you walk out that door, do not come back!" Ha-ha! And then I called his mom and said, "You better tell your son if he ever does that to me again, he's going to be a very sorry man, because as much as I love him I will not tolerate that." My mother-in-law is wonderful; she's always got my back!

One time Mauricio did go out to golf or do his thing, whatever it was, at a very—shall we say—inopportune moment. I had just had one of the babies, so I was hormonal, and I believe at that time my mother was dying, and all of it was making me feel overwhelmed. I think I'm generally pretty grounded considering how I grew up, but I definitely have that fiery, Irish side in me. Usually it makes my husband laugh—unless there's a shoe flying by!

Yes, that day I just lost it. When he came back from his little outing and walked through the door, I picked

up a heavy clog and winged it at him. He ducked, then laughed at me and said, "What are you doing?"

I have for the most part outgrown that kind of behavior, and I never let my kids see that side of me. But when you're working out the bumps early in your marriage, you can have those moments. So my suggestion to you is this: don't wait until you're ready to start throwing things at him! Tell him what you need, and that will help smooth things out.

Mauricio likes to tell people, "My wife understands that I wear the pants in the family. . . . She just picks what color, what size, and which ones I put on in the morning." Ha-ha!

So being supportive, and making sure that he's being supportive, and seeing to it that both of your needs are being met—all that is great. But don't forget that little thing called romance. You're in love with this guy, so you need to continue to cultivate that passion between you with tender, loving care.

It's surprising how many people, perhaps without realizing it, get that piece of paper saying they're married and think that's that. Then they just take each other for granted and become two complacent people living out their lives, not caring about how they look or act or treat each other. Maintaining the romance in your relationship is major. Huge. Ginormous! Don't let him forget the sexy vixen he fell in love with.

Making Lemonade Together

Supporting my husband has never been as heartbreaking—or crucial—as it was one particular time early in our marriage, shortly after Alexia was born.

Mauricio had gotten a job, a big one, in a clothing company. It was a very good position, but he was too young for it, really, and we both knew it. And that's what his bosses eventually decided too.

I will never forget seeing his face when he came home one day. I could tell he'd been crying. He said they'd let him go. It was so, so awful. The feeling I had was unlike anything I'd ever experienced before. I just wanted to grab him and hold him and say, "It doesn't matter! We'll be okay, no matter what," because I knew we would be. We loved each other! But I could see how terrible he felt, and he was trying to keep up a brave face.

I kept thinking, *How can they do this to my husband! And at Christmastime! Don't they realize we have a little girl and a baby and we have Christmas presents to get? How could they be so heartless?* But the pain I felt for my husband is unforgettable.

So after being devastated for a little while, we decided, hey, let's not sit here and wallow in this. Let's think. What could we do? We started brainstorming together, and after a while we came up with a great idea: we would go get our real estate licenses together!

And that's what we did. We took the course together. I was so proud—he scored at the very top of our class. And believe it or not, I was number three. I had been so scared because here I was—tutored on the set all my life, didn't go to college, thinking my math skills would never make it. And I'd overheard some people saying they'd taken the exams three times and failed. But not only did I pass; I got the third-highest score! I felt like Einstein!

After we got our licenses, Mauricio went to work for my brother-in-law Rick's family firm, Hilton and Hyland. And now

he is actually one of the top 10 brokers in the country. I'm so proud of him.

Thank God. Even though that was the worst moment of our lives, I thank God that those people let him go, because we sat down together and came up with the idea of going into real estate, which Mauricio was obviously meant to do. It made me realize the power of two people truly committed to their partnership.

Still, what I wanted to say to Mauricio that night—to reassure him that we'd be all right no matter what—is exactly the way I feel even now. The issue of money in this town can be ridiculous, but if something happened and we had no money anymore, I'd still be happy be-cause I'd have my husband and my children. I do say to Mauricio, though, "I'd be 100 percent fine with no money—but I wouldn't want to live here!" It may sound terrible, but we'd have to move! Ha!

Our plan B has always been that we would go to Vail, Colorado, and he could be a ski instructor (because he's a phenomenal skier), and hopefully I would just stay home and bake cookies and be with my kids. That might be a luxury, though, and if I had to work, that would be okay too. I love it here in L.A., in Beverly Hills and Bel Air, because I was born and raised here. But sometimes a simpler life away from all of this sounds really great!

Now don't get me wrong. I'm not suggesting you dress to the nines all the time with every hair in place and a full mask of makeup on. I sure don't live up to those standards—unless I'm going somewhere where the paparazzi might be lurking! Ha-ha! Of course you're not going to get glammed up like you're going out on the town. I'm not putting on my false lashes every day just to look good to my husband. That's taking it to the extreme.

No, I'm just saying you should make an effort for your husband in the same way you did before he was your husband. Care about your appearance, and present your best self to him as much as you can. I know from experience how easy it is to let things slide, especially when multiple small human beings enter the picture. At times, after I've had a baby, just getting in the shower is about all I can manage!

Let me tell you a funny story that really opened my eyes about this.

Usually in the morning I just throw my hair up in a ponytail and do something my kids call a "ponyball." They make fun of it—it's like a ball on top of my head. Sometimes I forget and go out like that. So one day I went to the market with my ponyball and some old sweatpants on, and I must say I really did look like hell. I had Sophia strapped onto my chest in the Baby Björn and when I sat down outside the market to nurse

her, this girl walked up and said, "Oh, hi! How are you? We met at an open house for one of your husband's listings."

She told me about how all her friends with her that day were looking at Mauricio and saying, "Who's *that*? He's so handsome!"

And then she said to me, kind of eyeing my oh-so-glamorous outfit, "With a husband like him you really shouldn't be running around looking like that."

OMG! I had to laugh, because she was right. I'll never forget those words!

My mom always used to say, "Don't run around in your sweatpants with no makeup, because you never know who you're going to bump into." Listen, I like to be comfortable, especially when I'm running errands with my kids, like going to Target or picking them up from school. So I'm not swearing off sweatpants. (In fact, I still sometimes go out the door in really scary sweatpants with frightening hair! And every single time I think, *Oh my God! Here's my mom's voice coming to haunt me!*)

But I try when I can to wear something comfortable but kind of pulled together, like casual leggings with a sweater. Or at least I try to make sure I'm showered and fresh, with my hair brushed. I don't wear makeup during the day unless I have a lunch or event or something.

But I can do lip gloss! That's not too much to ask!

My kids think it's hilarious when I hear Mauricio's car in the driveway and I run off to the bathroom to put on lip gloss, let my hair down, and make sure I smell pretty. "Why do you always do that?" they say. "It's just Dad!"

"Because I want to look nice for your dad!" I tell them. Just because you've got that ring doesn't mean you should just throw in the towel on basic upkeep. Of course I want to look nice and sexy for my husband. Not because I think he might cheat on me or something. No, you have to trust your husband. But he's been working all day and really, do you want him to come home to see you in sweats, your hair a wreck, and find smelly, poopy diapers in the can? I try to look nice when Mauricio comes in the door, and we always kiss, because that's a rule.

I also try not to look *too* shocking in the morning. I usually stumble out of bed and look at myself and think, *Holy Toledo, nobody wants to see that!* So I make a little bit of effort, which, believe me, is about all I can manage most mornings. I wash my face and brush my teeth right away, and I might even put some lip gloss on.

And . . . I know this sounds really ridiculous, but my eyebrows are so out of control that I usually brush them a little bit before I go downstairs to get my coffee. Fact!

These are all just little things that only take a few minutes—but it's the effort that counts.

Of course, you can look like a million bucks every second of the day and still find that love connection with your husband fading. That's because you also have to make time for the two of you—alone, without the kids. Among my married friends, date night is a cherished concept—though sometimes in theory more than practice! With the busyness of life, working and looking after the children, and taking care of everything else going on, who has time for date night?

Mauricio and I try to take one evening a week to go out together, just the two of us. We usually find ourselves heading to this old-school place called Ristorante Peppone, which has been around as long as I can remember. It's really dark and has red leather booths. (I love that.) We sit very close together! I really make an effort, especially when we're out on a date, to talk about things other than the kids or other domestic topics. You're never too married to be a sparkling conversationalist!

Marriage is a work in progress. However you choose to do it, make your romance a priority. Devote yourself to maintaining the magic that made you fall in love with each other in the first place. Find the time to look into each other's eyes. Tell him he's sexy! Flirt with him!

I hope I'm not making it sound like my marriage is perfect. A lot of people tell me they hope they can have a marriage like mine someday, which I find very touching. I do think I have a great marriage, and Mauricio is truly my ideal man.

But sometimes I just wanna strangle him!

We were recently filming at a party at a ranch in Malibu, in this big open area, and Mauricio and the three younger girls were there with me. I went to get Portia some food and asked Mauricio, "Would you watch Portia for a minute?" So I come back—and no Portia. And of course the camera is suddenly right there, and they're watching me look for my lost child. I'm thinking, *I'm gonna kill him! I'm gonna kill him!*

Mauricio said, "I only turned around for two minutes!"

I raised my voice and said, "You can't turn around for two seconds with a baby!" You know, men aren't like we are. As moms we have eyes in the back of our heads. But meanwhile the camera is picking all this up. *Oh great. Thanks, honey!*

We found Portia. She was with Farrah and she was fine, so my husband said, "Okay, she's right here, don't kick my ass!"

And I'm like, "Why do you say 'kick my ass'? Any mother would be upset . . ." And so on and so forth. The conflict only lasted a few minutes and then we moved

on, but it was unfortunate, because some people who watch the show already think I'm a ballbuster!

The shoe was on the other foot just last night when I almost burned the house down. Ha-ha! I put some eggs on to boil for Portia and then went upstairs to color with her and completely forgot about them. I had the door shut and we were laughing and the next thing I hear is this booming voice, "You're burning the house down!" I opened the door and there was smoke everywhere—along with an awful egg smell.

I came downstairs and Mauricio had on this long face, glaring at me, and I got upset. "It was an accident," I told him. "Why do you have to act like that?" But he gave me the silent treatment and we were actually mad at each other for another ten minutes.

Then he came upstairs and said, "I love you; good night." And just like that, we were okay. And so was the house, thank God!

I know some couples who just cannot let things go. They have to be right, or they can't get past their anger, or they feel like they have to make sure the other person feels bad for a certain amount of time. I want to say to them, "Get over it already!" Mauricio and I get over things quickly because we both want to be happy. I mean, at this point, after you've been through thick and thin and sickness and health, what is there to fight about, really? As you get older and understand

all you've created together, and fully appreciate the blessings you have together, smaller things that once set you off no longer seem so important.

And besides, who has the energy anymore?

Believe me, there is so much wisdom, so much peace in these four words: don't hold a grudge. I don't hold grudges with anyone in my life. I usually don't even remember what I'm supposed to be holding a grudge about. Neither Mauricio nor I hold grudges against each other, and it is so valuable in our marriage.

I won't lie. There are times when we go to bed mad at each other. But no matter how angry we are, we never go to sleep without saying, "I love you; good night," and giving each other a kiss. Sometimes I've done it through gritted teeth, let me tell you, but I've done it! It's a rule we agreed to when we were first married, and we respect it at all

What Makes Me Happiest

» Barbecuing with family and friends

» Going to amusement parks

» Decorating for Halloween

» Cooking with the kids on holidays

» Watching the girls play basketball with my husband

» Being with my family in the mountains in the snow, happily kidnapped in a log cabin, just us, away from the world

times. Sometimes one of us will start going to sleep before we've completed our ritual, and the other one will say, "Excuse me! You're slipping!"

We're not the only husband and wife who insist on closing their day the same way, and you've probably heard the advice before. But that's because it's so powerful! It's amazing how those words and that one little gesture can transform you overnight and make you wake up feeling different. It's the first step toward letting go of your anger, and in the morning, you're not holding on to that animosity anymore. It's like a little bit of magic.

I have learned so much about dealing with marital conflict from my sister Kathy and her husband, Rick. They met each other when she was fifteen, so they've been together since I was five years old. They have a truly incredible marriage. I've always looked to them as the positive role model in my life, since my parents were divorced.

Both Kathy and Rick have always been excellent at picking and choosing their battles. I know now that's what was going on, but I didn't entirely understand it when I was younger. Rick would get upset about something and my sister would say, "Oh, you're right, honey!" And then I'd think, *How did she do that? I wouldn't have said that!* Or she would get upset and he would say, "Okay, honey, don't get yourself upset."

How did they just let things roll off their backs like that? Were they just biting their tongues? I didn't know how they did it, but I could tell they avoided a lot of fights that way.

As I got older I realized it was a way of dealing with each other that they had perfected over the years. They probably did have to bite their tongues at first! But then it seemed to become second nature to them.

And now I know that my marriage would have ended long ago if I hadn't been able to accept my husband as he is! Neither of us is perfect. I know that Mauricio is really never going to be this way or that about a particular thing. For example, the other night there was a spider in the kitchen and I asked Mauricio to kill it. He didn't want to. He just would not get up out of bed to go do it. So I said, "All right, I'll be the man, I'll go kill the spider!"

Then I added, "Just like I have to be the one to lock up at night and make sure the family is safe!" He did not like that comment, but I have to be the one to go around locking all the doors. If I tell him to do it, he always misses one. Sometimes I'll check and even find a door wide open! This used to really bother me, but you know, really, in the greater scheme of things, is it all that important? Mauricio is an incredible dad and a wonderful provider for his family. He's my friend and supporter. He's a good person. He loves his fam-

ily and treats us like gold. He's an incredible human being.

Everyone has flaws, but instead of focusing on them, look at the big things that really count.

Sometimes a man's flaws may be a little harder to tolerate. He may make mistakes—even big ones that make you want to strangle him. You may not want to forgive him, and you may even want to leave him. But please, before you do anything rash, take some time to calm down and look at it sensibly, and be honest with yourself about the good parts of your relationship. If there's a lot at stake, you don't want to throw it away hastily. Think long-term and big picture. Does he recognize and admit his mistake? Is he sorry? Is he committed to not repeating it? It may be best to try to forgive and move on.

I have never had to deal with infidelity, thank God. Mauricio knows I wouldn't tolerate that. I've told him, "You ever do anything like that, you are done, finished, out the door." Ha-ha! But seriously, he knows it's true. I don't believe he would ever cheat on me anyway. But I know that it happens sometimes in marriages. One friend of mine came to me once very distraught. Her husband had had way too much to drink and he strayed, just that once. He was torn up about it. My friend was so angry and hurt. "Should I leave him?" she asked me.

Put a Wall Around Your Garden

I mentioned before that I'm not wild about guys' night out or girls' night out. I figure you can see your friends at lunch. My sister Kathy and her husband, Rick, never did that—every time they went out with their friends they went together. Nights should be reserved for family or for going out with other people as a couple. Oh sure, maybe once a month, now and then, go out with the boys, have a girlfriends' night, go to the movies. . . . But be careful. I've seen couples get in fights with each other that all started when she was out with her friends, or vice versa.

I don't see the point of purposely tempting fate, introducing risk, flirting with danger—or flirting with other people!

I know some people say that flirting can be totally innocent and harmless. Maybe so, but I believe that a relationship, even after marriage—*especially* after marriage—needs to be protected and sheltered from outside forces that could potentially undermine it. Even the strongest of relationships have a certain fragility that requires respect and TLC.

I confess that one reason I never flirt with people other than my husband is that I just seem to be incapable of it. I've been married the majority of my life, and I feel very shy and awkward around that kind of thing. If a man is hitting on me, I get so embarrassed and flustered! I immediately start talking about my husband and my kids. "Okay, I've got to go pick up my seventy-five kids at school now, bye-bye!" Ha-ha!

But I also think that because I am so genuinely attracted to my husband and so honestly content in my marriage I couldn't even fathom seeking the attention of other men. If you're feeling the need for interaction with or validation from men outside your marriage, I wonder, is it an indication there's something within your marriage, or your own heart, that needs to be examined?

To each her own. I'm just saying, be careful.

In my marriage? No! Never,

never, never, never, never! My friends don't believe me but it's the truth. "Not even Tom Cruise?" they'll say, because when I was younger I had a crush on him. No. If he—or even Mark Ruffalo, who I guess would be my actor crush now if I had to pick—were to ask me to dinner, hand to God I wouldn't go. I am seriously only interested in Mauricio, who to me is much better looking than anyone, Tom Cruise, Brad Pitt, anyone. (And by the way, Mauricio cannot say that anyone is pretty but me—except for Michelle Pfeiffer, because he's had a thing for her since he was a kid. Ha-ha!) I'm *half* joking . . .

If you want to call it jealousy, fine. I myself am not entirely unfamiliar with the green-eyed monster, though mostly from when I was much younger. Sometimes Mauricio is just too nice, though, like during our White Party that was filmed for season 1 of *Real Housewives.* This woman sidled up to my husband and was hanging all over him, saying really inappropriate, ballsy things. The look on his face was like, "What do I do?" But he's too nice to be rude. Like I said, too nice!

You may have seen the episode, but what you didn't see was one of my daughters coming up to me crying, saying, "Mommy, that lady's scaring me!" So that's when I said to this woman, "You wanna get a Manolo in your eyeball? You stay away from my family!" I'm definitely like a mama lion when it comes to my family. They're my cubs and nobody better mess with them.

Mauricio is funny; he deals with the idea of being jealous by pretending that he's the only man I've ever known in my whole life. He jokes around, "Oh, you know, Kyle wasn't born till I met her!" Ha-ha!

I just look at my husband and see the ideal man. To me he's flawless, inside and out. Sweet, kind, sensitive, and easygoing. And handsome. I buy all his clothes and I swear everything looks good on him, absolutely everything, because he's like a fit model.

I especially love when he has a five-o'clock shadow. I always tell him, "I like it when you have that look going on with the scruffy beard."

Then my kids will say, "He looks a little bit like a terrorist!"

Ha-ha! It's true, when we've been flying Mauricio has been

held at security a couple of times. They pat him down, take a little extra time checking him out. So maybe he looks like . . . a movie star terrorist. If they were casting a movie for a sexy terrorist, he would definitely get the role!

Oops, did I get a little carried away there? I did have a point though! The point is, a big part of nurturing your relationship with your husband is training your eyes on *him,* looking to him for the flirtation and romance and validation that you need, and being careful about letting third parties enter the sacred space that should be reserved for the two of you.

Outsiders can be a little bit like weeds—once they invade your flowerbed, it can be hard to keep them from taking over!

I told her to really look at the good in her marriage and how it stacked up with this horrible mistake her husband had made. Were the major aspects of their relationship and life together positive? And what was his attitude? He happened to be really broken up about the whole thing and had sincerely and repeatedly asked her forgiveness. He promised it would never happen again. He was desperate to save the marriage. "If this is the one that you're really in love with, and you've created a wonderful life together, then maybe you should try to make it work. It will be really hard, but perhaps you can try to forgive him and go forward with your marriage and keep your family intact."

It's very hard for me to say anything because each situation is different, and each person has different needs and expectations and levels of tolerance. But I admire couples who can work through betrayal and come out at the end genuinely happy, maybe with a stronger marriage. I know it's very hard, and there's a lot of pain involved. But I know it's possible. I've seen it happen.

I'm not telling you to be a doormat, though. If it happens more than once, I would definitely be hightailing it outta there! You don't want to be an idiot! One incident, a single mistake, is one thing, but I would not tolerate a repeat offender. I don't think that would be good for you or your family.

Of course it's not always the guy who cheats. A friend

came to me once very upset, a woman friend, and she started crying because she had done something with someone other than her husband. I took her hands and said, "Look at me. It did not happen. Do you understand me?"

She looked at me like I was crazy, and she said, "No, no, but . . ."

And I said, "Listen! Stop! It didn't happen. You're moving on and it didn't happen. Because otherwise you're going to ruin your life."

She knew it was a stupid thing that she did, and she hated herself for it because she loved her husband. She thought she should tell him and beg for forgiveness. But what good would have come from confessing it? Or torturing herself over it so much that it ended up affecting their relationship anyway? I told her, "You'll be able to learn from this, and maybe your relationship will be better for it. But it did not happen and I never want to hear about it again!"

"But what if—"

"No!" I just cut her off. Ha-ha! We actually ended up laughing a little, after she shed a lot of tears. I'm sorry, but sometimes you have to carry on as if it didn't happen. I am a very honest person. I cannot stand lying—liars make me insane. But there are times when it doesn't need to be said. There's no need to hurt the other person if it really was a mistake, unless you've put him at risk and have a responsibility to let him know.

Why destroy your whole life? Do what you need to do to acknowledge in yourself and to God what you did. Don't forget it; just learn from it and try to move on.

When you face conflict in your marriage, look at the bigger picture of what is valuable in your life and what you want to hang on to. You may have to work hard to keep your relationship intact, whether by not stressing the small stuff in order to keep the peace, or by carving out time alone together when it seems impossible to do so, or by forgiving your husband or yourself.

The important thing is to keep up the good work! Because if you do, you may get to keep that job forever—and that's a good thing!

Big Kathy

I don't know if you've noticed, but I wear a certain ring on my right hand all the time. I get a lot of questions about it on Twitter and Facebook because people have seen it on the show. It's pretty hard to miss, since the diamond is ten and a half carats. I have to say, the ring is pretty spectacular—just like my mom, who owned it originally and gave it to me. They're both kind of larger than life! I wear it all the time not just because I love it, but also because it reminds me of my mom and how much a part of me she is.

My mother (who was sometimes called Big Kathy to distinguish her from Little Kathy, my sister) had a tremendous influence on my life—on my values, my

strengths, my attitudes, and my way of doing things. I've even picked up annoying little habits from her that I keep discovering. Ha!

Mom was a real powerhouse. She had red hair, green eyes, and was 100 percent Irish. She looked a little

Big Kathy-isms

My mom was so funny. She had particular expressions she liked to use. When a guy she was dating called her, she'd say "Well, hellooo stranger!" using this deep, deep voice, all drawn out. My sisters and I say that to each other sometimes, just because it makes us laugh.

She had all sorts of furs, which really bothered me because for ten years I was a vegetarian. I'd tell her, "Mom, please! Don't buy those! The poor animals are dying for your furs!"

She'd say, "Darling, if you don't buy them, then they died for nothing!"

And she didn't mince words with people. Once we were out in Palm Desert and Kim's daughter Brooke had a guy friend over who had pierced nipples. When my mother was introduced to him she said, "Oh dear God, darling, how desperate for attention do you have to be?"

Even near the end of her life, after she got married for the final time, she was so funny. She called me up and said, "I was looking through Bob's things." Bob was her husband. "I see there are three Viagra pills missing! If that f–— thinks he's going to be doing anything with me, I'm going to tell him he just wasted thirty dollars! Kyle, you know those pills cost ten bucks apiece, don't you?" I laughed so hard!

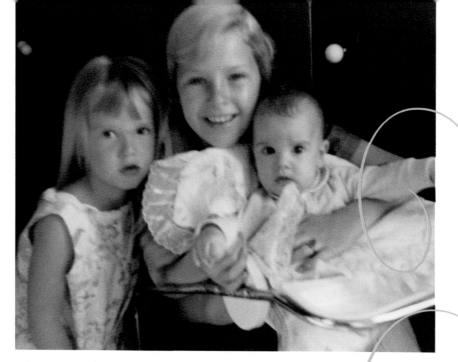

Above: Kathy, Kim, and me (at three and a half months old), 1969.

Below: Our nanny María, Kim, and me, 1969.

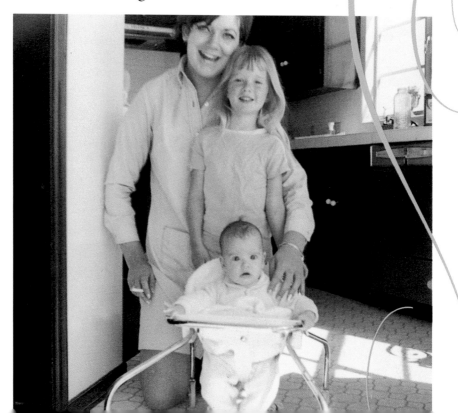

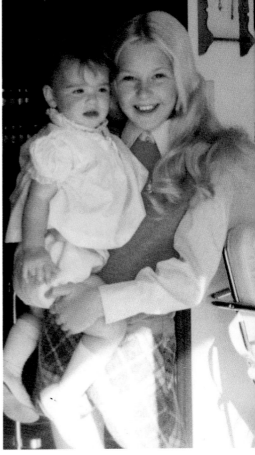

Opposite: My mom, "Big Kathy."

Right: Kathy and me (at fifteen months old), 1970.

Below: My dad, Kim, and me (at fifteen months old), 1970.

Right: My mom at our beach house. She had great style.

Below: Big Kathy.

Left: Kathy, Kim, and me, Beverly Hills Hotel, Christmas 1972.

Below: Our holiday card, 1973.

Right: Kathy and me at Kathy's wedding, 1979. I was ten years old.

Below: My mom and me at a hotel in Hawaii, 1981.

Left: From my Little House on the Prairie days.

Right: Eaten Alive—the movie that gave me anxiety.

Below: At nine years old with Victor French in Carter Country. He also played my dad on Little House on the Prairie.

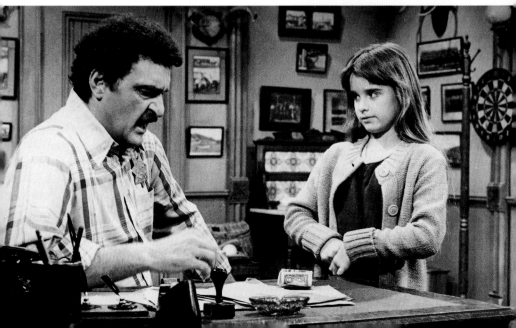

Opposite: Me at thirteen years old.

Left: Actor C. Thomas Howell holding Paris Hilton, 1986.

Below: Me with C. Thomas Howell at my sister Kim's wedding.

Right: clearly the eighties were not good to me. Fifteen years old.

Below: Farrah and me when I was twenty years old, 1989.

Top: My sweet dad and me with blond hair, 1991.

Above: Farrah and me in Palm Desert, 1993. My hair hasn't changed much.

Above: Me and Maurício.

Right: Getting ready for my big day.

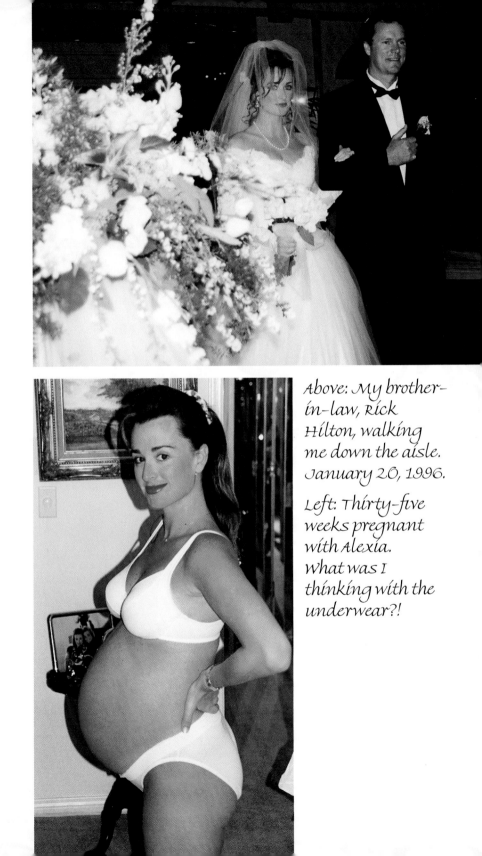

Above: My brother-in-law, Rick Hilton, walking me down the aisle. January 20, 1996.

Left: Thirty-five weeks pregnant with Alexia. What was I thinking with the underwear?!

Above: Mauricio with Alexia in July 1996. He had just turned twenty-six.

Below: Nursing Alexia, July 1996.

Above: Pregnant with Sophia in Acapulco. I had two and a half months to go. Huge!

Opposite: With Alexia when she was five weeks old.

Above: With Sophia at six months old. I could not lose the baby weight.

Above: Pregnant with Portia.

Left: With Portia a couple of months after giving birth.

like the Irish actress Maureen O'Hara and a little like Elizabeth Taylor. And Mom was an Aries, which you may know is a very strong, dominant personality.

Mom was *such* a big personality that even though she was only five foot three, people often thought she was much taller! (Some people think I'm taller than I really am too—*almost* five three, so can I just go ahead and say five three?—and I guess that's because I've inherited some of my mother's outspokenness!)

One of the most valuable treasures my mother gave me, much more valuable than the ring, was confidence. Mom loved me and my sisters so much. She thought we walked on water. I mean, she just made us feel like there was nobody smarter, nobody more beautiful, nobody more talented anywhere. Probably to a fault! But she wanted us to have that kind of confidence growing up.

She truly lavished attention on us. She was totally focused on her kids and managed both my and Kim's acting careers, but she always saw her real job as being the advice guru to all her girls. That was her happiness. Her ultimate goal was for us to have a good life and be the best we could be. She got married four times, but she always used to say, "It's hard for me to be married. All I care about is my kids." And it was true—probably to the point of annoying the hell out of all her friends and anyone around her! She wanted to be either with her kids or talking about them all the time.

And yes, I will admit that I'm a little bit too obsessed with my own kids, but, like mother like daughter.

Mom had this habit where she'd get a certain expression on her face and press her tongue to the roof of her mouth and make a sound like "tststs-ts-ts-ts-ts." I used to watch her when she did that and I knew she was thinking something like, "Okay, we're lost. What do I do now?"

So the other day I was driving and suddenly found

They Don't Make Stars Like They Used To

When I was growing up, my mother pointed out on more than one occasion how Bette Davis "always takes her time when she speaks." Mom always told us to speak clearly too; it was very important to her.

My mom loved the old-time, classic movie stars, like Elizabeth Taylor, Ava Gardner, and Sophia Loren. They were an inspiration to her, and she wanted them to inspire us too. We used to watch old movies together and she'd tell us all sorts of Hollywood stories. I remember listening to one about Elizabeth Taylor falling in love with Richard Burton on the set of *Cleopatra* and leaving Eddie Fisher for him. (She wasn't a big Marilyn Monroe fan, but she told stories about her too. I definitely knew who the Kennedys were when I was little!)

I think she liked the drama and glamour of old Hollywood; she was a drama queen herself! But she felt strongly

myself going, "tststs-ts-ts-ts-ts." I thought, *Where did that come from? Oh my God! I'm turning into my mom!*

I'm glad, though, because she passed on great values to us. One of the best things about her was that she wasn't a snob in any way, shape, or form. She taught us that no one was superior to anyone else, regardless of their occupation or the square footage of their house.

That's why I don't mind that some of my friends have mansions so enormous you could fit my whole house

that actresses were far more elegant in that era than in more modern times. And sexier too. Men used to fall at their feet! She considered them not only beautiful but smart, and she showed us how they carried themselves with such grace. She was big on carrying yourself like a lady! She would never let us chew gum in public because she thought it made people look tough and trashy; if she saw you with gum in your mouth she'd snap her fingers and open her hand and you'd have to spit it out!

Some years ago I saw Britney Spears do an interview with Matt Lauer on the Today Show and she was chewing gum with her mouth open the whole time. I was just floored! I thought, *Where is her mother?* I'm glad my mom exposed us to the elegance of those stars, their manners, and their way of moving and speaking, especially in an era where Madonna was writhing on the floor singing "Like a Virgin!"

into their kitchens! Ha-ha! Seriously, Lisa's closet—Lisa Vanderpump, my castmate on *Real Housewives*—is the size of some of my friends' apartments!

In other words, Mom made us understand that possessions don't make anyone superior *or* inferior. And that's what I try to instill in my own children, along with gratitude for all the things they're fortunate to have.

I was fortunate to have a privileged upbringing. My mother came from a successful family in New York City; my grandfather was an attorney who worked for the city. When she met and married my father, the CEO of a retailing company, they moved into a beautiful house they'd built in Bel Air. Mom loved diamonds, cars, and furs, but she had her practical side too. She did a lot of things for herself in a town where not many people did. Most women around here had their hair, nails, and everything else done for them. Not my mom. Before a big event you wouldn't find her at the beauty parlor all day. She would be working hard at home, cleaning. We had a housekeeper, but Mom scrubbed the house right alongside her. Then she did her own hair and nails before she went out.

I'm like that too. Of course sometimes with the show and other appearances I end up with someone else doing my hair and makeup, but I usually prefer to do those things myself whenever possible. Some people I

know seem almost incapable of doing personal grooming on their own! I have friends who have literally said to me, "I haven't washed my own hair in years," and I'm horrified. They go to the salon three days a week

Mom's Style Essentials

My sisters and I always joke that if our mother was a cartoon character, she'd be Cruella de Vil, only nice. She was a glamorous woman who adorned herself with furs and jewelry and loved luxurious cars. I remember leaning into her soft furs and smelling her beautiful perfume when I was a little girl. It was a wonderful sensation. These were Big Kathy's must-have accessories:

» Long red fingernails. I think the name of the color was Dragon Red.

» Norell perfume. I saw it in a drugstore recently and had to buy a bottle!

» Her huge diamond ring, of course, and big cocktail rings, including a diamond-and-ruby ring she loved.

» Diamond chokers and pearl chokers.

» Turquoise and silver squash blossom jewelry.

» Furs, furs, furs! Long coats, short coats, stoles, wraps, shawls. Black, brown, white, silver, gray. Mink, fox, who knows how many poor animals she wore!

» Cars. She loved them big and beautiful.

» And, *unfortunately,* a cigarette.

to have it washed and blown out "because I just can't do it myself! I can't reach." I'm thinking, *My hair is five feet long and I can do it myself and you have three strands and you can't do your own hair? What are you talking about?* Ha-ha!

Even my kids make me crazy when they say, "I need a manicure" or "I need a pedicure." Oh come on, you're little, if I can do my own you can. I go out and get mani-pedis sometimes, but I often do my own, especially if I'm crunched for time. The kids will say, "But we don't know how to do manicures and pedicures!"

"Well, you better learn," I tell them, "because you don't know if you're going to always be in a position to have all this stuff done for you!" I never want them to take things for granted. I try to teach them that they have to work hard for nice things—those things just don't land in your lap.

At the same time, I don't want my kids overly focused on possessions. At my house we could care less about trying to compete with others—which is another thing I got from my mom. She never cared about trying to impress people or overspend or pretend to be someone she wasn't.

We were very privileged, absolutely. Mom had furs and diamonds and cars! But there were always people around us who were much wealthier or better-

connected. In this town? You bet! And there were people with less money than we had. But so what? Mom taught us to appreciate what we had and feel good about ourselves no matter what. I think that's why I am not a jealous person at all. I never feel intimidated or insecure around people who have more than me.

Actions define a person. Just like my mom, I don't let the housekeeper slave away on her own. When I come home from grocery shopping, no way is the housekeeper unloading everything from the car by herself. I would feel incredibly guilty if I let her, mostly because it's disrespectful. Mauricio and I know people who were billionaires at one time and now have nothing. You never know what life has in store for you.

Although I've mentioned several ways that I take after my mother, I don't want you to think we always saw eye to eye. Oh no. She was a take-charge character; it was always her way or the highway. She had our best interests at heart, but I definitely fought with her when I was younger. And while I now appreciate her qualities of being outspoken and direct, I didn't always.

She was *such* a straight shooter that it embarrassed me when I was little. She'd bluntly come out and tell it like it was to anyone, and at times it made me want to crawl under the table.

Hurting

Until my father died from cancer a few years before my mom, we'd never had any cancer in our family. After my parents, many people in my extended family got cancer and died, so cancer is a sensitive subject with me. That's why I was so keen to participate in a bike ride that we filmed for season 1 of *Real Housewives* to raise awareness and funds for cancer research. I was thrilled that Mauricio and I ended up as the second biggest fundraisers, second only to a huge corporation!

All the cancer in my family, and especially my mom's death from breast cancer, has also made me very committed to taking care of myself, to doing the kind of things my mom didn't do, like having regular mammograms. I go to the gynecologist not just annually but twice a year to have everything thoroughly checked out.

But there are other health issues I care a lot about too, things I've experienced firsthand. I share a bit about them here in the hopes that hearing my story might help someone going through similar issues. If I could even help one person, it would mean so much to me.

Shortly after my mom died, I began a descent into two years of hell from severe pain and other health problems. Of course I was depressed over my mother's death, but that's not what I'm talking about: this was real, physical pain and it was severe. In my shoulder, it was so unbearable that it made me cry. I couldn't even move my arm. I also had pains in my legs, ringing in my ears, burning in my throat, vision changes. You name it, I had it.

I went from doctor to doctor and was tested for every disease on the planet. First they told me I had Epstein-Barr, and then arthritis, and then this and that. I don't even remember the list of things they came up with.

In addition to the physical symptoms, I began suffering terrible anxiety. I'd get panic attacks and couldn't breathe.

I started worrying obsessively. If I had numbness and tingling in my legs, I was sure I had a brain tumor. Or Parkinson's. Ha! Wait, Alzheimer's! Or no, it was multiple sclerosis!

I tried to hide it from my kids, but I would wake up in the middle of the night and tell Mauricio, "I'm going to be in a wheelchair; I won't be able to take care of the girls!" He was always supportive and tried to talk me down from my panic, and I had friends who did the same. My physical therapist would assure me, "You'll be fine. You're not dying!" But the pain was literally preventing me from functioning, and I was debilitated by the anxiety too. Even when they ran tests to prove I didn't have the disease du jour, I was convinced I was dying.

After I'd seen just about every doctor in L.A., they all gave up on me and decided I was a hypochondriac.

Then one day I remembered a commercial I'd seen. It said, "Depression hurts."

Oh my God. Could it be that the pain and anxiety were actually symptoms of depression? Depression hurts—why didn't anybody tell me that? I finally realized I needed to go see a psychotherapist. For weeks, every time I walked into her office I was hyperventilating. But eventually she made me understand that I wasn't dying— I was depressed! The depression led to some of the physical pain, and then when I became worried and upset about the pain, that in turn caused more pain.

The therapist also said I had general anxiety disorder, which explained a lot of why I had always been such a worrywart. She wanted me to put me on Lexapro, which I resisted at first. I'd never taken an antidepressant before; I'd always thought, "No, I'm a strong person! I'm a control freak! I'm not going to take anything!" But after a while I said yes to the Lexapro. And thank God I did, because it helped me so much. Between the therapy and the medication I felt like I was finally able to emerge from an endless, dark tunnel.

I eventually weaned myself from the medication, but I still have the anxiety disorder. I'll always have it, but when it rears its ugly head, I now know the right coping mechanisms, and I know there's help I can turn to in the short term, in the form

of medication and therapy. Doing *Real Housewives* is quite challenging for me because it creates a lot of stress; a big part of the show centers around conflict. When it gets really bad, it can kick up my anxiety disorder, and I find myself worrying obsessively about things. That's when I'll get a hangnail and think my hand has to be amputated. Ha! I kid only slightly.

I also know that when that happens, I can turn to my friends, who talk to me and reassure me. I also talk to my mother-in-law, Estella, who is a psychologist and has been so supportive and helpful.

Most important, I talk to Mauricio, who is always supportive and talks me through it. I am so grateful to him for the many nights I have woken him in a full-blown panic attack due to the pain caused by fibromyalgia.

I also try to laugh about it, because laughing is really the only way to deal with it! (If you watch *Real Housewives,* you may have seen the girls teasing me about my fear of flying. They find it funny, and so do I, really, but it's part of my anxiety problem, which can be truly crippling.)

A little while after I pulled through those horrible two years, the most horrible of my life, I learned that in addition to depression, something else had been contributing to my pain: I was diagnosed with fibromyalgia, which is a disorder that causes pain throughout your body. When the doctor began asking me questions about the pains I'd had in my life, everything fell into place. Even as a little girl, I had severe growing pains that would make me scream and cry. And fibromyalgia can cause depression and anxiety too! So it was all a vicious cycle.

If you happen to be experiencing pain or depression or anxiety or any kind of suffering, first of all I want you to know that you are not alone. There are people who understand what you're going through, and you can usually find them by going online and looking for support groups.

My ordeal taught me that physical pain can be a manifestation of the pain you're feeling in your head and your heart. If you're ever in a situation similar to mine, remember that.

If you're specifically suffering from widespread pain in your

body that doctors can't figure out, consider that it might be fibromyalgia. For a long time the medical community didn't understand fibromyalgia or even believe that it existed. That's changing, but not all doctors have gotten with the program yet. Make sure you find one who has.

And no matter what kind of pain or health issue you might be suffering from, try doing what I do whenever my problems begin to flare up. At the very first sign of pain or anxiety, I immediately begin to focus on taking extra good care of myself. I try to avoid as much stress as possible, so I cancel anything that isn't absolutely necessary. I skip the parties and lunches and events. I don't have any wine. I try to eat well and—this is really important—get lots of sleep. All those things make me feel better more quickly.

Above all, don't ever be afraid or embarrassed to ask for help. And take it when it's offered. I'm so glad I did.

Let me tell you a story about my mother and that flashy diamond wedding ring she always wore, which is now mine. One time when my mother was due to arrive at the airport, she had ordered a car to pick up me and Kim at home so we could meet her there. I was about eleven or twelve. When she got into the back of the car, she said, "These men have been staring at my

For Richer, for Poorer

One more story about Mom and her big diamond ring.

She had a reputation of having daughters that married well. Kathy married a Hilton and Kim married into the Davises, a very prominent, wealthy family in L.A. who owned oil and entertainment businesses. When I married my first husband, the rumor going around was that I had married a prince. Ha! He was sweet and had such nice manners, but he wasn't a prince. Still, my sisters married very well; it's true.

Mom used to say, "You can marry someone with money or without. You might as well have with." But all my friends' mothers said this! One of my friends said to me, "Yeah, my mom's version of that was, 'It's just as easy to marry a rich man as a poor man. You might as well marry the rich man.'" Then she added, "But I didn't pay attention!" Ha-ha!

My mother had a funny way of demonstrating the concept. She used to take out this puny little toy ring and say to one of the girls, "Pretend I'm the man. Will you marry

ring. They've watched me the whole time I've been go-
ing through the airport." Sure enough, these two men
got in a car behind us and followed us when we drove
out of the airport.

"Girls, always be aware who's following you," my
mom told us. "Always watch in the rear-view mir-
rors!" What a scary situation! No wonder I was such a

me?"And then she'd put the ring on the girl's finger. I
watched her do this.

The girl would say yes, and Mom would say, "Okay, we're
gonna do this again." She'd put her hands behind her back
for a minute, then bring out one hand holding her huge dia-
mond ring and repeat the question, "Will you marry me?"

The girl would go "Oh!" and her eyes would pop, and
then we'd all burst out laughing. It's true, the big diamond
added a lot of zing to the proposal!

I hope that story doesn't make my mom sound terrible.
As I've said, I don't care about the money—I'd love Mauricio
either way. But I have four daughters now, and I understand
where my mother was coming from. She wanted the best
for us. When my kids grow up I don't want them to have to
worry about money. I don't want them struggling to pay the
water and power bill or wondering if they can afford braces
for their children. That's why I emphasize education so much
with them. Sure, I'd like my daughters to marry men who
are intelligent and successful. What mother wouldn't? But
I don't ever want them to have to rely on a man to get by.
Marrying well should not be their life plan!

nervous Nellie when I was a kid—and no wonder I'm so neurotic now! Ha!

Finally my mother told the driver to pull over at a gas station, and the other car pulled right in behind us. Mom got out of the car and marched right over to their window and banged on the glass with her fist! I couldn't believe it. I was cowering in the back of the car. All I could think was, *Why can't Mom just shut up?*

These guys rolled down their window and looked at my mom like, *What the hell?* She put her ring right up to the tip of the driver's nose and said, "See something you *like?*"

You have never seen two men more shocked in their lives. Then my mom just whirled around and marched back to our car. She turned to me and my sister and said, "Take that as a lesson, girls. Never allow yourself to be intimidated by anyone."

Oh my God.

So, like I said, my mother wasn't the type to keep her mouth shut, especially if someone was being treated unfairly. Mom had a fiery temper, but I always thought of myself as quiet and shy until one day when I was shopping at Neiman Marcus with Farrah and my then-mother-in-law. I was nineteen. A tiny baby was crying nearby and I heard someone saying, "Shh! Shh!" and not in a nice way. The baby kept crying and finally the person who'd been shushing her said, "Shut up!"

It turned out to be a stranger telling that baby to shut up. Can you believe it? So I went up to the woman and screamed at her, "How dare you!" I also used some four-letter words, and my poor ex-mother-in-law, who was truly shy and reserved, was absolutely horrified. She said, "Oh my, Kyle, please, you must not act like this!" Ha-ha!

That was the first time I realized, oh yeah, I definitely have my mom in me. I definitely speak my mind! Some of it must come from that confidence she encouraged in me and my sisters.

She also tried to encourage a sense of humor in us as much as she did confidence. Humor was a huge part of who my mom was, and it was impossible not to absorb some of her enjoyment of life. Some of her wicked wit no doubt rubbed off on us.

We were even able to find humor in things when she was dying. She had an amazing ability to see the comic side of life even when she struggled. At one point, the part of her brain that controlled motor skills didn't always function properly. So we were at a party one night, standing around talking, and she just suddenly fell over, knocking me over too. We both landed on the floor and just lay there laughing and laughing. We couldn't stop!

You might wonder, how could we be laughing at that time? But thank God we could. It's a gift from God, really, to be able to laugh even in a time of sorrow.

My mom died of breast cancer. I'll never forget when she called me on my thirtieth birthday and told me she'd found a lump. Being the worrier I am, I felt my heart immediately drop. Then I thought, *That's ridiculous, I know lots of people who have lumps and they're nothing. And we didn't have any breast cancer in the family.* I said, "Mom, it's not going to be anything!"

She said, "It's pretty big."

"Well then you need to go and have it checked, and you'll be fine." I told her.

She started crying. "Kyle, I'm scared!"

I was supposed to be going away for my birthday with seven couples to Mexico. I told my mom I was going to cancel. She said, "No, no, honey. You go and you have fun. I don't want you to worry. I'll go and have it checked." Just like a mom to insist that her daughter go enjoy herself no matter what she was going through.

I did go on the trip, but I didn't enjoy myself because, of course, I could never get Mom out of my head. When we came back, we found out it was cancer, a growth about the size of a nickel. They said it was somewhere between stage 3 and stage 4.

She hadn't had a mammogram in five years. Immediately I realized there was a lesson for me there: you have to confront your fears head on. I know how scary it is to get a mammogram; I never get over the

anxiety of it no matter how many times I do it. But a mammogram could have saved my mother's life. They ended up doing a lumpectomy and radiation, but it was very aggressive, and the cancer kept coming back and eventually went to her lungs and her brain. She survived for three years, though, and I'm so grateful we had that time with her.

My mom was always in denial when it came to doctors. After her cancer diagnosis, my sisters and I would sit in the doctor's office listening to him talk and she'd just look out the window, not even wanting to hear what we were saying. I think she wanted to pretend it wasn't her he was talking about.

She had never taken care of her health. She smoked (and I hate smoking, by the way!). And I told you above about her chats with the girls late at night when they came home from their dates. Well, the second she snapped on the light she'd grab her cigarettes

My Dad, Ken Richards

My father was an incredibly loving, attentive father. I used to spend every weekend with him at his house in Santa Barbara. He loved cooking, and I remember so many happy dinners with him.

He was so sweet and devoted. Sometimes when I had terrible growing pains in my legs that would make me cry, I would call him and he would drive the hour and a half down from Santa Barbara to wrap my legs. He was already retired when I was born. I just knew he was a wonderful dad.

and light one up. She also didn't exercise or pay attention to what she ate, so she was a little overweight. I wished I could have made her do the things that would have helped her stay healthy.

My mother gave wonderful advice to her daughters about men, but I used to say to her, "I wish you could give yourself the same advice!" She was divorced three times, and she dated again, but nothing ever worked out in the long run. As much as my mother loved being a mom and was happy in her life, I really think she always wanted to find somebody to love and build a lasting relationship with. And yet whenever there was a man around, well, she wasn't exactly the most adoring wife! I'm not going to lie! Ha-ha!

My mother actually decided to get married for the fourth time while she was battling breast cancer. I found it so funny. I said to her, "Mom, why are you getting married if (a) you're sick and (b) you don't even like being married?"

We had the wedding at Kim's house, and when the priest said, "Do you take this man . . . ," Mom looked at me and rolled her eyes and said, "Ugh . . . yes."

I started laughing. "Mom, you can't do that! You're getting married!" She was just one of the funniest women you'd ever want to meet. Right to the very end, even though she was terrified of dying and hadn't accepted it at all. She fought it all the way, and it was very painful for us to watch, but she never lost her sense of humor.

We had insisted on taking her from the hospice so she could spend her last days with us. After a ridiculous amount of red tape, we finally brought her to Kim's house where we set up a hospital bed for her. One day we were trying to bathe her and she started to fall off the bed. Kim shouted, "Kyle! Kyle!" and we struggled, and it was kind of hilarious. My mom couldn't even move, but she started laughing so hard! I said, "Kim! Kim! Get the leg!" Here we were, all of us laughing, with my mom just days away from dying!

Mom's best friend, Diane, joined us in those last days. The two of them loved to eat and always teased each other about it. But at this point my mom wasn't eating anything and wasn't really able to talk anymore either. Finally the doctors told us to stop giving her Ensure or even water, because we were prolonging her passing. God, when you're told to cut your mom off from water, that is so, so difficult.

We did have some swabs that we would soak in water and then put in her mouth to ease the dryness. One day we gave her a swab and she just clamped on to it, gripping it with all her might. Diane said, "Darling, relax. It's not a chicken bone!"

My mom immediately burst out laughing, and the two of them laughed so hard and so long that even Diane couldn't talk! That was Mom's last amazing laugh. And maybe her last living lesson to me—a reminder that attitude counts for so much. Even in the

most painful times, you can laugh, and you should, because it can lighten your heart and maybe even give you a bit of extra strength.

Then at the very end, she communicated loud and clear without using words.

I had been laying by mom's side the night before she died, but the hospice nurse said, "Honey, your mom's not going to let go if you're there right beside her." I didn't want to miss her final moments, but the nurse said she would come and get me.

At about 5:00 in the morning, Kim woke me up and said, "It's time."

We had put on a CD with sounds of the ocean to make everything as peaceful as possible for her, and we were soothing her, telling her, "It's okay, Mom, you can go."

Suddenly we heard loud clattering sounds in the kitchen. I figured it was Mauricio, and I thought, *If he knows my mom's dying, why doesn't he come in here? And what is he doing with the silverware anyway?*

"I'm sorry, I don't know why he's in there making noise," I said.

The hospice nurse said, "I'll go get him." She left, and when she came back she just stood in the doorway, wide-eyed.

"What?" I said.

"There's no one there," she said. But we could still hear the noise. "It's your mom."

I've heard stories about things like that but I'd never experienced anything like it firsthand. We all looked at each other and nobody could believe it.

Then the noises stopped. And in the very next moment, hand to God, my mom made a sound like she was gasping for air, and that was it. She took her very last breath, and then she was gone. I swear on my life.

And then all of a sudden the door to my sister's room slammed shut! I ran to look into my room, but my husband was sound asleep with the kids. How could the door have slammed shut on its own? Maybe it didn't. I know that was Mom on her way out.

Her body now looked so different, so not like her, that it almost scared me. I realized Mom was saying to me in my mind, "I'm not in there honey, don't worry. I'm not in there, I'm out *here* now." It was the most incredible experience I've ever had, and it brought me so much peace.

The hospice nurse said she had seen similar things happen at the very end, especially when the person dying had a very strong personality. She told us, "That's your mom saying good-bye."

I know a lot of people won't believe the story—some just aren't open to that kind of thing at all—but I can tell it to you with confidence because so many people witnessed it. I'm so glad that I *was* open to the meaning of it all, because the experience made me feel so much

better. I know it was Mom trying to make me feel better, just like always.

Before I finish my chapter about my mom, Big Kathy, I want to tell you the last part of the story about the ring. Mom gave it to me shortly before she died, partly

Spirited Conversations

I'm not embarrassed to say it: I believe that people can communicate with us from other realms and that some individuals here on Earth have a special gift for tuning them in and helping us understand our lives. But I was very puzzled during an episode of season 1 when we went to Camille Grammer's house for a dinner party with a friend of hers who was a psychic. The psychic and I got into a disagreement, and she said some pretty harsh things about me and to me. As usual, I spoke quite directly to her. She told me I didn't get along with women, which was completely off-base because I love the women in my life. I grew up in a house with all women. Are you kidding? I'm a girl's girl through and through, just like my mom. She loved having her girlfriends over all the time, and they'd cook in the kitchen and laugh hysterically together.

So we had another psychic to dinner for season 2, and this time she got things so right it was almost scary.

I invited all the girls from the show to dinner at my house, and after dinner we all sat around the table and had a séance. (This psychic was also a medium.)

Yes, you can call me the Shirley MacLaine of *Real Housewives*! Ha-ha!

because she knew Kathy and Kim had a lot of jewelry and I didn't have as much. Kathy and Kim each have an incredible jewelry collection. But she also wanted me to have it because she felt I was always so responsible. I was always the nervous Nellie, worrying and

So the psychic was going around the table, and in the middle of talking to someone she all of a sudden stopped. "Wait, hold on one second!" she said. "Kyle, your mom is here. She's really interrupting a lot. Okay, she wants me to let you know she's here. But she is also saying that she wants all the girls to have their turns first!"

Everyone started laughing, including me, but I was getting shivers too. I'm having goose bumps just telling you about it now—because that's something that my mom always used to say! She always had this thing about making sure that everyone got their turn and no one was excluded. My sister Kathy told this story of when she was a kid and some boys and girls were in her room playing spin the bottle. My mom walked in and saw a plain-Jane type of girl just sitting there in the circle and immediately said, "Now, is everyone getting their turn? How about you, sweetheart?" Here Kathy thought they'd be in trouble for playing spin the bottle, but my mom was only concerned that "plain Jane" would be left out by the boys.

So you see why I was freaked out, but also pleased, and kind of excited. My mom was there with us that night in my dining room, watching out for all her girls. Just like always.

wanting things to be right, even as a little girl, and my mom always said I was ridiculously mature for my age. She used to joke, "You know, Kyle was changing her own diapers and making her own bottles when she was one year old—and scheduling her own dental appointments at eleven!"

When she gave me her ring, she told me to change the setting, because she'd never been wild about it. So I took it to Loree Rodkin, a well-known jewelry designer in L.A., and asked for something simple. I have small hands so I didn't want it to be crazy big. It already made my own wedding ring look like a toe ring when it I wore it on the other hand. I would joke and put my wedding ring on my toe and show my husband. "You like my toe ring?" Ha-ha!

Plus I didn't want it to cost a fortune. So I asked for simple, but simple was not what I got! Mauricio picked it up from Loree and called me and said, "I can't believe this. I feel like I'm carrying a Lamborghini in a box." If you haven't seen it, it's quite big, antique or maybe gothic style, with swords on the side and cognac diamonds mixed in with the regular diamonds. I have it on my right hand in the cover photo. It looks like it would be clunky, but it's *so* smooth on the inside. It's perfect! I wear it all the time, every single day.

People have asked me, "Don't you worry walking around with that? Aren't you afraid someone will try to take it?"

"I dare anyone to try to get this off my finger!" I tell them. "I will take them out, believe me! This is not coming off my finger unless you take my whole arm!" Ha-ha!

Hmm. That sounds like something my mother might have said!

Mom in the House

Of all the questions I'm asked, this one is my favorite: How do you juggle a baby and the kids and the show and everything else in your life?

The reason I like that question so much is that it means people see me as a real mom, completely involved in raising my kids. Because I am! I've never had a nanny. And that, my friends, is highly unusual where I live.

Being a good mother is the most important thing in the world to me. I'm a hands-on mom—like most moms outside the rarified world I live in—and I

wouldn't have it any other way. Moms everywhere are juggling and struggling to do the very best they can for their kids. I'd love to tell you how I do it.

A lot of people have said to me, "Oh, your kids— how did they turn out so nice?" I believe you get out of kids what you put into them.

I always wanted a traditional upbringing for my children, and that's why they're not actors. They don't want to be actors. No, I want a family sitting down together at dinner every night. Well, almost every night. Mauricio and I get a lot of invitations, but we have a rule: we have to be home more nights than we're out. So in a crazy-busy week that would be three nights out, tops. I believe children need their parents' presence.

Here in Beverly Hills, a lot of women let nannies raise the children and the drivers take the kids everywhere. There's too much of that, and it's very sad to me. Even outside of Beverly Hills, I've noticed some moms make their social life a priority and leave their kids with babysitters or their older children. Children crave your attention. They soak it up like a sponge.

If there's one overall piece of advice I could give to parents, it's this: be there. Simply be there *with* your children and *for* your children as much as you can. You get out of your children what you put into them.

I see my children as such an incredible gift. They're my favorite people in the world to spend time with and

My Mom Suggestions

These are the things I believe and try to do to raise good, happy children—and not go completely bonkers in the process!

» Physically be there for your kids.

» Treasure each moment you have with them.

» You're the all-powerful mom, so take charge and don't let others take over!

» Teach your kids as much as you can.

» Give your kids a spiritual or ethical grounding.

» Punish without getting physical.

» Build confidence by letting them talk and hearing them out.

» Make them mind their manners.

» Use positive reinforcement!!!

» Resort to scare tactics if necessary.

» Make sure your child has time to be a child—and save yourself some drive time too. Ha!

» Delegate.

» Make things easier for yourself and have people come to you.

» Create boundaries for your children.

» Learn to say no to things that aren't really important.

» Accept that you're not perfect, and give yourself a break!

» Respect your children. They will respect you in return.

I don't want to miss a moment. With my crazy schedule, I'm always scared that I will, especially with the baby. I'm so fortunate to be doing a reality show, because it allows her to be with me while I work.

One reason that I like to do things for myself, like my hair and nails, is that I really don't want to leave my children for several hours. By the time I go to a salon and get my hair washed, done, and come back, four hours have gone by and I've just lost a huge chunk of time with my kids.

I admit that I might be a little extreme about not leaving my children. I've never let them go away for more than a few days for a school trip. It's very hard for me to be apart from them; I have separation anxiety. I feel so much for women who have to go to work and don't have a choice; they have to spend a big part of their day away from their children. They work so hard and then come home and have to do the laundry and the cooking and make a house look nice. I admire their hard work so much, and I feel they don't get enough credit for it. I just love that about women—being able to do it all. I dare any man to try to keep up with us! Ha-ha!

I do have a housekeeper, as I've mentioned. And it's wonderful to have her help. But just because there's someone there to do things for me doesn't mean she should be doing *everything* for me—especially when it comes to the kids.

For example, I learned the hard way that I have to pack my kids' lunches myself. My mom always told me, "Honey, if you're lucky enough to have a housekeeper, never let her make your kids' lunch. You need to be in charge of what they're being fed." Okay, so for a long time I never let the housekeeper pack the lunches.

Then one morning—during the time my mom was ill and I was feeling overwhelmed—I came downstairs and the housekeeper had already packed up the kids' snacks for the day, because she wanted to be helpful. I was wary, but I checked inside the bags, and thought, *Oh, she's packed exactly what I would have!* She kept making the snacks every morning and I'd check and, yep, she was doing it right. So what's the big deal then, I thought—even though I'd hear my mother's voice in my head saying, *Always do it yourself!*

Then one day when I dropped Sophia off at her preschool the teacher pulled me aside. She said, "Um, I think you need to reconsider Sophia's snack—the Weight Watchers bars are really not a good idea!"

Oh my God! I was mortified! I didn't know whether to laugh or cry! That's when I realized what my mom was talking about. I thought the same things were going into the bag that I would have put in there, but no. From that day on, I made sure I was the only one packing my daughters' lunches and snacks. I'm the one who knows what's healthy for them and which things

What's to Eat?

I strive to teach my girls the same philosophies about food that I maintain for myself: try to make good choices and eat as healthily as possible. If you want to have a little something that's not so healthy, fine. But be aware of what you put in your body, because it affects your health, your hair, your skin, everything.

I try not to make a big deal about what my kids should or shouldn't eat, though, because I do have girls, and there's so much subliminal pressure in our society for them to be thin, which I don't want to add to. Sure, eat wisely, but don't keep talking about it. Just make it a way of life.

Parents are in control of what goes in the refrigerator. You do the shopping. So unless they're out with their friends, when they're going to grab what they want, you control what goes in their mouths.

I like to have a ton of fruits and vegetables in the fridge, along with yogurts and cheeses. And I often make pretty healthy dinners like grilled salmon and veggies. I do get requests for fun stuff, and usually I will get it, because I don't want the kids to rebel. And there's always chocolate around our house—not just for the kids!

With Farrah I always used to go to the health food store and buy healthier versions of sugary cereal. Instead of Froot Loops, for example, I might get Fruity O's. And that was fine with Farrah, because that's all she knew. I could get away with it. But once you start having more kids and they hear from their friends, "Hey, this isn't Froot Loops!" you're busted—they want the real thing.

Still, I am trying something else right now. I buy the Fruity O's at the health food store but put them in Froot Loops box. So far it's working—we'll see. Shh!

they actually like so they are less likely to trade with their friends at school—although they still trade anyway. When I find unfamiliar things in their lunch bags, I ask, "Where did this come from?" and they tell me, "Oh, I traded."

"I picked these things according to what you asked for and you *still* traded?" It drives me nuts! I don't have any advice for that, but if you have any tips for me, let me know! Ha-ha!

The point is, you're the mom. You know best, so make sure you're in charge!

My mother definitely knew best about most things, though as you can see I didn't always accept it at first. My mom was always trying to teach me something. Every time she opened her mouth, there was a lesson. When I was young, I thought, *God, my mom is annoying, always trying to tell me things all the time!* But then as you get older, you realize that if you as the mother aren't going to tell your kids these things, who will?

That goes not just for the big life lessons but small things too. Every time my mom cooked, she'd say, "Clean up as you go along." I mean, she said that till the day she died. I used to think, *Why does she have to say that all the time? What does she care?* And now whenever I'm in the kitchen and everything's piling up around me I hear her voice and think, *Yes, now I know why she said that!*

TV Time

It may sound strange coming from someone who appears on a TV show, and in fact first appeared on a TV show when she was five years old—but I don't like my kids watching too much television.

It's very easy to use television as a babysitter, and believe me, I know it's a good babysitter! There are definitely times when I pop in a video if I want to keep Portia distracted. It is, on occasion, unavoidable! But I really don't like to do that too much.

My kids have restricted television viewing. They're only allowed to have certain channels on the TVs in their rooms, and Portia doesn't have a TV at all and won't for awhile. I'd rather they be reading books than watching TV. Portia loves books, and I'd much rather be reading to her than zonking her out with a video. I realize some kids take to reading more than others.

Television can be okay. Some channels can be educational and can truly help a child learn their ABCs or even life skills. I don't think you should forbid TV entirely. But I am very strict about my kids not watching anything that is R-rated or remotely questionable in its suitability for kids.

I'm dating myself here, but I will never forget the brown cable box in my house when I was a kid and the Z channel at the very end of the lineup. I knew that when my mom left the house, I could watch Emmanuelle, or whatever racy stuff was on in those days. I do not want my daughters seeing that. Kids grow up too fast today, and I want to keep mine as young as possible for as long as possible.

I don't let my kids watch MTV either. What about these teenagers who become pregnant? I guess those shows are supposed to serve as cautionary tales, but when the teen moms end up being glorified on the covers of magazines, that's not a cautionary tale. I don't even want those ideas in my daughters' heads.

For certain shows I'll use my oldest daughter as a gauge. I said to Farrah once, for example,

"Alexia really wants to watch *Gossip Girl*. What do you think? Because I don't watch the show."

Farrah said, "Absolutely not!" For other things, she might say I'm being a little too neurotic, so I'll be more open to thinking about it. But she's young and hip, so if she says no *Gossip Girl*, it's no *Gossip Girl*!

One TV show the girls have absolutely no interest in watching is *Little House on the Prairie*. Because the show is still in syndication I get residual checks for it. But some of them are so small—like 99 cents! Occasionally I'll catch *Little House* reruns on TV. It brings back a lot of good childhood memories.

I've tried and tried to get my kids to watch, but they couldn't care less. I would think they'd want to see me when I was little, but apparently not. They're bored by that kind of entertainment, as I think their whole generation is, which really saddens me. But I suppose when you go to school the next day and everyone is talking about *Gossip Girl*, what are you going to be talking about—Laura Ingalls? My girls may not get to watch *Gossip Girl* but they're not exactly TiVo-ing *Little House on the Prairie* either! I guess they don't want to be the nerds of the group.

My other show—*Real Housewives*—is another story. That I'd prefer they *not* watch—at least Portia, unless it's just light, fun stuff. It's funny because I was away and I guess my husband and one of the girls let Portia watch part of the dinner-party-from-hell episode—the one I mentioned before, when I got into an argument with the psychic.

A few days or so after I returned from my trip, I was sitting with Farrah and Portia, and Portia said, "Let's play a game!"

"Alright, go ahead, you start," I said.

Portia said, "Does Mommy have two legs?"

Farrah and I looked at each other like, "What?" and then I remembered during that dinner-party episode, the psychic had said to my friend Faye, "You had two legs last time we checked. Why don't you use them!" Ha-ha! That's where it came from. That's when I figured out someone let her watch the show!

In that same episode Faye said to the psychic, "Is that what you do? Is that what you do?"

I don't even remember what she was referring to. So one day Portia turned to her sister and said, "Is that what you do?" We all fell over laughing. But I thought, *Oh my God, what have I done!*

To tell you the truth, I really think my daughters see the person on *Real Housewives* as somebody else, and they see me as Mommy. The personality in me that comes out on the show does not come out like that all the time with my family.

One day I was getting ready and I looked in the mirror, and as I told you earlier, I usually have my hair in a ponytail or a clip, with no makeup on. I took my hair down and Portia said to me, "Oh, you look like Kyle Richards right now!" Which is so funny to me! She doesn't think of me as Kyle Richards. I'm just Mommy.

Speaking of that stressful, and kind of embarrassing, dinner-party episode (embarrassing because I was *so* outspoken in it)—a lot of people assume the show is scripted. You have no idea how many times I've thought, *I should just start lying and say, "Yes, they made me say that!"* I would love to blame a script for what I said in that episode. Ha-ha!

Even after I grew up, my mom had plenty to teach me. She came to my house once before she passed away and said, "Honey, when was the last time you cleaned the chandelier?"

I said, "Um, well . . . I didn't know you were supposed to! How do you even do it?" She wanted to teach me as much as possible before she left. She said, "It's not fair. You're too young for me to be leaving already."

I want to teach my kids everything I can while I can. Parents have so much knowledge that they can pass on to their children to improve their lives. Even trivial things. Just this morning I was in the shower and realized I'd never told my girls to brush their hair before they get in the shower, to take all those loose hairs that come out into the brush and throw them in the trash so they don't clog up the drain. Plus it's good for their hair. So I called the girls together and told them. They just kind of stood there with blank stares, probably thinking the same thing I did about my mom: *how annoying!* But they're going to look back and realize why I do those things.

Share your knowledge with your kids. Feed them lessons all the time. One day they'll thank you for it!

That goes double, even triple for the values you impart to your children—the *biggie* lessons. What we're all concerned with as parents is giving our kids the

fundamental principles and ethics to grow into mature, well-functioning adults who can take life on and win. A solid foundation is the most valuable thing you can provide for your children, and if you raise your kids right, they will definitely appreciate it—eventually, at least!

In fact, right at the top of my values list is appreciation, along with gratitude. I always say to the kids, "Your dad works really hard to enable us to have the things we have. We're very fortunate, because there are people who are literally worried about where there next meal is coming from."

Now they're seeing me work hard too. I've continued acting on and off since starting my family, but now I'm very busy with *Real Housewives*. Even though I'm on a reality show about my life, it's very time-consuming. I want my daughters to understand that all the material stuff doesn't just come to you automatically. It certainly didn't for us.

I tell my daughters I hope to God they go to college and become successful on their own and marry someone successful, but they don't know what the future holds. I just try to impress upon them that they have to work hard to get things, and that they should never, ever take what they have for granted.

But material goods are not the be-all and end-all of life, either, and Mauricio and I are determined that our kids understand that too. I don't want them to think

that this is it—you get an education, you work and get money, and that's it. They've got to feel there's more to life than this. That's one reason we've made spirituality a priority for our family and particularly for our kids.

Sometimes I get tired of all the superficiality of this Beverly Hills culture and think, *I gotta get my kids outta here.* I suppose there are problems everywhere; you hear about kids in small towns getting bored and taking drugs. But you have to work extra hard in this environment to teach kids meaningful values. I have my daughters in a religious school because I think it helps remind them that there is a higher power and that there are higher principles to strive for in life.

No matter your religion, or whether you even subscribe to any religion, I believe it's crucial to expose your kids to the meaning of life beyond material possessions. A firm ethical grounding gives them strength for coping with their lives and moral courage to be a good and kind person—which is what you want, right?

As you can tell, some of my child-raising philosophies are rooted in what you might call old-fashioned notions, you know, about religion and tradition. But when it comes to discipline, I'm not so old-fashioned. I do not believe in spanking. Not at all. You see kids biting or pinching or hitting another child and then the parents spank them as punishment. What kind of mixed message does that send? Violence is not good, so

now I'm going to spank you? To me, it's unnecessary and creates resentment in your child. My kids think the scariest thing they've ever seen is when I raise my voice. Then they know I'm mad. I don't need to hit them!

It is true that my husband and I, now and then, do fall into the trap of wanting to be the nice guy and the nice mom and have a hard time saying no. We do say no adamantly to certain things, but only if they're truly important to us. Do we spoil our kids? No, I don't think so, unless you mean spoil them with love. I don't ever think you can spoil your kids with too much love!

For example, sometimes one of my daughters will say, "Mom, I'm not feeling good. I'm really tired. Can I go to school late?" Sure. I see no problem with that. I try to be open-minded and understanding. I try to respect my children, and hopefully in return they'll respect me too.

I am very intent, however, on making sure the kids behave politely. Having good manners is part of treating people respectfully, and it's also a skill that will help my kids get along in life. Good manners—that's a make-or-break issue with me.

What I don't include in the concept of behaving politely, though, is the idea that children should be seen and not heard. That really is an idea whose time has come and gone. According to old-school thinking there should be no back talk from the kids—but I think that

teaches your kids not to have opinions. When my kids let me know they have an opinion, I want to hear it. I want them to feel that their point of view is important so that when they grow up, they have a voice and aren't afraid to use it.

Of course, this does sometimes bite me in the ass! Ha-ha! Sophia is very opinionated and very strong in putting her opinion out there. I've told her that it's great and her persistence will pay off someday. But sometimes when she's being really persistent with me and just won't let go, I say, "Please! Stop!"

And then she smiles and says, "But my persistence will come in handy someday, right?"

Yes, yes, she's right.

I don't want my kids to be people-pleasers—especially in a dating situation, when a boy might want to do something they're not comfortable with. I still sometimes go back and forth between being a people-pleaser and having the courage of my own voice. When I was a kid, if I ever talked back to my mother, whoa, I was in trouble! So sometimes I do have the tendency to go along with things just because I don't want to make trouble. And then other times, as I'm sure people would agree, I'm overly opinionated. Ha!

Kids should grow up being true to themselves, with their own viewpoints and the confidence to speak up. I insist that they be polite and civil in expressing

themselves, but they should also know that their parents are willing to hear them out even if they disagree. Once they share their thoughts, then you can discuss it. If they're wrong, fine, you're the parent, so you call the shots. But I think my kids are much more open with me because I let them air their opinions.

For example, I've said to Alexia on occasion, "You shouldn't have done that."

And she's said back to me, "Hmm. You know what, you're right. I shouldn't have." Wow! I never would have said that to my mom. I'm so happy I have that relationship with my daughter.

It goes back to building confidence, and you *know* how strongly I feel about that!

One of the most effective things you can use to build confidence is positive reinforcement. It's essential.

When Farrah was little, I knew she was smart. I didn't know if she was going to be a genius or not, but I made her feel like she was a genius! With every little thing she did, I made it a priority to praise her. You're so smart, you're so this, you're so that. And then, guess what? She turned out to be all those good things. Ha!

I'm not suggesting you bullshit your kids. If your child can't sing, don't tell her she's the next Christina Aguilera. But find out what her good qualities are and really focus on those. I don't believe you can ever go overboard reinforcing the positives in children. For

example, Alexia is a great photographer, and I've really encouraged her with that, and she's steadily gained more and more confidence—and her pictures are getting more and more impressive! And with Sophia, I give her positive reinforcement about her advanced math ability and her talent with sports.

But I'm also not suggesting that it's never necessary to be strong with your children in ways they may not like. It's natural to want to be friends with our kids. I want my kids to love me and think I'm fun and cool, and yet I also have to be the one to put my foot down sometimes. I've seen some parents who want so much for their kids to like them that they miss the boat on establishing the boundaries and rules that they need. Your children probably don't realize it, but they do need a structure, a framework they can understand about what's right and wrong, acceptable and unacceptable. They actually crave boundaries, because it gives them a sense of security. It frees them to explore and learn on their own from a place where they feel safe.

I am not above using scare tactics with my kids. Ha-ha! Trying to teach Portia to brush her teeth, for example, of course I tell her, "Go brush your teeth!" Repeatedly. You can tell her to do it and lead her to the bathroom to do it, but sometimes you need a little something extra to really drive the lesson home. So when the message didn't seem to be getting through

to Portia, I sat down at the computer and put her in my lap, and found pictures online of people who had rotten teeth! Totally disgusting mouths! "See this?" I said. "This is a picture of someone who didn't brush their teeth!" Ha-ha! My mother used to do those kinds of things with me. When their health and well-being is at stake, pull out the stops.

I have to admit, though, I've used scare tactics in less-than-life-threatening situations too. When my older girls were little and we were out and about, sometimes we'd see a homeless person on the street. They'd ask me, "Why is he living there, Mommy?"

I'd say, "Honey, he didn't go to college. That's what happens when you don't go to college!" Ha-ha!

For all this talk about teaching your kids lessons and instilling values, there is also something to be said for just letting kids be. Children should be allowed to be children, with time to simply enjoy themselves.

I do not understand why schools give kids so much homework these days. My daughters are not sleeping the hours they should because they're up until midnight doing homework. And then they have to get up at 6:30 A.M. to get ready for school on time.

Why does a child have to go to school so early in the morning, work all day, and come home and work all night? Isn't there enough opportunity for learning in the day? Hello! They're *kids*. Can't they come home

and enjoy being kids? No wonder they grow up so fast. They're made to act like adults.

I would give anything for the homework to ease up, and I know some other parents feel the same way I do. I've even heard of communities that have started making their schools reel it in. I say we should all speak up about this and try to get school officials in our own communities to come to their senses. Down with homework!

We put so much on kids these days, so much pressure to perform and participate. Some moms can hardly wait to tell you all the things their kids are involved in. "Oh, you know, Timmy's got soccer, and guitar, and math club," and on and on—it's just exhausting! They need to have time to go outside and just get on their bikes and be kids.

Which reminds me, I'll be so glad when the kids' sports season is over, although it seems like when one ends, another begins. Sophia plays tennis, and both Alexia and Sophia play volleyball, soccer, and basketball, though they usually have to choose between volleyball and soccer. That's pretty much right at the line of what I feel is acceptable. I feel really, really strongly about this: kids shouldn't be over-scheduled or over-stimulated. I don't want my kids on the computer all the time; I want them to have plenty of time and space with nothing to do but find their own interests. Read

a book. Go outside and play. Set up a lemonade stand and be a kid!

And let's face it, you have to consider all the running around moms have to do too. When each of your chil-

My Crazy Life

Monday, 6:20 A.M.

This is the most peaceful time of my day. The *only* peaceful time of my day!

I'm a morning person, and every day I wake up at 6:00 A.M. while the rest of the house is still asleep. I come downstairs and make myself coffee—half caf, half decaf, Starbucks Verona, two cups, with one packet of Splenda, one teaspoon of sugar, and a huge amount of Coffee-mate. Yes, even though people make fun of me all the time, it has to be Coffee-mate; don't even try to give me cream, because that powder just takes coffee to a whole new level! Then I read the newspaper, and it's such wonderful, luxurious "me" time. Honestly, having my coffee is the most exciting thing that could ever happen to me in the morning. It's the only time to myself that I ever get.

Oh, I am so tired. Hey, where are my glasses? Oh my God, they're on top of my head. See how tired I am?

Anyway, Monday is usually my day off, though lately the show's producers have been trying to squeeze me in on Mondays too. Sunday is also supposed to be a day off, but we filmed yesterday and then last night Mauricio and I took two of our girls to a concert, and they each got to bring a friend, and we got home at midnight.

dren have umpteen activities on their roster and you have to drive them back and forth to each one, that can be tremendously time-consuming. And you're already time-crunched!

This morning I need to make my girls' lunches and snacks and then drive them to school, but I also have to talk to a bunch of people by phone about what I'm going to wear when we film. I have a meeting here at the house at 10:00 and a spray tan at 11:30, then there's another meeting at noon. I take my daughter to soccer at 3:00 and have to film at 6:00 P.M. So my day is like boom, boom, boom. I don't even have time to meet a friend for ten minutes at Starbucks.

The other day they were filming a dinner party at the house, so I had a chef come in at 9:30 in the morning, the crew arrived at 11:30, and it wasn't until midnight that my workday finally ended, when everyone went home. At least work was here at my house that day, because when you travel, they film you practically every single second. If you're lucky they say, "Okay, we're powering down. You can go upstairs and take forty minutes for yourself but then you're due back down here for dinner."

I've been so busy that I haven't had a chance to work out in a long time. I don't think I'll have time today. Well, maybe twenty minutes on the treadmill after I finish the newspaper.

In any case, I think you have to make some kind of time for yourself if you want to be effective as a mom. Give yourself a time-out.

Professional Mom

Sometimes I do consider myself a pro in the mom department. Not that I know everything, but I have some tricks up my sleeve. First, though, I'll tell you my number one imperative about mothering: follow your instincts. Do what you believe is best and what works for you. Forget about being politically correct or doing what so-and-so insists is the best way to go. Now, on to the tips!

- *Baby's Nails:* Some of my friends have told me, "Oh my God, I'm so scared to cut my newborn baby's nails with the clipper or the scissors. I don't want to hurt them!" You know what? I just bite them off! At that age the nails are paper thin, and they just peel right away.

- *Eye infections:* Newborns are very prone to eye infections. There's a very simple way to take care of them that my doctor told me about. Just express a few drops of your breast milk and put it in their eyes. Just like that and the infection is gone!

- *Potty training:* I strongly advise you to do potty training in the summer. I let my kids run around naked in the backyard. If they're naked and they start to pee, they don't like the feeling of it running down their leg so they'll immediately stop, and that's when I grab them and rush them off to the toilet.

- *Time-Outs:* Speaking of potty training, accidents will happen—sometimes long after they seemed to get the hang of it. Ha! I don't believe in ever punishing my child for an accident, whether it's peeing on the floor or spilling juice. Why would you do that?

 Now if they've done something wrong deliberately, maybe having been mean to another child, then I will send them for a time-out. But the time-outs shouldn't be longer than one minute per year of age. So if your child is ten, she

gets ten minutes, and Portia at three years old would get three. If calculating it this way seems too lenient, please remember how children perceive time. Ten minutes is a long time to a kid! I ask my child where they want to go for their time-out to sit and think. I don't insist that it be their room because I don't want them to associate their room with punishment. And then afterward, I just move on. I don't harangue my child with, "Well, what did you learn? Are you ever going to do that again?"

- *Breast Versus Bottle Versus Cup:* These days there is so much pressure on parents to go by the book of what's accepted socially. For example, a kid is supposed to nurse until they're a year old and then go straight to a plastic cup. Well, I don't believe in that. I think it's a much more comfortable transition if the child goes from breast to bottle for awhile before he takes on a cup. If that makes your child happy and secure, why not? And I think a child is more likely to get all the water and nourishment she needs that way as opposed to drinking from a cup, which she might abandon after a few sips.

- *Sleep:* Again, I don't care what Little Timmy does, as in, "Oh, you know, Little Timmy was drinking from a plastic cup and sleeping in his own bed at six months old." I don't care about Little Timmy. I do what works for me! Ha! I'll probably catch a lot of flak for this, but I'm a big believer in letting your kids sleep with you. And so is my husband, thank God. I think the prevailing wisdom is they have to be sleeping in their own bed at six months. But we are perfectly happy having them in bed with us until much, much older. Not every night! But if they're scared or just want extra cuddling. People say, "How could you?" But what about cavemen times? I bet Little Timmy slept beside his parents then! When my children were babies, I actually let them sleep on my chest for many months, or I'd lie down with them and then go back to our bed later on. I don't let them cry forever alone in their beds. I would rather they feel safe. And

Mauricio and I are fine with having the kids in our bed—on some nights, not all—until they don't want to anymore. I'll come right out and say it—Alexia sometimes slept in our bed until she was about eight, and Sophia at eleven still does. I've even seen Mauricio creep out of bed sometimes and go get Portia after she's gone to sleep and bring her in with us. Who wouldn't want a soft chubby little arm around them while they sleep? I tell you, I have at times woken up to see my husband hanging off the bed, with his feet at the head of the bed, a dog on his pillow, three kids under the covers, and another dog somewhere in the mix. I believe they call it "the family bed"! We've thought about getting a bed custom-designed to accommodate us. Ha!

Let me issue one caution, though. When a child is very, very small, you don't ever want to run the risk of rolling over onto them. I actually slept halfway sitting up with my kids after they were born, and I usually slept half-awake anyway, as I know many mothers of newborns do. It's not a good idea to have your child in bed with you if you're a heavy sleeper or if you've had a couple of drinks. They do, however, make little tiny mattresses with frames now that you can put in bed with you to hold the baby. They're low but high enough that you can't roll over them.

- *Multiple children:* When you have more than one child, I believe it's very important to ensure each child gets some totally one-on-one time with you. I will ask my husband to take care of the other kids so that Alexia and I can spend the day together, for example. The other day I took Portia to the carousel and to California Pizza Kitchen, and then we had our nails painted together.

- *Teenagers:* When a child hits the age of thirteen, that's about when the divide starts—you know, when they can very easily start to pull away from you. That's when I start paying extra attention. Some parents think, *Oh, they're teenagers now; they don't need so much attention,* but I believe it's just the opposite. I stay on top of it and

concentrate on maintaining the closeness of our relationship, not in a smothering way, but in an open, loving way. I do it for both our sakes! It helps your child navigate the tough years knowing you're there for them. I was so happy the other night when we were at a kid's party and Alexia and her friends were taking pictures and Alexia said, "Wait, I want my mom in the picture!"

- *The Sex Talk:* It is not always fun and comfortable to talk to your kids about sex. Actually, it's never fun and comfortable! With Farrah, I bought some old books from my day that broached the subject in a kind of funny way. And she and her friends were able to giggle about it but still absorb some of the lessons. I'll tell you what I've found, though. The very best place to have the sex talk is in the car while you're driving! Look, it's embarrassing for both of you, and the more uncomfortable you feel, the more uncomfortable your child will be too. In the car, you minimize eye contact, which

lets you both off the hook a little in terms of the discomfort. You turn to the child and look briefly at her but keep your eyes mostly on the road! Believe me, it saves a lot of embarrassment for both of you. Ha! Some of you may prefer the sit-down eye-to-eye talk. Whatever works!!

- *Curfew:* Farrah had a strict curfew, 11:00 P.M. until she was in her senior year of high school, and midnight right before she went to college. People would say, "Are you kidding?" But Farrah didn't mind. She never once asked if we'd make it a later curfew. Sure, she'd call us and ask to stay out later, and we'd consider it on a case-by-case basis. But she never really made a huge fuss in general because I think it made her feel secure. Kids like structure and rules because they provide a sense of safety. Remember that when you're feeling like a mean mom enforcing your rules. Your children depend on you for drawing boundaries that actually let them feel confident and free.

Oh right—time-crunched. Here I've been telling you all about The Tao of Child-Rearing According to Kyle, but I haven't yet answered the original question! Ha-ha! The juggling question—how to do it all?

Well, lately it's been pretty hard for me to juggle, I confess. The way it goes around our house is this: I try to get up early in the morning so I can have time for some coffee and the newspaper. But as soon as I hear, "Mom!" I know one of my kids is awake, and I think, *No, no, not yet!* Because once they're up, that's it for me for the rest of the day. If I jump into the shower, then one of the kids usually jumps in there with me, and . . . it goes from there. Sophia and Alexia used to, and now Portia likes to. We had an open shower at our old house, with no doors, so whenever I was in there, people would just wander in and start talking to me. The dogs would be in there too, staring at me. I was like, "Oh my God, can't I shower alone for five minutes?"

And now that I'm doing *Real Housewives,* things are *really* ridiculous. It seems like we're filming all the time. I miss the days of just taking my kids to school and picking up odds and ends at the store and going to yoga. God that would be so relaxing! You don't know how much I love going to Target, but I hadn't done it in so long that last week I was determined to. So I spent the day there with Portia and my niece Brooke, Kim's

daughter. We got the big carts and shopped. We ate lunch there, and a couple of people looked at us, like, "Is *that* the girl from *The Real Housewives of Beverly Hills?*" Ha-ha! I was so excited to be there that I didn't want to leave! It was the best day. It reminded me of when I used to go to K-Mart, and they had the machine air-popping the popcorn and the Icees. I don't know why I loved that so much, but I did. I guess Target reminds me of when I was a little girl.

But there's just not much time for that these days.

Part of my problem is that I need to learn to delegate more. I think some moms are better at that, and I'm trying to learn from them. So my advice is to delegate, and do as I say, not as I do! I mean, some things your husband can do, right? Or even your kids. And some things are worth paying someone else to do, like hemming your kids' clothes (if you're as bad at that as I am, at least).

I found a dry cleaner that will pick up and deliver, and I made sure they weren't too expensive. Same thing with the dog groomer. You do have to do your research, though, because some businesses will charge way too much for that convenience. Basically that means getting on the phone or online and comparing prices. You have to find the affordable ones.

Perhaps most important in managing my time is the ability to create boundaries between my work and

personal life and stick to them. It isn't always easy, particularly because *Real Housewives* is all about putting your personal life on camera. But sometimes I let it go too far, and I think this is a common issue for all women, especially mothers: you just take too much on, and you hate to say no, but you have to.

I went through a very upsetting experience not long ago that illustrates this perfectly.

First, a little background: I believe you can look at certain things as a coincidence or a miracle—like after you've lost both parents, and you see things and wonder, is that a sign? Okay, I know people are going to think I'm a nut job here, but after my mom died, I went to a psychic and she told me that my mom was always around us, but she would come to us as a hummingbird or we would see white feathers when she is around. I'll get to the hummingbirds later on. But the white feather plays a part in this story.

This was one of my very worst moments as a mom. Nothing like it had ever happened before, and it made me feel like such a bad mother. And I pretty much see my entire purpose in life as being a good mother.

One day, while the *Real Housewives* crew was at the house, there were deliveries of furniture and flowers and food, and we had recently moved into our new house, so a chandelier was being installed that day. Then a light fixture broke and had to be fixed

and there were literally about thirty-five people in the house coming in and out all day. It was complete mayhem.

The phone rang. It was Sophia calling from school. She said, "Hi, Mom, it's okay, you don't have to come to school because I already got the award."

Oh my God. Oh my God. I'm going to start crying all over again just thinking about it. Sophia received an award they give all the kids at one time or another; it's for being a good person. The parents are supposed to go to school in the morning to see their child receive it. I started sobbing. I couldn't breathe. I had to call Mauricio because I'd forgotten to tell him too. The dates had been switched, and there was so much going on with the show that I was simply overwhelmed.

I was just doing too much.

I cried my eyes out and for a minute I thought, *I can't do this anymore. I can't do the show anymore.* I had never before missed any of the kids' games or awards or anything.

So I ran out and left everyone at the house and bought Sophia some flowers, picked up her favorite food, and drove straight to her school. I pulled her teacher out and started crying again. I couldn't stop. I said, "You've only known me since I've been working on this show. I've never had this happen. Oh my God. What do I do?"

She said, "Oh, honey, Sophia knows how much you love her."

I told her, "I need to take her out early and be with her. Is that okay?"

I took Sophia out of school early and said, "We're going to have a picnic." Again with the tears.

She said, "Mom, why are you crying?"

"I feel so bad. I'm sorry. I made a mistake." I just held her and she started crying too.

She said, "Mom, you don't have to cry." And then she bent down. There was a huge white feather at her feet, and she picked it up. I'm starting to cry right now just telling it. I thought, *That's my mom letting me know that even though I missed it, she was there.* She was there for Sophia. I believe that with all my heart. The feather is taped to Sophia's vanity now.

All right, I've got to collect myself before I go on.

The thing is, I was just doing too much. When I missed Sophia's award, I said, *Slow down, Kyle. You have to slow down!* I can be forgetful sometimes— that's why I have a million alarms every day on my Blackberry. But that was an all-time low for me.

So I've been trying to draw my boundaries and say no when I need to. I was supposed to go to Las Vegas to shoot *Housewives* on a weekend after I'd spent part of the week away in New York and part of it in Chicago giving a speech to the United Jewish Federation.

But I said, "No, I just can't do it. I've been away from my children too long. I can't do it!" I broke down.

I caused them some inconvenience because the crew was already there, which I hate to do, but in the end they understood. They told me, "The crew is packing up. You need to be with your kids."

As mothers, I think we have to learn to say no. We want to do everything for everyone; we don't want to let anyone down. But you have to know when it's time to get rid of the unnecessary stuff and concentrate on what really matters: your family. And your sanity!

I guess part of the answer to how I juggle it all is that I enjoy it. I'm hardly ever alone. The other day the older kids were off somewhere and Mauricio had gone out for a few minutes with Portia and all of a sudden I realized: *oh my God—I'm alone!* That never happens. Everything was quiet. It was just me, myself, and I. I would be lying if I didn't say it was quite the relaxing moment.

But I'm most happy when the house is full of kids and their noise, and I'm being their mom.

Sisterly Love

My mother always taught my sisters and me that whenever one of us accomplished something it was a feather in all our caps. We've grown up thinking that one sister's achievement reflected well on all of us. We want the best for each other and we celebrate each other.

No one knows you like a sister does. You can't love anyone quite like you can a sister, or *fight* with anyone like you can a sister. The sister bond has always fascinated me; it almost can't be explained. I see it in my own daughters.

Kim and Kathy and I cry laughing at some of our memories from growing up, and we have so many inside jokes and expressions that sometimes people

don't know what we're talking about. They think we're talking gibberish. For example, when we want to alert each other that the paparazzi have shown up, we say, "Cameron is here!" We still get together all the time for family gatherings, and we sing, "We Are Family"—you know, the Pointer Sisters' song? "We are family! I got all my sisters with me!" It's our tradition.

The way you have fun and laugh with a sister is just the best. But the way you can cry with a sister can be almost life-saving. At the most difficult times in my life, I've leaned on my sisters for support. Thank God for them. After my mother passed away, I don't know what I would have done without Kim and Kathy. And when Farrah went off to college, I was so devastated that I would just call them up and cry and cry. "I just can't take it!" I'd say, but they'd talk me through it. We all lean on each other for support. Any time one of us has a problem, we don't keep it private. Everyone

The Entertainer

I really am a frustrated singer. When I was about five, I remember getting up on the pool table and performing for my sisters. I sang that Donna Summer song, "Love to Love You Baby." I had no idea what I was doing or that the song was really about sex. I was just imitating the way it sounded, so I was going, "Ohhh, mmm, ohhh," and making the same kind of sounds Donna Summer does on that record, really low and moaning. *Oh my God! I was five.* My sisters just laughed and laughed. Ha-ha!

knows what's going on. We have a family meeting and pull together and look after each other.

The three of us used to have so much fun together when we were kids. As I mentioned before, Kathy was

Creature of Habit

You know, I was born and raised here, and I stayed in the same community to raise my family, so I have some routines that I'm very attached to. I've been going to some places all my life with my family. First with my mom and sisters and now with my husband and kids and sometimes my sisters' families too. Two of them are very close to my heart.

The Polo Lounge at the Beverly Hills Hotel

I've been coming to brunch here for as long as I can remember. There's something so wonderful about walking into the lobby of this big pink hotel on Sunset Boulevard with all the chandeliers. It reminds me of my childhood. And I just love seeing the people I know at brunch, because everyone in town goes for brunch. It's the best.

La Scala

The first time I went to this restaurant I wasn't even born. It's true. My sisters and my mom used to go there when she was pregnant with me, and we kept on going after I was born. We never stopped. We used to joke about it; we were at La Scala so much we called it "the office"! We still go there all the time. I love it.

born ten years before me and Kim five years after that. We're all cut from the same cloth but have our own individual personalities. I was strong but sensitive, and quite emotional. I liked to joke around, but I worried a lot and was always responsible.

Kathy was always very funny, a prankster and practical joker. She still is. When I was born she of course loved to carry me around like a doll but when she was fifteen, who could be bothered with their five-year-old sister?

Kim was a child actor (she was on the TV series *Nanny and the Professor* and did other TV shows and movies) and didn't have a lot of opportunity to make friends; as the middle child she was always eager to please. When my mom went out, Kim would vacuum and clean the whole house and then write a note, "Mommy, I was in bed at 10:01, I'm sorry. I know you said 10:00."

Kim was also really good at saving her money, and she used to stash it in secret places in her bedroom. Kathy knew I knew where it was and she liked to steal it, so she would ask me, "Where does Kim keep her money?" I'd tell her and then get a commission! Ha-ha!

We tell the story all the time about how Kathy, being the oldest and the ringleader, used to play pretend store. My mom kept all the crystal she collected in the living room, and we weren't even allowed to walk into

Just Who Are These People?

There are so many things I don't know about my family, and now that both my parents are gone, I really wish I had asked them more questions. Hopefully my sisters will remember some details, but a lot of it is probably lost forever.

When we were little we found many of the things my parents used to talk about boring and ridiculous. Like, who cares about Aunt So-and-So and her big boobs? My mom told me once, "Your aunt has triple-D boobs. You never know, yours could end up that big." I thought, *Why are you telling me that? You're making me sick! I don't want boobs that big!*

Now I wish I knew more about that aunt with the triple Ds. But it's too late. And didn't I hear that my paternal grandmother once ran naked down the street? Why did she do that? Was she mentally ill, or what? Was she just a streaker? Ha-ha! Maybe she was senile or had Alzheimer's. Tell me what happened! I need more details!

Seriously, find out all you can about your family. Do your family tree. Ask your parents questions and listen to them when they're going on about something you might think is unimportant now. One day you'll wish you had paid attention.

Thank God my mother-in-law, Estella, is very good about tracking the family history and keeping the stories alive. I'm glad my kids will have that, because someday they're going to want it.

that room except for on Thanksgiving and Christmas! But Kathy would go into the living room and take the Lalique and the Baccarat and bring them to her bedroom and announce, "The sale starts in ten minutes!" Kim and I would come running, so excited to shop! Kathy was such a good saleswoman. Kim would want a piece and Kathy would say, "No, I'm sorry, I'm not selling this, it's an heirloom!" That made Kim want it more and it would go on like that until Kim was begging to buy it, and Kathy would finally relent—at a higher price, of course. Then we would take our newly purchased "goods" back to our room.

Then eventually we would hear Mom's voice, "Who took my crystal?" and she'd make us put it all back. But we fell for that crystal sale every time!

We also used to play dentist on this particular girl who lived in our neighborhood. I was very little but I remember it well. Kim and I would assist Kathy. We'd have paper towels and clothespins and all sorts of "instruments," and Kathy would tell the girl to sit down on the toilet and "Sit still!" Then she'd turn to one of us and say, "Nail file!" or "Walnut picker!" And she'd clean the girl's teeth! Ha!

I was always very close to Kim growing up, even though we were complete opposites. She liked hamburgers; I liked hot dogs. She liked ketchup; I liked mustard. Night and day. We both had a huge thing for

Top: Bath time with Farrah.

Above: My maternal grandmother, "Doe-Doe," who lived with me growing up, with Farrah.

Right: Kim and me playing around.

Below: Me with my sister Kim and Bethanny Frankel.

Above: My mom, me, Kim, Kathy, and dear friend Wendy North dining at Morton's, Beverly Hills, 1991.

Below: Bad hair day with my best friend since second grade, Lorene.

Above: Me and Kim.

Below: The cousins: Kathy's, Kim's, and my kids. From left to right: Kim's daughter Whitney Davis; Kathy's kids Conrad Hilton, Paris Hilton, Nicky Hilton; Kim's daughter Brooke Brinson; Kim's daughter Kimberly Jackson; Barron Hilton; my daughters Alexia and Farrah; and Kim's son Chad Davis.

Above: My mother-in-law and father-in-law, Estella and Eduardo.

Below, left to right: Whitney Davis, Brooke Brinson, my daughter Farrah, Paris Hilton, me, and Nicky Hilton.

Above: Lorene, Farrah, and me, Christmas 1998.

Below: BFF Lorene and me playing around, Palm Desert, 1993.

Above: My BFF Tina and me after doing the three-day Avon Breast Cancer Walk right after my mom died. A very emotional day. April 2002.

Below: One of my dearest friends in the world, Faye Resnick, me, and Faye's daughter Francesca.

Above: Me and Sophia, 2008.

Below: At Farrah's graduation from USC. My ex-husband, Guraish, Farrah's biological father, is with us.

Top: Maurício and me on Halloween 2007.

Above: Me and Maurício in Napa Valley. We were on a seventy-mile bike ride to raise money for cancer (appeared on season 1).

Right: Happy together.

Below: Faye Resnick, me, and my friend Tiffany.

Top: My beautiful girls.
Above: The family.

Top: On honeymoon in Cancun, Mexico, 1996.

Above: My four daughters and me on the Caribbean island of Nevis, July 2008.

Opposite: Mauricio and me in Hawaii.

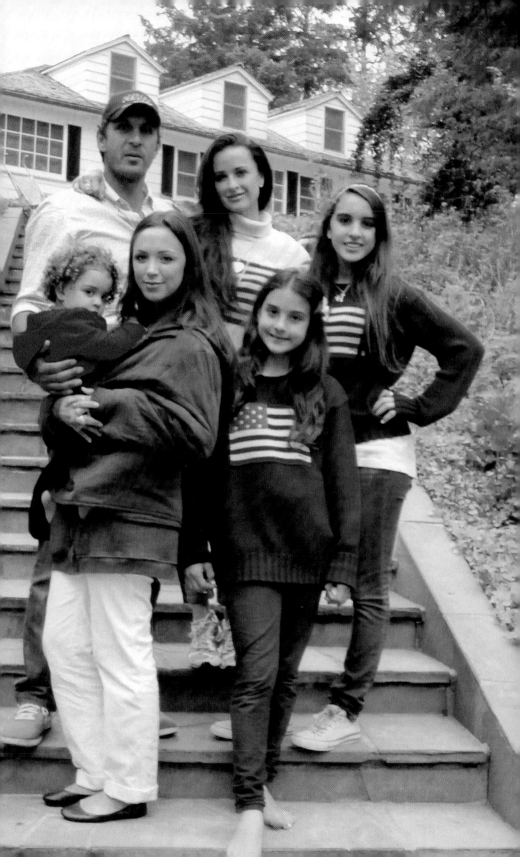

Opposite: Fourth of July in Gearhart, Oregon, at Tiffany's.

Above: Mauricio, Sophia, Chloe, and Portia. Nap time.

Left: Mauricio and me in Oregon.

Below: Me, Mauricio, and Portia on Halloween.

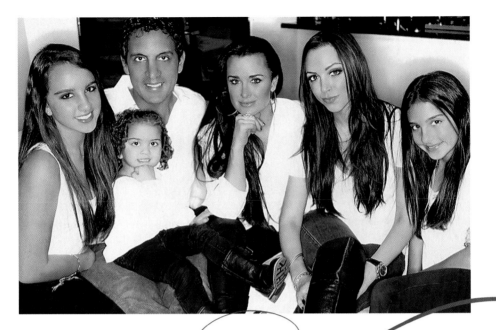

Above: At home with family.

Below: My beautiful children, my beautiful life.

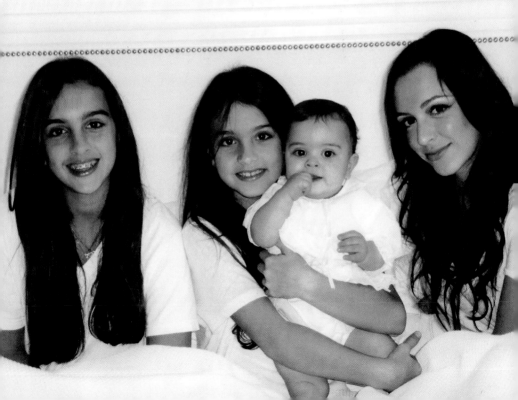

sunflower seeds, though. We ate them all the time when we were little, especially when we were on set filming together. To this day when we're driving out to Palm Desert we'll get a huge bag and eat to the point that our lips are falling off from the salt!

Kim always wanted me around, and when I was about five, she did a movie called *Escape to Witch Mountain*. (I had a tiny part in it too, playing my sister as a younger girl.) Kim's character in the movie had special powers, and I thought they were real! Whenever my mom said no to something I wanted, whether it was a bicycle or a stuffed bear—I always wanted a koala bear when I was little—I'd say, "Well, Kimmy's gonna get it for me!" Ha! The funny thing is that as Kim got older, she did buy stuff for me.

Because she spent so much time acting, Kim didn't go to other people's houses a lot. If she was invited to sleepovers, she'd be nervous and want to bring me along. Her friends got so tired of it. "Ugh! Here she comes dragging her little sister again!" Ha-ha. But I cried every time Kim left anyway, so we were a matched pair. *So* close.

Of course we fought at times too and sometimes it even got physical, which I now find kind of unbelievable. What were we thinking? We literally ripped each other's hair out. She would dig her nails into my arm, so then I would bite and leave teeth marks on *her* arm.

One Big Happy Family

I used to have a lot of family barbecues at my old house, and everyone would come over—my sisters and their husbands and kids and their boyfriends and girlfriends. Then after my sister Kathy finished renovating her house (after three years!) she started hosting the family get-togethers.

It's so fun, a house full of people—and animals. My brother-in-law Rick has dogs and cats and birds. He even has a special kind of cat, much larger than a regular domestic cat, that looks like a tiger and walks around on a leash. It's scary-looking to me, frankly! But that's where my niece Paris got her love of unusual animals, from her father.

I love it when we all get to-gether, which is pretty much all the time. There are always kids running around and screaming. That's the way Kim and Kathy and I like it, because we grew up in a house full of people.

My sisters and I are still very close, and I'm close to all of my sisters' kids too. In fact, Kathy's girls, Paris and Nicky, and Kim's oldest daughter, Brooke, are more like little sisters to me than nieces. I was about twelve when Paris was born, so I'm just about in the middle of her and Kathy in terms of age.

It was so exciting when she was born! That's when I think I truly realized I wanted be a mom.

Kathy and Rick lived in New York in a little apartment, and they had a twin bed in Paris's room. Mom was there teaching Kathy everything about being a new mother, because Paris was Kathy's firstborn. Kim and I came along with her, but my mom and Kim stayed at the Waldorf Astoria, so I got to sleep in that twin bed in Paris's room!

I would lift her up out of her crib (even when I wasn't sup-posed to!) and lay her on my chest. I felt such an overwhelm-ing love for that baby that tears would roll down my cheeks. I would think, *Why am I crying? This is so strange.* But I just loved

her so much. She was the most beautiful baby, with blond hair and huge lips. I have never seen such full lips on a baby in my life! She was the first baby I was allowed to feed and hold and change her diapers. Like a real-life doll!

I couldn't stand it when Kim would come around and try to steal Paris from me. We ended up getting in huge fights. She was seventeen, and she would try to act like she was the older, wiser one, like the mom, and I would get so mad! Kathy always said, "Girls, take your turns!"

It's so funny. There I was changing Paris's diapers and taking care of her. And then later, much later, after I started doing *Real Housewives,* I started going to Paris regularly for advice.

Just goes to show you we can all learn from each other, no matter what our ages or relationships.

Oh, speaking of ages—I remember after Paris was born my mother went around saying, "Do you realize what a young grandmother I am?" And I thought, *Really? You don't seem that young to me!* But looking back, it's true—she was forty-one, almost forty-two. My God,

I'm forty-two right now! Mom wasn't one of those grandmas who didn't want anyone to know she was a grandma. She was so proud and loved every minute of it. She became just as obsessed with her grandkids as she'd been with us. Her friends probably wanted to kill her!

Then when Nicky came two and a half years later, I was actually there at the hospital for the birth. After that Kim had Brooke. Then I had Farrah. Obviously I was in a rush after falling so in love with my sisters' kids. After that, Kathy had Barron, and on and on.

I tell you, someone was always having a baby in our family! When Portia came along it had been a while since anyone had had a baby! So you can imagine how much love my little love bug gets from not just me and Mauricio but her sisters and my sisters and their kids.

I love my nieces and nephews very much. Brooke and Whitney, Kim's second daughter, go with me to Mommy and Me classes, pick Portia up at school, and sit with us at the house. I have a more maternal relationship with Whitney and Kim's younger kids,

but Brooke, Paris, and Nicky are like the little sisters I never had. I have great relationships with them. We laugh like sisters, we go to dinner, we go dancing. And Kathy and Kim will be happy I'm there, keeping an eye on them. Ha-ha!

The cousins are all very close, too, like siblings. They spend a huge amount of time together. Farrah and Brooke are dating identical twins—the sons of our very close friends. I was at the hospital when those twins were born! It's a small world around here.

My sisters and I each have four kids, so there are already twelve children, and now with their boyfriends and girlfriends it's a huge crowd at barbecues and Sunday dinners and holidays. It's so fun to have a big family.

No matter how many people you have in your family, I hope you embrace them and enjoy them and rejoice in them. They are truly a blessing.

My mom or dad would scream, "You girls are gonna give me a heart attack!" Back then we thought it was normal to fight with each other, but not now. My girls never lay a hand on each other!

I suppose this is a good time to talk about the fight I had with my sister in season 1 that caused such a ruckus.

As upsetting as the incident was to a lot of people—some felt that I attacked her unfairly—it was far more painful to Kim and me. I really want to explain the context of that incident, because the cameras didn't capture everything that led up to it. How could they? Kim and I have been sisters for forty-two years. That's a lot of context! If you didn't see the episode, this is what happened. All the housewives had been at a party and Kim and I had been arguing. Really we'd been at odds during the whole season. So at the end of the night we got into the limo with the other housewives, and she accused me of "stealing" her house, which I'll explain below. However, there were a lot of things off-camera that viewers didn't see that just sent me over the edge. I got so mad that I kind of lost it—I got in her face and yelled at her and accused her of being an alcoholic. It's true that I came off looking like a steamroller, and Kim seemed scared and vulnerable. After that, people called me a bully, which just killed me, because I've never been a bully in my life.

Oh my God. I cannot tell you how horrible that was for both of us. It affected our relationship for a long time. Terrible, terrible, terrible. We didn't talk for months.

We didn't want Bravo to air the footage at all, and we fought very hard—*very* hard—against it. But we're not producers of the show and we don't have editing

May I Give You Some Sisterly Advice?

Just a few pointers about dealing with the sisters in your life!

» If you want to borrow a sister's clothes, ask first—unless you think she'd refuse, in which case take the clothes and tell her later! Ha!

» If you're going to get into a knock-down, drag-out argument with your sister, please try to keep the claws retracted. I can still feel Kim's nails tearing into my skin!

» I suppose I should also say that, in a fight with your sister, you should refrain from biting. Even if she started it!

» This too: if you're going to fight with your sister, please try to do it in private. Doing it around other people (like a few million) only makes the conflict

rights. They were determined to air it, because it is "our reality," and it was an extremely difficult challenge for us, to say the least. Knowing that the episode was going to be aired was torture, and the producers did feel bad for us, so they brought the episode to my house to let me watch it before it aired. We all shed tears that day. No way could I watch it when it aired.

more hurtful to everyone, and no one wants to be involved in your family disputes.

» Always try to keep the lines of communication open with your sisters, even when you're having major discord. When you're so mad that you stop speaking to a sister, every day that goes by is a real loss for the both of you. When you keep talking through the disagreement, or just in spite of it, you'll have a much better chance of resolving things and minimizing the pain in the process.

» Always make a point to reminisce with your sister and laugh as much as you can. In our family, making people laugh has served us well through the years!

» Keep some things just between, or among, you and your sisters. It's fun to have sister secrets and your own private language! And it reminds you of the unique bond that you share. There is simply no one like a sister!

After the show aired, people said mean things to me on Twitter and Facebook and various websites. It was so hurtful to have people judging me without knowing anything about my life. I thought, *Those people didn't know us! They think they do because we're on a show portraying ourselves, but that doesn't mean they know who we are deep down.*

You can't properly defend yourself in that situation. It was so difficult. Anybody who knows me knows there's nothing more important to me than my family.

I take full responsibility for what comes out of my mouth on *Real Housewives.* But when I say things, people who watch the show might not ever see what led up to it. And like I said, in this case, the backstory of that fight between me and my sister took place over many years.

I did have a lot of anger toward Kim. And it turned out that she was harboring huge resentments toward me that I didn't even know she had. When she said, "You stole my house," she was referring to properties that our mom had left to us when she passed away. To each sister individually she left one small property, and then she bequeathed one larger home to the three of us all together.

Because Kathy and Kim already owned homes in the desert, they decided to let me buy them out on the house that had been left to all of us. They didn't need it,

and it worked out perfectly for me. So we each ended up with our own home there, and we each owned a smaller property too.

Later on, Kim decided she wanted to buy back in to the home I now owned. And I said no. I didn't want to mix business with family. I planned to renovate the house, and I didn't want to have to go to her about every little detail of the process. And she already owned a large home there. People asked me, "What does she mean you stole her house?" I mean, you can't actually pick up a house and carry it across the street and no one will notice! But try explaining the actual story on Twitter.

"Thank you for my sisters, a gift from you to me. For when I look into their eyes, it's you that I will see."

—from a poem I wrote for my mother's funeral

I just didn't realize how bitter Kim felt toward me for that, for not allowing her to buy back in. I can see now that she must have been holding on to a great deal of deep-rooted anger, and it just all came to a head that night.

I have an intense relationship with my sister, but I love her very much. And while people who watched season 1 may think I'm the strong personality of the two, the fact is Kim's a very strong personality too. She has every bit as much fire in her as I do. It didn't come

When Tragedy Strikes

My sisters and I have suffered through the loss of our parents—a painful experience, as anyone who's lost a parent knows. Every family endures tragedy of one sort or another. If it's played out in public it can be particularly difficult, and sometimes the circumstances surrounding a loss make it all the more wrenching.

Whatever the source of loss or tragedy or crisis, one thing remains true: that's when family has to pull together. That's when you have to rely on your sisters or brothers or aunts or cousins, even on the friends who are family to you. That's when you as family have to form a tight circle of love and support to get you through the painful ordeal.

Sometimes a loss is compounded by conflict among the people left behind. But that is precisely the time when you should try your hardest to set personal disagreements aside to come together.

I could never have gotten through the death of my mother or even Farrah going to college without my sisters' help. And I believe that my own daughters have already begun building the same kind of bond that will see them through personal tragedies and crises in their lives.

Some of my friends feel almost like sisters to me, including the women I've become close to from *Real Housewives*. When one of them is hurting, I do too. When you truly love and care for someone, you suffer along with them. At those times I try my best to step in like a sister to lend a hand or a shoulder, and to give my time and effort to help them. I envelop them with love.

Tragedy sometimes makes us feel that we can't survive the pain, can't make it through. But with sisters and family and friends, we can. What a blessing they are.

off on the show that way because I had pulled her in with girls that she didn't know, and they really weren't her cup of tea at the time. (Yes, I'm the one who asked Kim to be on the show in the first place, and I'm sure she has wanted to kill me because of it on more than one occasion. Ha!) Kim may have seemed shy and uncomfortable, but I promise you she is an extrovert who is usually never shy or reserved!

No matter what, though, having that fight play out on camera for millions of people to see was just absolutely horrible for both of us, as was the aftermath. Kim was of course very hurt. And I began having anxiety attacks from the stress.

This is where the hummingbirds come in. I told you about the psychic who told us our mother would come to us as hummingbirds. When she said that, I was astonished because I've had many strange things happen with hummingbirds. They often flit around me and won't leave my side, to the point that I've been able to take close-up pictures of them right next to me. And I had an experience with a hummingbird after the big fight with my sister.

I was immediately devastated by the fight. Afterward I lay in bed sobbing and talking to my mom. "What do I do, Mom? What should I do? Talk to me." I just cried and cried and hoped for an answer.

Finally I got up and went downstairs, and I saw a hummingbird outside the window of my kitchen door,

just lying on the ground. I was shocked; I'd never seen a hummingbird still like that. Even if they linger close to me, they always seem to be flitting about. So I opened the door and picked it up and held it in my hand, sobbing.

The In-Laws

I'd like to clear up a common misconception once and for all.

Mauricio is Mexican. I think most people know that, though a few people think he's Italian. No, he was born in Mexico, lived there until he was six, moved to the U.S. for a while, and then went back to go to high school, and finally moved here when he was about twenty.

But Mauricio does not have any Mexican blood, which confuses and even upsets some people. When I say he has no Mexican blood some people think I'm insulting the Mexican people, which is ridiculous. *I don't care where Mauricio's blood comes from!* I'm just trying to explain his background.

Mauricio's father Eduardo is Russian, which explains my husband's last name, Umansky, the name I use in my personal life. Mauricio's grandfather had taken the family out of the country to escape the genocide during World War II and ended up in Mexico. Mauricio's mother, Estella, is of Lithuanian, Greek, and Turkish descent. (Makes sense—Mauricio looks like a Greek statue to me! Ha-ha!)

But just like I would say I'm American because I was born and raised here, the Umanskys say they're Mexican. Because they are! They loved their life in Mexico. So no one is disavowing their heritage here!

Then I looked at the bird and thought, *This is my mom!* I said, "Mom, what do you want me to do? What are you trying to tell me?" I glanced up through the window and saw my housekeeper looking at me like, oh my God—she's lost her mind! Ha-ha!

In any case, it doesn't matter where they came from because they're wonderful, lovely people, and I feel so fortunate that we're all family. Sometimes my mother-in-law comes to the house to babysit if Mauricio and I have to go away, and the kids visit her here in town too.

Mauricio's grandmother and his cousins and uncles still live in Mexico City and we visit there sometimes. His grandmother Olga—or Tita to the kids—is amazing. Even in her eighties, she's always so put-together and energetic. I want to be like her! She walks a couple of miles every day and she's always dressed to the nines, with her big sunglasses, jewelry, and manicured nails. I love her for that. After that rough patch at the beginning that prompted me to write her a letter, we developed a very nice relationship.

I had one real advantage with my in-laws when I started dating Mauricio. You know how some mothers can be very critical of the woman their son is dating, especially of their cooking? Well, I had it made with Mauricio's mother, because she didn't know how to boil water or make toast! Everything I made—and I didn't have much of a repertoire then—she thought was amazing. She always wanted the recipe! I could have made soup from a can and she would have said to Mauricio, "Darling, this girl can really cook!" Ha-ha!

The bird was totally limp and his eyes were shut, and I was pretty sure he was dying. Then all of a sudden his eyes popped open. It was the most unbelievable moment. And then he flew away.

I went inside and told my husband the story and even he got tears in his eyes—which is something, because, you know, men are not ones to be thinking, *Ooh, that's a sign!* But I believe it was a sign from my mom, letting me know she was there and I know she was sad about what happened.

I admit it: the fight was something that (a) should have never happened and (b), if it did happen, it should have been a private family moment. But when cameras are filming you living your life, it's easy to forget they're around. Kim and I have been on camera since we were little girls, and the *Real Housewives* crew is with you so much that they become very familiar. They're not strangers! I mean, my kids get excited and jump up to greet them when they arrive at my house. When your emotions run away with you, you can totally forget you're being filmed. That's actually the whole point of the show!

I never thought of myself as a naive person before, but I realize I was very naive in thinking that filming a reality show would be easy. No big deal, you're just being yourself and there's a camera there catching it, right? I'm a very open and honest person, so no problem. Right?

I had no clue how anxiety-provoking it could be. My niece Paris seemed like she had fun with her reality show. I think some of it was actually difficult for her and hurt more than she let on, but I figured if she could handle it, so could I. I mean, I am older, but I guess she's stronger! Dealing with the public's misperceptions of me, especially with regard to my sister, was just really rough.

Strangely enough, I think something good came out of the blowup between Kim and me. Since that fight, I feel like our relationship is so much better. For me, it's been an opportunity to go back to where we were not just before the fight but to where we were years ago. She got things out, I got things out, and it was therapeutic in an odd way. I can't speak for Kim, but I think it was a blessing.

The whole experience also taught me some lessons. In fact, the very source of much of my distress—people who didn't know me criticizing and judging me—was actually instrumental in helping me learn those lessons.

People on Twitter and everywhere else said negative things about me, not just that I was terrible for attacking Kim that one time but that I was rude to her all season, and how dare I not stick by my sister? Finally I sat back and thought, *Okay, even though those people don't know the background of WHY I felt or acted the way I did, I can learn from them nevertheless.* Even though I had my reasons for reaching my boiling point,

there's a better way to handle things. I don't need to get so frustrated or angry.

Obviously my approach to Kim wasn't working anyway, so clearly there needed to be a change if I wanted our relationship to improve. Maybe I needed to be gentler. Maybe I didn't always have to try to be the mom in my relationship with my sister.

It took an outsider's point of view to teach me those things, but finally Kim and I were able to talk things through.

So here's my advice. Issues between people can and should be dealt with in a civilized way. It's much better for everyone involved if you can keep your cool. Because that old expression—sticks and stones may break my bones but words will never hurt me—just isn't true.

Also, there's something to be said for communicating with the target of your anger. You know, face it and deal with it—sooner rather than later. Don't wait until the resentments, yours or hers, build up to the point of explosion.

Thank God Kim and I are okay now. That doesn't necessarily mean we won't ever fight again, but she means the world to me. And Kathy, too. We are family!

My Mane Philosophy

My hair . . . well, I am totally neurotic about taking care of it. Some people are consumed by dieting; some are fanatic about their skin. I'm fanatic about taking care of my hair.

And I thought you might like to benefit from my neurotic obsession. Ha-ha!

People used to ask me all about my extensions, but, um, I don't have extensions. Never did. I think they're terrible for your hair. I especially hate to see so many young celebrities getting them, because they're just destroying their hair and really won't be

able to get it back. I realize that some people feel extensions are the only way to get the thickness they want.

My niece Paris has her own line of hair extensions and really likes the look they give her.

Gentlemen Prefer Blondes

I have to tell you, I know from experience that the old saying is true: gentlemen really do prefer blondes! On my worst day as a blonde, my very ugliest day, more men would look at me than they would on my absolute best day as a brunette. Honestly, I'd still rather be a brunette, because a blonde is just not who I am.

Okay, now that we've got that settled, let's move on to the hair on my head. Ha! I get a lot of questions about my hair, mostly about what I use on it. People assume because of where I live and what I do that I must spend a ton of money on products—but I don't! My shampoo comes from a drugstore!

When people ask me what I *do* to my hair, the answer is simple: as little as possible! I really believe less is more with hair.

The best way to have beautiful hair is to accept the hair God gave you, love it, and work with it. Don't try to turn it into something it's not.

And above all, treat it right! *That* I can help you with.

I was the only brunette among my three sisters. I had dirty blond hair when I was very little but it got darker as I got older. And I had long hair too—always long, dark hair. Well, *almost* always.

My mother drilled it into me to take good care of my hair. We kept it long, though she took me every six weeks to have a trim. But one time we were in a mall and she was suddenly seized with the notion that she'd have my hair cut. She was thinking I could get a Dorothy Hamill cut, you know, the wedge worn by the Olympic figure skater back in the '70s? My hair was all the way down my back then, so it would have to be totally chopped.

But before she got me situated in the salon, Mom called my agent and told her she was going to cut my hair. My agent said, "Don't you dare! Don't you know that's her look? She has to stick with it!" I didn't quite get what she meant at the time.

That was my mom's one impulse regarding my hair, but after that she was constantly telling me that I could never cut it. "Never, never. It's your signature!" She got a little carried away with it at one point because it had grown past my butt. I said, "Mom, my hair is half my body! It's making me look like I'm three feet tall!" Ha-ha! So after that I kept it just to my waist.

My mother never would have allowed me to dye it either. Now, I had gone through phases when I used purple and burgundy mousse in my hair. That was back when we were all trying to look like Madonna. It was just mousse, not dye, and that was okay because I was young. Although, looking back, that was *not* a good look. If I had actually colored my hair or, God forbid,

come home with a tattoo or piercing, my mother would have thought I was all of a sudden a gang member! She was very uptight about these things.

Eventually, of course, I just had to experiment, so when I was sixteen I got a layered look. That also was not a good look. I grew it out again and then when I was twenty-one, I went an almost platinum blond for a little while, then stopped that and let my hair recover.

It was about another ten years before I did anything else drastic to my hair. I got tired of my mother always badgering me about not cutting it. I went to the hip hairstylist of the moment in Beverly Hills, you know, "You gotta go to him, he's so cool, he cuts all the celebrities' hair!" So he cut all my hair off into a Meg Ryan kind of short look, really choppy with the ends sticking out. I looked like an artichoke. And then I would take the ends and put stuff in them to make them stick out even more.

I felt like I was rebelling. My mom was sick by that time, so maybe I was rebelling against what was happening to her.

She was so disappointed. She made me feel like it was the end of the world. I said, "Well, I like it! Everybody else likes it!" But then later after I let it grow out everyone said, "Oh my God, that was the ugliest haircut I've ever seen! I can't believe you did that to your hair!" They were right.

Not long after that, when my mother started losing her hair because of the chemo, she decided to shave it all off. So I wanted to shave mine too. She wouldn't have it. "That will end up killing me before the cancer gets me!" she said. So I passed on that.

And I've been a brunette with long hair ever since.

I learned a lot from my hair missteps. It's what your mother always tells you: just because everyone else is doing it doesn't mean you should. I used to think this applied to things like drinking and sex but I learned it's equally appropriate for hairstyles! I am a brunette. I just don't look good as a blonde. And just because I wanted to look hip and cool with the do of the moment doesn't mean it was going to look good on me.

Sometimes you can get swept away by a persuasive hairdresser who convinces you a whole new look will be fabulous. Don't let that happen. My advice is to always mull over a radical change of hairstyle very carefully and thoroughly before you go under the scissors. Ask your friends and family what they think. Go to more than one hairdresser to get their opinions. Go to a wig store and try on the cuts and colors you're *dying* to get, so to speak—that's a great way to get a sense of how your dream do will look on you. And if you do have a signature look, one that you're known for and everyone loves, be extra careful. There's nothing wrong with wanting to change things up, but think it through beforehand.

Something else I learned is that coloring your hair just is not good for it. And the more extreme the color change, the more damaging it is. I'm talking damage that doesn't repair itself in a few weeks or even months. Being blond dried out my hair tremendously, and it took a very long time to get it healthy again. So don't just think, "Oh, I can always dye it back!"

If you really must color your hair, there are healthier ways to do it than using dyes and peroxide and bleach. Look for formulas—or salons that use formulas—that

My Obsessive, Neurotic Dos and Don'ts

» Don't torture your hair! Minimize the heat and the styling products you use on it.

» Do find the color and style that work for *you*. Just because something looks great on your friend doesn't mean it's right for you.

» Don't change your hair length or color drastically without considering it carefully first.

» Do use gentler, more natural tints and dyes if you are determined to color your hair.

» Don't spend a lot of money on shampoos and conditioners and brushes and such. Go to the drugstore, try some out, and determine which products and tools are most effective for your hair.

are gentler, like vegetable dyes. More companies are coming out with colors now that are free of chemicals so they're easier on your hair—and better for your body.

Now, having said all that, I do want to be clear that I have nothing against covering your gray. Of course not! I have to cover my gray. I just touch up the roots myself. I use Nice 'n Easy Root Touch-up by Clairol. I also have someone do it for me, but it's very easy to do it myself, not to mention inexpensive.

» Do look for the gentlest products and tools you can find. Never use a brush that tears at your hair, and make sure your hair dryer has a cooler setting so you don't have to blast your hair with heat.

» Do brush your hair starting from the bottom, brushing the very ends of your hair, going up a bit and brushing down again, and so on. And go slowly!

» Don't wash your hair every day, if possible.

» Do try putting the shampoo only on your scalp, letting the suds run down to clean the rest of your hair.

» Do wear your hair the way you like it, and forget about the number on your driver's license!

» Don't *rip* your hair when brushing. Every time you hear that "snap," you've made a split end.

» Sleep with a hair mask on at night or a heavy leave-in conditioner. Put a towel on your pillow.

Look, I know that for some women going to the salon is an escape, an indulgence. But it takes so long! And it costs so much! If I want to escape I'd rather do something other than sit there for four hours in a chair getting nothing done.

When I need a cut, which is every six to eight weeks because my hair grows fast, a stylist comes to the house. After I had Portia, I was nursing and didn't want to leave the baby. So I had the stylist—her name is Pamela and she's fantastic—come here to give me a trim. It's not only a time-saver; it's also actually cheaper because I'm not having to pay her through the salon. If she colors my roots I often do a touchup at the three- or four-week mark between visits, because that gray starts creeping up on me! If your hairstylist isn't cool with you doing your own touchups, then I think you need a new hairstylist!

I really don't believe in spending a lot of money on my hair. For example, the shampoos and conditioners I absolutely swear by are made

And You Pay How Much for That?

Like I said, some women I know never do their own hair, hand to God. One woman with whom I am acquainted—she shall remain nameless—goes to the salon literally every day. Like some people go to the gym—every day! And I just think, *What a waste of time and money!*

by Pantene. I've been using it forever, at least since I was a teenager. I saw a commercial for it and tried it and I thought, it really is like the commercial—my hair looks good! Now some of my friends buy it too because I've recommended it to them. And no, I am not a paid spokesperson for Pantene! Though I should be. Ha-ha!

I just could never go for those super-expensive shampoos, are you kidding, with all my hair and all the kids' hair? I'd have to sell my house—which isn't an option! Pantene works for me, and it doesn't cost a fortune. I buy several bottles at a time because between me and my family, we go through a lot of it. There's really no need to go for the fancy stuff at the salon; just experiment with different brands from the drugstore. Find one that you really like and stick with it. (Some people believe it's best to switch off between different shampoos now and then, because your hair and scalp acclimate to the product.)

Beware, though: sometimes you'll settle on just what you want then find they'll change the formula on you. That happened to me with Pantene's conditioner and it just tortured me. I used the same thing for years and years and now I have to choose from so many different versions of conditioner they've come out with. It's overwhelming when you walk into the store. My God, do they have to have fifty different types of conditioner

to confuse us and drive us insane? Ha-ha! I try to pick the types that suit the look I'm going for—heavier conditioner for a straighter look, for example. Or a clarifying shampoo that's good for removing buildup caused by product. Too much product leaves your hair dull. That's why I'm not a fan of too much product. You have to be the judge. It may take some trial and error.

I try not to wash my hair too much since doing so dries it out. Go as long as you can between washes. I try to make it every other day and push it another day when I can. I can get away with that because my hair is dry; if yours is oily, you may have to do it more often.

If I work out, of course, I have to wash my hair no matter how long it's been since the last time I did, which is one of the reasons I don't work out. Ha! No, I'm kidding. I do, but sometimes I do skip a workout because I just washed my hair yesterday and don't want to wash it again. Hey—why not? You can go to the gym tomorrow! (When I exercise, by the way, I use Goody coated rubber bands to tie my hair into a knot or a bun, because they don't break my hair.)

I have all these neurotic little tricks. When I wash my hair, I don't put the shampoo on the ends. I just put it on my scalp and let it run through to the ends. And I always make sure to brush my hair slowly, starting by brushing the bottom of the strands and then going a little higher and brushing from there, until you reach

the top of your hair. Otherwise, you'll rip your hair up and create split ends. I use a regular, inexpensive paddle brush. I know some people use expensive natural boar bristle brushes, but they're not great for my kind of hair. They just give it static. Same thing with the brushes as the shampoos: you have to find the type that works best for your hair. For example, if you're going for volume, a round brush might be your best bet. But ask your stylist, someone you trust who knows what your hair is like and the styles you want. Just don't think you have to spend a fortune on your brush.

To give my hair extra conditioning, sometimes if I'm not going anywhere I'll stick it in my hair and just leave it all day. I also put a mask on my hair that I have concocted. And I'm big on using oils in my hair, mostly Moroccan oils that I put in after almost every blow-dry, when my hair is dry. You can find different brands at beauty supply stores and online. One I like has the consistency of K-Y Jelly. Hmm, yes, I think this Moroccan oil might have multiple uses! Ha-ha! (Just kidding!) So you just put a dot of it in your palm and rub it in your hands. Then what I do is tilt my head to the side a bit and kind of slap my hair lightly with it all over. Not so much on the top because it will make my hair look dirty. If you use just a tiny amount, it will make your hair smoother and shinier.

Now we come to a very important stage of the hair

care process: the styling. This is a make-or-break stage, and I mean the "break" part literally.

I really try to avoid heat, because heat doesn't do one good thing for the condition of your hair. All the flat-irons girls are using now are so hard on hair! Instead of having to have straight hair every day, why not embrace the hair you have and find a way to work with it? It will be beautiful! I tell my girls to just leave their hair alone, quit touching it! But they insist on flat-ironing it. "Mom, we're never gonna be okay walking around with our hair curly like you want us to!" Okay, then, walk around with it damaged! One day they'll be sorry, because undoing the damage can take years.

I did let my girls get Brazilian Blowouts, thinking it would limit the daily damage of the flat iron, but then I found out that they weren't healthy—they contain a lot of formaldehydes. So now they get botanically-based straightening treatments.

Sometimes, of course, I do use hair dryers and other kinds of heat on my hair, but only when I have to. And instead of using a curling iron with metal that clamps down on your hair, I use a curling wand and wrap my hair around the barrel, and it gives me a nice loose wave. I will occasionally use Velcro rollers on my hair but I don't usually need to. In fact, that can sometimes make me look like I have *too* much hair. I really have a lot of hair on my head, believe me!

Time-Crunched Hair

Lately I've been very short on time. When I'm doing the show, I have a million things to do and I think, *God, how am I supposed to get my hair washed, blow-dried,* you know, all of that? I bet you feel the same way sometimes!

I had a bunch of meetings yesterday. I knew if I washed it and did nothing, it would take all day long. Seriously, that's one reason why I don't like to wash it every day, because I don't want to have to dry it every day. The days I work I have to blow-dry it, but the days I don't I let it go wet.

So yesterday after washing my hair, first I left a little bit of conditioner in my wet hair. Then I twisted my hair into a knot, put a coated rubber band around it, and walked around awhile like that. Later when I undid it I had a bit of a wave. I threw on a sunhat and a little dress and I was good to go. If I had on jeans and a top, I'd wear a cute fedora. I'm a big believer in hats! They can actually add some style to your outfit, and allow you to avoid having to style your hair.

Products can also damage your hair. The mousse and the hair spray and the gel and all that stuff makes your hair lose its shine and dries it out. I use the gentlest hair spray I can find, Shaper by Paul Mitchell. It's not sticky and drying, and it doesn't weigh my hair down.

You have to realize: your hair can really age you. If you look at a teenager, she'll have thick, glossy hair. But after years and years of abusing it, not only the hair but the girl herself will start to lose that youthful

look. (Mark my words, Farrah, Alexia, and Sophia!) Torturing your hair will make you look older; taking care of it will make you look younger. Simple as that.

Which brings up the question of age and hair. Some people think, *Oh, you can't have long hair when you're past forty.* Or thirty-five. Or whatever. Well, if that's true then I'm past the point of having age-appropriate hair! Ha-ha! I think the rules have changed. Just like being a blonde is not me, having some kind of bob or other cut that's supposed to be "appropriate" for a woman my age is not me either. Just because you're a soccer mom—which I am!—doesn't mean you have to look like what you *think* a soccer mom should look like.

It's much the same thing when a woman has a baby and thinks she has to cut off her hair so it will be easy to take care of. "I don't have time for this; I have a baby to look after." But you know what? My hair is actually very easy. I can throw it in a ponytail, which as

My Must-Have Hair Products

» Nice 'n Easy Root Touch-up by Clairol

» Pantene shampoos and conditioners

» Goody Ouchless hair elastics

» Moroccan oil

» Shaper hair spray by Paul Mitchell

» Paddle brush

» Roll brush

» Curling wand

you know I do all the time. My long hair takes a long time to dry, but I don't have layers or the kind of cuts that require a lot of styling and take forever.

I'm not great at styling my hair anyway. I don't have a lot of styles. I put a hot roller on top sometimes to give it some height. I can go extra straight by drawing it super-straight with a paddle brush. I can do the hot wand. That's about it. When I do a braid, though, that *might* be bordering on inappropriate for my age. The other day I thought, *Maybe this braid to the side will look cute!* Sophia said to me, "Is *that* how you're wearing your hair?" Ha-ha! I always know when it's time to take it out.

Personally, I plan on keeping my hair long for as long as I can get away with it—meaning that if I decide at some point it doesn't look right, I'll cut it. But only then. My mom would be so pleased to know I've stayed true to my signature look and kept my hair long. Maybe I'll have it long right up until the day I die. Then my mom can see it for herself. Ha!

I Enjoy Being a Girl

I remember this earthquake that happened when I was little, and while everyone was running out of the house, my mother was screaming, "My eyebrows! My eyebrows!" because they weren't drawn on. Back when drawn-on eyebrows were the style, she had plucked hers to death, and for the rest of her life, she always had to draw them on. (Of course, if you've ever seen my eyebrows, you know I would never have to worry about that!)

So we're all outside, and we looked at my mother. She had literally grabbed her eyebrow pencil and she

was scribbling brows on her face. She ended up with two question marks on her forehead, and we couldn't stop laughing.

My mother used the scare tactics on me like I do on my kids, and she always warned me not to pluck my eyebrows. She'd say, "Do you want to have this happen to you?" So that's why I walked around with two caterpillars over my eyes until I was twenty-five years old! Ha-ha!

I'm going to use the same scare tactics on you now. Do not overpluck your eyebrows—because they may never grow back! And you'll end up with two question marks over your eyes!

With beauty, it's like anything else: trends come and go, but if you're not careful, you may be stuck with them forever. I'm not suggesting everyone keep caterpillars over their eyes, but if you've got bushy brows and pluck them to thin lines, that style will go out and you'll wish you had your normal thicker brows, which will always make you look younger and frame your face better.

Do you detect a theme here? Yes, my viewpoint on faces is similar to my viewpoint on hair. I think true beauty is about your own individuality, not about what everyone else wants to look like or thinks you should.

And perhaps even more than with hair, you should *definitely* not do too much to your face! Come and

My Absolute Essentials for When I'm ...

. . . out for a night on the town: For sure I have to have on my armor—my spray tan—and I gotta have the false eye lashes. The lashes just take it to a whole new level. I say to my friends, "Well how dressy are you getting tonight?" And they say, "It's a lash night!" Oh, and Altoids—I can't forget them. I like them in cinnamon, even though they make me sneeze!

. . . stranded on a deserted island: Lip gloss! I should say sunblock, but if I'm gonna be on that island forever . . . I can't live without lip gloss! It looks sexy, it makes your lips seem fuller, and I even like the way it feels. I could just not be without it. (Of course, we're talking beauty items here. Otherwise I'd have to have something more practical, like water. Ha!)

. . . suffering through a morning after: Well, for this I really am going to say water. Try to get as much sleep as possible and drink a ton of water! My eyes don't get red normally but on those rough mornings I might brighten them up a little with Visine, which I also use when I'm doing photo shoots. And I use copious amounts of eye cream. I hate those kind of nights—I feel like they age me ten years in just a few hours. It's amazing what you can do when you're young, because as you get older, the day afters get *so* much worse. And at this point, do I really want to waste that many calories on liquid?

Finding a Makeup Artist

In Beverly Hills, makeup artists are a dime a dozen. But in other towns it might not be quite as easy to find one. If that's the case where you live, don't despair.

First, try to begin your search as early as possible. The smaller your community, the fewer makeup artists there are likely to be and the greater the risk they'll be booked way in advance. Start by looking in the yellow pages under *beauty* and *makeup,* or do a search online. I know some websites keep lists of people who work in local areas. If that doesn't turn up someone, try contacting photography studios and wedding planners. Do you know anyone who's had a wedding or other big event recently? They might be able to give you a reference. Personal references are the best way to find someone who won't make you look like the clown that was hired for the party down the street.

Once you've located some candidates, ask for references and pictures. See if the artist will provide a tryout for you at a reduced rate so you can see if you like his or her work and what changes you might want.

Don't be afraid to speak up, no matter what. It's you who's going to be wearing your face, so you want to feel like yourself before you head out the door! If you don't like something the artist has done to you, raise the issue before you leave so they'll have a chance to fix it. You can always wipe the whole thing off and start over when you get home! Unless you're due to walk down the aisle in about twenty minutes. Ha-ha! Personally, I think the best idea is to learn how to do your makeup *yourself.* Nobody knows your face like you.

walk around the streets of Beverly Hills and you'll see what I mean.

My mom was very much into looks. She thought you should always look your best—even in the middle of an earthquake. She was a clean freak, and she taught us to be very meticulous about making sure we were always showered and fresh and smelling beautiful.

I'm all with her on the clean and fresh, but I try not to emphasize the looks aspect of it so much with my kids. I just try to let them be kids, because I worry about them falling into the trap of obsessing over their looks—especially living where we live. Society is too wrapped up in appearances, and I want my kids to understand that it's so much more important to be a good person, and intelligent, than it is to be beautiful. Beauty will fade one day anyway.

And that's what I'm telling you too.

But I do have to say, I love the whole process of beautification! I love makeup and talking about makeup! All the girly routines of skin care and "putting on your face" and all that are really fun. And I'm pretty good at them, too, if I do say so myself.

I mean, of course, I have some expertise in these matters, having grown up with a houseful of preening, primping women who all hogged the bathrooms. Since there were no men in my home I wasn't exposed to

sports or anything like that. Makeup and beauty tricks were our sports!

I'm actually a frustrated makeup artist. I usually prefer to do my makeup myself when I'm filming. And if I let someone else do it, half the time I go to the bathroom and spend thirty minutes redoing everything. They always want to powder me and I think powder makes me look older, and I'm neurotic about which mascara to use. I'm not a good client for a makeup artist! The only makeup artist I trust is Thierry Pourtoy, who's been doing my sisters' makeup and my niece's makeup for many, many years. But even with Thierry, I say, "These are the colors I want, and this is how I want it . . ."

I don't like sitting around for two hours while somebody is doing my hair and makeup. It drives me insane! I go to shoots with other TV people and they'll have all these people fawning over them and I think, *Did I make a mistake? Should I have used somebody?* In Beverly Hills, everyone does, even if they're not on TV, even for just going to parties or events. But when I do, I usually regret it, so I've learned.

My friends used to have me do their makeup when I was a kid, and even now I get requests. My friend wanted me to do it for her wedding but that was too much pressure. I did do my daughter's friend for her bat mitzvah. I was honored because they had hired many professional people for the event.

I think Portia may be taking after me as a budding makeup artist—the other night she did my makeup and then Alexia's! Okay, it wasn't perfect, but not bad for a three-year-old!

Just like with hair, you don't have to spend a lot on makeup. I'm constantly getting new shades and types and formulations of this and that, so I would go broke if I bought expensive stuff. I have a mix of products, some high, some low, and many in-between. I'd say my cheapest stuff costs a few dollars and I think my most expensive item is my Make Up For Ever foundation, which is about forty dollars. I'm not organized, so I end up with a mishmash of thousands of things, so many I could open a drugstore!

It's very important to know what colors make your eyes pop. My eyes are hazel, and they're gradually turning more green as I get older. Purplish shades like plum, eggplant, and wine look good on my eyes. They make them look more green.

Brown shades are good for blue eyes. A saddle kind of color will really make them jump. On brown eyes, purple is flattering and so is brown. As for blue eye shadow on any color eye, I think it's best to stick to deep hues like midnight blue rather than the lighter, flashier shades. A dark blue works well when you're going for a smoky eye. I really like MAC eye shadows, and NARS too. You should experiment with different colors. Department store beauty counters are good

places to try them out without having to buy. Then you can always buy cheaper brands in that shade if you want.

Okay, before we go any further, I have to tell you what you need above all, before you even start to put

Lashes 101

I'm telling you, false lashes can make such a difference in the way you look. Even if you've been intimidated by them before, you have to try them. Just follow my instructions!

» I use individual lashes. They're much easier to apply than full strips. I try to buy the knot-free types, but they can be hard to find, so if you can only get them with knots, you'll probably want to apply eyeliner over them so the knots don't show at the base. Specifically, I buy DuraLash Naturals Flare in medium black, knot-free.

» You have to use a magnifying mirror when you apply your lashes, no matter how good your eyesight is, believe me. I like to put mascara on my real lashes before I start applying the fake ones. It gives you a better sense of where to place them. While some people use tweezers to put on lashes, I find I can do it better with my fingers. It's best to squint your eyes when you're applying the lashes, as far as you are able while still seeing clearly, because it brings the lash line into full view.

» As for glue, I don't recommend the kind that comes in a bottle. Lisa Vanderpump said to me once, "I

all this makeup on: a magnifying mirror. Oh, I know, they're horrible; they scare the living daylights out of me. They make me want to cry because I think, *Is this what I'm gonna look like in the future? God!*

But I'm a perfectionist, and I want to see every lit-

don't have any eyelashes!" and it turns out she was using the liquid stuff. That will rip out your own lashes! I use Duo Eyelash Adhesive, dark tone, which comes in a tube. So you squeeze a little tiny bit out, dip the lash in it, then place it on your lash line, starting at the far corner.

» Keep applying, working toward the inside corner of your eye, and stop at the middle, using the center of your pupils as a guide. I usually use about eight to ten lashes per eye. Repeat with your other eye.

» Take a look at yourself. Does there seem to be a very abrupt change in the darkness and thickness of your lashes from the outer half your eye to the inner half? That can happen. If so, work mascara into the lashes of the inner half until it's all balanced out.

» Never, ever tear the fake lashes off. At the end of the day, or when you want to take them off, close your eye and apply a warm washcloth to the lashes. If some don't come off, just leave them on, either just go with it and add more to them or simply leave them in until they do come out, balancing your real lashes with mascara. If you pull off the false lashes you will always take several real ones with them.

» Enjoy looking wide-eyed, sultry, and glamorous!

tle thing. You know when you see people and their makeup looks uneven? I don't know if you notice those things, but I do. I'll think, *Why does she have the line coming out so far from one eye and not the other?* So I use a magnifying mirror to make sure I get everything perfect.

Back to the fun part. I always use Bobbi Brown concealer under my eyes, in Sand. But I think you need something different for the rest of your face, because you'll probably want to cancel out redness there. I use Dermablend Professional Cover Creme to go on the broken capillaries around my nose. That's a *must* for me.

As for mascara, I am a huge fan of L'Oréal Voluminous. I like both the regular, original one in the gray tube, called Voluminous Full-Definition, and the Carbon Black Voluminous version, though it smudges more easily. Voluminous almost makes me look like I have on false lashes.

Now we've come to my real secret: false lashes. I put individual lashes on the outer corners of my eyelids on top of my mascara, and it makes such a difference. You have to try it, especially if you're going out at night—it adds so much drama and pop to your eyes. All eyes will be on your eyes! I just buy the kinds available at the drugstore. Depending on my mood, I'll put four to five on the ends if I want a cat-eye effect, and then other

times I will keep going, working all the way to the top of my eyes, and end up using half a pack.

It's easy to do it once you start, but people are intimidated and scared to try. I promise you, the individual lashes are much more forgiving than the whole row of them in one piece. Those strips are harder to put on and, even though they can be dramatic, you have to be careful or you'll end up looking like a drag queen! I've done it where one eye ended up seeming smaller than the other, and it looked like I had a stroke! And then because I'm a hypochondriac, I thought maybe I did have a stroke. Ha-ha!

If I want a smoky eye I use liquid liner on the rim, along the inside of the lid, just under your lashes. I like Make Up For Ever's waterproof version. It's very black. And I have another liner that is actual kohl, you know, the intense black liner that's made from some kind of mineral powder that they've used in Middle Eastern countries forever? I get mine online and it's cheap, cheap, cheap. I think they're four dollars apiece on eBay. The only problem is that they break easily.

For makeup removal I use Andrea EyeQ's, the little pads in a plastic jar. I use the oily kind unless I'm wearing the individual lashes, because the lashes will actually stay on a few days or so if you're careful. So if I've got lashes on, I use the non-oily pads, which aren't as strong.

A Special Word About Chipmunks and Blowfish

I understand the appeal of fillers. I have used Botox myself. I never wanted my husband to know that, because if I were to tell him I was putting botulism in my face he'd think I'd lost my marbles!

Perhaps I have lost my marbles, but I'm living in a town where nobody has crows' feet—and I cannot be the only one who has them! I know, I know, would you jump off a cliff if everyone else did? But sorry, I am *not* going to be the only person in Beverly Hills with crows' feet.

I kept that secret, at least from Mauricio, until the live reunion show after *Real Housewives,* season 1. Andy Cohen from Bravo asked me—*live* on television— "Have you used Botox?" *Uhh. Oh my God. Great. What do I do now?* I couldn't lie. I just can't lie. So I had to fess up. "Yes, I have." Are you happy now? Ha!

Afterward, Mauricio said, "You never told me that." He's not a fan of that kind of thing. He's also not a fan of all the plastic surgery looks we have in this town, and neither am I.

I think old-school plastic surgery is fine, when an older woman gets a face-lift. But— even though every plastic surgeon in Beverly Hills is going to hate me for saying this—people have taken it to extremes, to a whole new level that is just frightening. They're blowing up their faces so they don't have cheekbones anymore. I was so excited when I got older and my face began thinning out. My cheekbones began showing! Yay! Then someone told me, "You really need to fill this in here and here."

"What?" I said, "But I thought it was good that my cheekbones are showing!"

"No," she said, "it's a sign of aging."

Well, if it's a sign of aging, then sign me up, because I looked like a jack-o'-lantern

when I was sixteen! Now everyone wants to look like a jack-o'-lantern! Except me, apparently.

I have friends who are only thirty years old who make a face and say, "Oh I have a line here, I'm going to put Botox in it." Well, Portia has a line in her forehead when she makes that face! Should she have Botox? Is it really not okay to have laugh lines? We can't look like we laughed at some point in our lives? Let's not get out of control here.

And there's so much plastic surgery! So much *bad* plastic surgery! I know people who've had things done to their faces to the point they don't look like themselves anymore—they end up more like Jim Carrey in *The Mask*! I just think, *What have you done?* It's horrifying. And it doesn't make anybody look younger. You look the same age but with work done. And when the work is so obvious, you might as well wear a sign on your head that says, "I'm insecure."

Kevyn Aucoin, the late, great famous makeup artist that I so admired, wrote in his book that a perfect face is a boring face. You don't want to look like a Barbie. The women with the most beautiful, interesting faces always have some little quirk, something a tiny bit off.

I look at my niece Paris, for example. She has such a gorgeous face; her bone structure is beautiful. And she has the nose that runs in our family, a little bit long at the tip. It's similar to mine. If she were to ever get a nose job and end up with a little button, I think it would destroy her face. Or look at Jessica Simpson—that little bump on her nose makes her so pretty!

Kathy, Kim, and I all have our mom's nose. It always bothered me that it came down a little bit in front, especially when I smiled. So a few years ago, I finally got up the courage and had a nose job. I'd never been under in my life. I still have my tonsils and my wisdom teeth! Really, I'm a wimp. So I was scared of the whole idea of surgery. But after I'd gone through it, I thought, *That was nothing!*

But I ended up really regretting it anyway. My doctor who did it is a great doctor, and my nose doesn't look "done." He did a good job. It's just that while I got rid of the beaky part of my nose that came down, I was left with a little bump at the top. A bump I'd never had! So I did

away with what I hated, but also ruined what I loved. It wasn't worth it. Now, my better side is my right, when it used to be my left. Was it worth it? Hmm, not really.

You can't change one part of your nose, or your face, without changing some other part in the process. Now I know that. It just goes to show you that if it's not an emergency are you sure you really want to go through all that?

Implants are one thing I never wanted. I mean, sometimes I wish I had perfect boobs. Yes! But implants? No way. Not only because my mom died of breast cancer and it scares me to have something foreign in there, but because I think implants look ridiculous. Unless it is medically necessary, I'm sure your boobs look just fine.

It's a running joke that everyone in Beverly Hills has had a boob job, but it's the fillers that I'm afraid are getting to be an epidemic of nightmare proportions. Even girls who have youthful, full faces are doing it. Such a shame. Everyone is plumping out their cheeks and puffing up their lips so much it's like we have a bunch of chipmunks and blowfish walking around town.

I have to tell you, back when they were using synthetic collagen instead of all the Restylane and Juvéderm and other line-fillers they have now, I went with a friend who wanted some for her lips. They asked her if she had done the test to make sure the collagen wouldn't cause a bad reaction. She said, "Oh no, I don't have the time or the patience for that." So the doctor said she'd use something else instead that didn't require any testing.

They filled up her lips and when they were done, my friend said, "What's in the filler?"

"It's collagen," the doctor said, "it's from a cadaver."

Oh my God! We both almost had a heart attack. How disgusting is that? My friend was flipping out. I kept telling her "Don't worry, I'm sure it's fine." But I was thinking "Holy S*&T!" Thank God it wasn't me.

Even without cadavers, getting injections in my face causes me a lot of anxiety. I would not want to be the doctor shooting me up! I start hyperventilating. *I'm afraid it's going to my heart! I can't feel my eyeball! I can't*

breathe! Can you imagine if they find out one day that we're all going to die from this? This would be one empty town, let me tell you. It would be two old men walking around alone and maybe a few dogs.

So the moral of this story, as if you couldn't tell, is: go easy! If you're going to do something to your face, think minimal. Think moderate. A natural-looking face is a prettier face.

First of all, don't be rushing to do any of this when you are young! Appreciate your beauty. Later on, if you want to do something, remember, less is more. Please, for all our sakes, don't overdo the filler! And don't make the mistake of thinking surgery will make you look younger. It won't. In the hands of a good surgeon it may make you look better—or not. That's the risk you run when you go under the knife.

Above all, try to embrace who you are and what you look like and the number of years you've racked up. Because really, it's far preferable to looking in the mirror and finding a stranger staring back!

I don't always use foundation. In the daytime I often just wear tinted sunblock, either Laura Mercier or Proactiv. They make you look like you have nothing on, yet they give enough coverage to even out your skin tone. Proactiv looks incredibly natural. When I want more coverage, Make Up For Ever has a liquid foundation that's amazing, especially for filming. It's called HD Foundation, and I've really found it to be the best one around. I put on my foundation *last* because the eye shadow sprinkles down on my face and I end up washing it off.

My favorite blush in the entire world is called The Balm, and the shade I love is Hot Mama! You can buy it online or in boutique makeup stores like Sephora. It's actually a shadow and blush all-in-one that comes in a powder. I've shown it to the makeup artists I've worked with, and they've all started using it themselves. I like cream blush because it looks so natural when you put it on, but I gave up on it because it comes off in about two minutes.

There's Lipstick on Your Teeth

One of the lip glosses I can't live without is L'Oréal Infallible in Sunset, even though I've worn it on the red carpet a couple of times and people have said, "Oh Kyle, you have something on your teeth!" I love it so much I wear it anyway. I've heard of smearing Vaseline on your teeth to keep your lip gloss from smearing on them, but really, must I? Yuck. I'd rather just wipe the lipstick off.

I haven't been wearing lipstick lately—I'm more into lip gloss. I have about fifty of them! My most beloved lip gloss ever is Trish McEvoy Irresistible. It's really sparkly, looks nice in pictures, and stays on. But I don't care who makes the lip gloss—or any of the makeup— as long as the colors are pretty. Some of my favorite lip glosses are inexpensive, like L'Oréal No. 8, Fairest Nude.

Again, I want to emphasize: there is no need to pay a lot of money for this stuff!

I like to wear bronzer, so I went into Saks one day and I said, "What's your best bronzer?" The guy just gave it to me and I didn't even ask him how much it was, though I certainly ask the prices of a lot of things. But really, how expensive could it be? And then I got the bill. Oh my God! It was $120! This tiny little compact. I was miserable. I was so embarrassed to go return it that I asked my sister to take it back for me! So then I went to the beauty supply store and got this bronzer the size of a grapefruit in a gorgeous color for $10. I thought, *Yes, that's more like it!* I mean, how do they charge me $120 for a bronzer just because it has a cute compact? Are you kidding me?

If you can locate a good beauty supply store near you, they will have a variety to choose from. Otherwise, look online to find sources that have a good selection and prices.

As much as I love makeup, I go without it a lot. Dur-

ing the day, unless I have a work-related thing to do, or a birthday lunch, or something like that, I wear tinted sunblock and lip gloss and that's it. I think it's good to give your skin a break. If I have a big party at night, I just wear moisturizer all day, get in the shower and

Face Time

In season 1 of *Real Housewives,* in one episode I wanted Kim to have a makeover before she went on a big date. So I took her to my facialist, Carina. I don't know if you saw it, but Carina puts this huge contraption on you that penetrates to the deep layers of the dermis and tightens your facial muscles.

I think it truly does make my face feel much tighter and gives it a glow, especially when she adds microdermabrasion. But when you've got that contraption on, you look like Hannibal Lecter from *The Silence of the Lambs*! It's crazy, and it never gets old laughing at it. Every time I go there I take a picture of myself with my Blackberry and start laughing, because I just cannot believe some of the things we do to get beautiful! It doesn't hurt—it's actually relaxing—and Carina is amazing. But it looks really scary!

After that episode aired, people bombarded me with questions about that facial. And then so many people started going to her that she had to hire extra people to help her. Hey, with unemployment so high, I might as well send some more people her way, right? Ha! She's at carinaskincare.com.

wash my face and then I have a clean canvas for my evening makeup. I think makeup always looks best the first time you apply it for that day. It never goes on as well or looks as good when you've had to take off a bunch of makeup first and start all over. So, if you have a special event in the evening or a late afternoon meeting, you might want to forgo wearing makeup earlier in the day and start with a fresh canvas before the event when you really want to look your best.

Because I have dark hair and dark eyebrows, it's easier for me to get away without wearing makeup. When I was a blonde, it made me feel more washed out, because I didn't have the framing effect of the hair and the brows. If you have light hair, you may want to supplement the sunblock and gloss with a swipe or two of mascara to give your face a little more definition.

Of course it's always easier to go barefaced if you have great skin. And having great skin has a lot to do with what you put into your body. I do believe that limiting junk food and eating healthily will benefit your skin. I took special vitamins for my hair, skin, and nails when I was in my twenties. I do recommend a good multivitamin. And don't smoke! Look, I'm not a doctor, but most people who smoke tend to have drier skin and hair. One more reason to quit!

Don't get your hopes up too high about all the creams and potions and lotions you can buy to mi-

raculously transform your skin. Take all the claims with a grain of salt. Nothing's going to turn back the clock ten years; I'm sorry. Some products can make your skin look healthier and more vibrant, but it's a matter of finding the right ones for you. Once again, there's no substitute for trial and error. Skin is very individual, and what clears up one person's acne can turn someone else's entire face red and inflamed. Obviously your dermatologist can help, unless she's intent on pushing some super-expensive line of products that she sells in her office. Maybe what she's selling is great, but don't be pressured into buying something you can't afford, because there are effective, less-costly alternatives.

Same goes for the department store. I can't believe young girls who will shell out a week's salary for a little jar of face cream. Your skin care regimen does not have to be that expensive.

And this will be familiar too: less is more, even when it comes to skin. My mother very much had a less-is-more approach. Talk about low maintenance—she used nothing but Nivea on her skin her whole life and didn't have one wrinkle!

These days there are so many kinds of skin products with all sorts of ingredients and supposed benefits. It's temping to get a whole variety of them to target every possible flaw from every possible angle. But you have

to be very careful piling on treatments. Some of them will cancel each other out and, worse, you could end up with really irritated skin. So don't go overboard. I use a line called Verabella on my skin. I love their products so much I teamed up with them.

Now I won't spend $200 an ounce for a skin cream, but I do go to a higher price point for my skin care than

Vanity and . . . My Vanity

Makeup is one of the most fun things about being a girl, isn't it? Oh my God. After I get my hair done in the morning, or whenever, I like to sit on the counter in my bathroom with my feet in the sink. That way I can get really close to the mirror. I prop up a book I just love, *Making Faces* by Kevyn Aucoin, who was a genius. I flip through it and think, *What am I going to look like for tonight?* I cannot recommend the book more highly—not only for all the different looks, but for all his great tips.

As you might imagine, all my makeup and tools and everything can take up a lot of space, and as you know, I'm not an organized person—whereas Mauricio is a neat freak. So when we renovated our new house, he had the bathroom designed so that the vanity would have the two sinks, one for each of us, and in the middle between them he had the marble counter cut out and lowered to create a space for my stuff, so it would be out of his way. It works better this way!

I necessarily do for my makeup. Makeup is here today gone tonight, but your skin is forever. You can still get good products at a drugstore. Whatever your beauty budget is, I would make skin care a priority over face paint.

Even though I do have several skin products, when I travel I pare it way down. Unless I'm going for longer than five days, I just take a heavy moisturizer. For longer trips, I pack all my products, but then I have to check them in my luggage, and I always worry they might be lost.

I also bring a little spray bottle of Evian when I fly to spritz my face on the plane, to make my skin less dry. And another tip I learned from my sister Kathy: as soon as I get to the hotel, I lay out a hand towel on whatever space I have in the bathroom and line up all my beauty products so they look pretty and organized in a clear working space. I need a neat area to work in because, as I might have mentioned, I am not an organized person, and pulling my-

Browbeaten

Recently I got a question on Twitter from someone who asked me, "Who does your brows?" I answered, "I do them myself."

So then someone else weighs in and sends a message like she's outraged. "There is NO WAY you shape your eyebrows yourself. Why don't you just be honest about it?"

Uh, what could I say? The truth! "I am being honest about it," I said. "I shape them myself. Really, it's not that hard!"

self together can be a lot of work sometimes. I need all the help I can get!

One of my absolute rules is I never go to sleep with my makeup on. I don't care how late or crazy my night is; that makeup is not staying on my face. During the day, all kinds of pollution ends up on your face. So if you don't take your makeup off your skin absorbs all that and makes it look old or can cause it to break out. Get it all off there and give your pores a chance to breathe.

I use Verabella cleanser to wash my face. I don't want heavy soaps that make my skin feel stretched and dry. I

Sunbathing

Getting real suntans is just not my thing anymore. I used to sunbathe years ago, and I love to be out in the sun, but I don't like baking in it now. Recently I was in Cabo, in Mexico, and I thought I'd let my guard down and get a little color. But I ended up with a little sunspot on my cheek. I thought, *That's it. I'm never doing that again.* It's fine to be out there relaxing in the shade, but why be working on a tan when you can just get a fake one and save your skin? I used to use tanning lotions by Clarins and Lancôme, and I still think they're good, but now for convenience I just either have a girl come to my house to spray me—it takes under five minutes—or run up to the booth and get sprayed.

My Must-Have Beauty Products

Eye shadow: MAC (Satin Taupe), NARS (all colors)

Mascara: L'Oréal Voluminous Full-Definition and Carbon Black Voluminous

Eyeliner: Make Up For Ever waterproof liner for inside the eyelid, Hashmi Kajal kohl eyeliner (available on eBay)

Eye Makeup Remover: Andrea EyeQ's Makeup Remover Pads, Oil-Free and Ultra-Quick

Concealer: Bobbi Brown (in Sand), Dermablend Professional Cover Creme

Tinted Sun Block: Laura Mercier, Proactiv

Foundation: Make Up For Ever HD Foundation

Blush: The Balm

Lip Gloss: Trish McEvoy, L'Oréal, MAC Viva Glam 5

Lip Balm: Burt's Bees

Skin Care: Epicuren, Verabella

Face Wash: Cetaphil, Verabella

Toothpaste: Colgate whitening toothpaste

Breath Mint: Altoids

Body Lotion: St. Ives with Royal Jelly

Sunless Tanner (bottle): Clarins, Lancôme

like something that is gentle but does the job. And then I put on my gels and creams. My husband can never get used to how long it takes me to get into bed.

My nighttime routine drives my husband insane! By the time I get to bed, he's been sound asleep for thirty minutes! He's said to me, "You think you could shorten your routine a little bit?"

I say, "If you want me to look good, this is the way it goes! It's work!" Ha-ha!

I am not lazy about my manicures and pedicures, though. Whenever I see women who are really put-together, they always have one thing in common: nice manicures and pedicures. To me it's such a shame when you see someone who looks very nice, you know, the clothes, the purse, the makeup—but then her nails are chipped. It just kills the whole deal.

So I always make a point to keep my hands and nails looking as perfect as possible (though I otherwise don't give my hands any attention, because they're past hope. I did not get my mother's hands; I got my father's, and let's just say I'll never be a hand model. I have learned to accept the fact that I just don't have nice hands. Period. End of story. Good hair, bad hands. Ha-ha!).

I usually do my nails in a natural tone, unless I'm trying something out, but I have fun with the colors on my feet. For the summer, I'm into sparkly, bright colors and in the fall I like deep purples. I'm neurotic about

getting germs so I take my own tools to the salon. But I don't go to the salon all the time, as you know, and certainly not every time I have a chipped nail!

Every woman should be able to do her own nails, and don't tell me you can't! I know it's hard to do the right hand if you're right-handed, and vice versa, but you just have to learn to do it yourself! DIY is a beautiful thing!

Kyle Style

I always say that I'm a juicy drummette—you know, the tiny but meaty part of a chicken drum. That's me—I'm five feet three inches on a good day, I have big boobs, and I carry my weight in my stomach. I'm a drummette!

People say, "You can't be fat when you're a size 4!" You'd be surprised. I have a small frame, but my weight goes up and down, and I can get chubby easily. I'm not saying I'm fat, just that I have my problem areas. I've always tended to gain weight around my middle, and by now, four kids later, we're talking muffin top.

When I say that everybody laughs and says, "Oh please, you don't have a muffin top!!"

Listen, you don't know it because I won't show it! That means I'm doing my job!

I love fashion, but being stylish and well-dressed is about much more than picking the coolest things off the rack. As much as I adore clothes, handbags, shoes, jewelry, hats, and so on, I have to be selective—in fact, downright strategic—about what I wear because my body isn't perfect by any means. Not everything looks good on me.

I wasn't into fashion when I was younger. I was kind of a tomboy, so I didn't care so much about what I wore. But Madonna came on the scene when I was about fourteen, and that's when I started playing with fashion. I had to have the lace and the gloves with the cut-off fingers, all that stuff. It was ridiculous! When the movie *Flashdance* came out, I had to have the sweatshirt with the neck cut at an angle and falling off my shoulder. I cut up every sweatshirt I owned!

Then as I got a bit older, I took to copying what my sister Kathy did because I thought she had good style. But she dressed very mature for her age, wearing things like Chanel suits at twenty-five. That was elegant, but too mature for me, so I'd copy her but play with it. Maybe make the skirt shorter and wear a hat.

I've learned a lot about fashion and style since then. And the older I get, the more I learn. But one principle above all stands the test of time. The absolute most

important rule of style is: wear what looks best on your body.

So simple and yet so many people do not seem to grasp it. Camouflage your flaws and highlight your assets. Cover your worst features and show your best. Simple.

For example, I'm not going to put on a pair of really low-rise jeans that creates a monster muffin top that will knock your socks off! But I can get away with showing my legs.

All through this book I've been emphasizing confidence, and I do believe that I'm a confident person. You may feel it's a contradiction for me to criticize parts of my body—but I don't. I can be a confident person and not like certain things about my body. I know my flaws. I don't love them and am not gonna parade them around for all to see, but having some imperfections is just life. It's part of accepting who you are and being confident anyway.

My middle has always been my problem area. I've had four kids, and I've never had lipo or had my boobs done, and that's just the way it is. I'm very grateful to Miracle Bras and Spanx! But I still have to be diligent about finding clothes that work with my body.

Jeans are actually a perfect illustration of what I'm talking about—and what it takes to *do* what I'm talking about. The concept of dressing for your body is simple,

but finding the garments to fill the bill often isn't. With jeans, it's like a science. You have to do a lot of research and probably try on a million pairs before you find a few styles that are exactly right for you. I have found three and only three brands of jeans that work for me: Paige, J Brand, and Adriano Goldschmied. When low-rise jeans were all the rage, it was terrible for me and my stomach, and now the higher-rise style is coming back to cover the muffin top—yay! Except that now the top part of the stomach is getting squished. See what I mean? It's a complicated science! I'd love to wear boyfriend jeans, but they make me look like Humpty Dumpty—an egg with legs. I'm not going to fall into that trap!

Flare legs are flattering on me because they balance my upper body. I have kind of big boobs for my size, and flares are good for someone who's short and curvy. Skinny jeans look fantastic on someone who's tall and thin. Occasionally I'll wear them, always with heels, but I don't think they're my best look, and I always put a longer jacket over them.

I don't know what your body type is, so I can't tell you exactly what will look best on you. Set out to discover what's best for your body and stick with it.

And if you find a pair of pants or something that makes you go, "God, this looks really good on me!" then of course buy it, but don't stop there. Buy mul-

tiples! Try different colors of the same great piece. It's like finding gold, so rake it in. If they're good quality, then you'll have something that makes you look hot forever.

I recently found this pair of black Alice + Olivia pants that made my body look much better than it really is. Those pants made me look like I had work done on my body. So I went back and said, "I need them in gold, I need them in white . . ." They're staples that I'll wear and wear and wear. Another suggestion: when you find your perfect pair of jeans, buy at least two pairs, so you can wear one with heels and hem one to wear with flats.

What all this means, then, is that if you're serious about tracking down the most flattering styles for you, you're going to have to pass up a lot of trends in the process. You may get lucky and a trend will work perfectly for you—boyfriend jeans may look totally hot on you—but as a general rule, chasing trends will distract you from your mission.

I'm not big on buying trends, anyway, for the simple reason that trends don't last. And if you do follow trends, then you end up with, oh, say, seven pairs of parachute pants in your closet that you won't be able to *give* away! I like to buy classics that won't look dated in six months. That's especially true if I'm going to spend a lot of money on something. I want to know I'll be able to wear it for years to come.

Body Beautiful

I want to talk a little about diet and exercise—but just a little. Ha! I thought this would be a good place to do it, since I have been going on a bit about my flaws, my muffin top, my life as a drummette. One reason I can do that so openly—and laugh about it!—is that I just don't think it's such a big deal. We are human beings, not mannequins.

Go back to the old-time movie stars, when movies were still in black and white. And even after that. When you look at those actresses, none of them was really skinny—and they were all gorgeous. Maybe they didn't need Botox and fillers back then, because they weren't starving themselves! Their faces were a little fuller because their bodies were a little fuller. And both their faces and bodies were beautiful!

When I was younger, I was always hyper-focused on my body and whether it was the right size or looked the right way. I still am focused on my body, but I'm much more relaxed about it. Frankly, after four kids,

I never want to see a bathing suit again. I can be really cocky in a dress, but a bathing suit—no way! If I'm invited to a pool party I always say, "Oh darn, I forgot to bring my suit!" Then if the hostess offers to lend me one I'm like, "No, thanks. I don't like to borrow bathing suits. Cooties, you know." Ha! And if I do have a bathing suit on, once I'm settled, I'm not getting up. One time I was at the beach with my family and someone said there was a tsunami warning. So I told Farrah's boyfriend, Taylor, "If there's a tsunami, you're in charge of grabbing Sophia and Portia, because I'm not moving!"

Thankfully, my daughters aren't obsessed with things like that. They are accepting of themselves and happy with who they are. I am so grateful that my kids have never said, "Oh, I want to go on a diet." When I see a really thin girl in a magazine or on a TV show, I make a point of saying, "That girl is too thin; that's not attractive at all." And it truly doesn't appeal to me in the

least. That is not how God meant for our bodies to be.

I like for my kids to eat right and exercise, of course. It's important for their health. But society puts way too much pressure on girls and women to be skinny. I'm not buying into it.

I do watch my weight. But I don't weigh myself. My closet gives me a reality check. It's a drag when you walk in there and find out something you love doesn't fit anymore. That's when I know I've gotten carried away and need to pull in the reins a bit. If I can fit into my clothes from years ago, great. And, if I don't look exactly the same as I used to? I can accept that too.

I like to eat healthy things like grilled salmon and vegetables. If I'm trying to lose a few pounds and I'm out to eat, I'll ask the restaurant to hold the potatoes and bring only veggies. I say it begrudgingly. And then waiting for my salad and broccoli I look at the basket of bread, and want to cry my eyes out.

My whole family loves going out for sushi. At some point I started switching out the white rice for brown rice. I had heard for so long that eating white stuff like bread and potatoes was tantamount to putting glue in your stomach, so I finally said okay, okay! After I've really plumped up over the holidays you might even see me ordering sashimi instead of sushi, to avoid the rice altogether.

But other than cutting back a bit on refined carbs, nothing too extreme. I'm not the type to have a salad for dinner with lemon, hold the oil. Forget it. If I'm having a salad I'm having it with good dressing! Besides, when you pick up a magazine and find out that some celebrity lost twelve pounds in a week by doing something along those lines, you have to know, come on, it's not as simple as that. Who wants to live on a permanent diet anyway?

Sometimes I give in to my cravings for things like cheeseburgers and fries from Fatburger. Yum. And my favorite treat is a hot chocolate-chip cookie with cold milk. Oh my God, my daughter is standing next to me right now smiling! Because she knows that's our favorite. Pizza and root beer—that's a good combo. I'm not much of a dessert person, but cupcakes do call my name. I do drink wine, but the sulfites in it

bother me. When I go out and have something to drink, it's usually a margarita, no salt.

I keep healthy snacks in the house like string cheese and apples and raw, unsalted trail mix. And in the afternoon, I often satisfy my sweet tooth with a skinny caramel macchiato from Starbucks. And let's face it—you gotta have chocolate. Don't most women have to have chocolate in their lives? I keep frozen dark chocolate in my freezer at all times—a whole bunch of it, because there have been times where I would have betrayed my country for just one piece of chocolate. Ha! I'll dig through drawers trying to find old scraps of candy from Halloween or Easter. So I need to have a supply on hand. And I'm pretty good about breaking off a little piece and eating it and stopping there.

But it's hard when you have kids. When I'm being bad I eat all of their leftovers. I cut off the crusts of their sandwiches and eat them! Anything they leave, it goes into my mouth. Sometimes I do it without even thinking. One day I was getting things out of the car and I found a french fry on the floorboard and I just popped it into my mouth. I thought, *What is wrong with me?* Ha-ha! I love tweeting things like that, to see people's reactions. Half the people responded saying, "Ew, that's disgusting!" The other half are like, been there, done that! Phew, I wasn't the only weirdo out there!

My attitude toward exercise is very similar to my attitude toward food. I used to go to a boot camp type of place three times a week and take yoga twice a week. My body was in the best shape ever, but that was before I had Portia, when the kids were in school all day— and before *Real Housewives.* I got off track, then I hired a trainer who helped me get back, but he hasn't seen me for about a year! Since the show I'm just always on the go.

On the go—right, that reminds me of those women who say that they stay fit just by running around chasing after their kids. They are so full of it! I run around and take my kids everywhere, but after Portia was born, it took me two years to lose the weight! A small child is not a workout. (Then again, who knows what I would be like if I *wasn't* running around!)

We set up a little gym in our

new house, so I try to get up in the morning to get on the treadmill or the bike. But if it's a choice between an extra hour of sleep or working out, usually the sleep wins. I really love to go outdoors and walk or hike. That's when I feel the best. And for some reason, that's what my body responds best to. Maybe it's because that's the activity I enjoy the most.

I love trees, I love birds, and I live in the hills, so I can easily go out into the sunshine and move my body. It puts me in a great mood. Sometimes I go with a girlfriend and we walk together and talk. The other day I went with my husband and another couple we're close to. It was a Saturday morning and the kids were all sleeping and we walked for about an hour. It was so fun. It was just the best way to start the day.

That's more than exercise; it's a way to enjoy life and enjoy your world.

And by the way, as I'm telling you all this I'm popping Cheez-Its into my mouth. Ha-ha!

When you view it from that perspective, you can justify spending some hard-earned money for certain items. Timeless, high-quality pieces can actually be investments. I have a beautiful pink Chanel blouse that my sister Kathy gave me at least ten years ago. And the other night I wore a Gucci jacket that belonged to my mom. I remember when she bought it—it was in 1979 when we were in New York with my sisters shopping. Chanel and Gucci are obviously very high-end and I don't even know what they originally cost, but look at how many years they've been worn! If I'm contemplating buying a really costly item, I ask myself: "Can I give this to my kids one day?" (Not that they're waiting for the actual transfer of goods—lately my girls have been stealing from my closet without even telling me!)

My big-ticket purchases tend to be handbags and shoes, because they are the kind of staples you can wear with so many different outfits. To me they're a perfect example of classic investment pieces. At least that's the story I tell my husband and I'm stickin' to it.

I will also spend more for a really great jacket, because like shoes and handbags, jackets can be strong, versatile staples for a wardrobe. I do try to get them on sale, though. I saw a gorgeous Dolce & Gabbana blazer on my niece Nicky, and I wanted it so badly! She called me one day and said, "My blazer's on sale right now at Neiman Marcus." So I flew down there and

bought it on sale. That was years ago, and I still wear it all the time. It's a navy-and-white pinstripe, and I wear it with a white button-down shirt, with red heels, with black, whatever. I love it.

You have to love what you buy. Especially when you're putting down a lot of money. Because even if an item is on sale, there's no point in spending even a dollar on something that you're not going to use. My motto when I'm shopping and can't decide on something is "When in doubt, do without."

Only buy something if it makes you feel beautiful and confident—not because someone says it looks good on you. Friends are well-meaning, but they're not the ones who'll be wearing the clothes. Ditto for husbands or boyfriends or sisters.

I actually prefer to shop by myself. I'm the only one who can really determine whether something's right for me, and other people can distract me from my goal. I know it's fun to go shopping with a girlfriend, but for serious buying, you're better on your own. I don't even like it when a salesperson starts following me around asking if she can help. I want to say, "Please don't talk to me! Because I'm really on a mission to find something that looks good on me!" Or when they say, "You're going to love this." How do you know? We've never even met!

It pays to be ruthless about the things that are already

hanging in your closet too. I recently went through my whole closet and got rid of everything that didn't make me feel good. You really should do this on a pretty regular basis. I also try to stick to the rule that if I haven't worn it in a year, it goes—unless it's true vintage.

You should also use this time to make any repairs on clothes. Often I'll find a favorite jacket hanging there, out of action, when a quick trip to the tailor could put it back into circulation!

I used to think, *Well, at least I have a full closet.* But in fact, once you can actually see what you have, it's easier to find the pieces you really want to wear.

It's hard to get rid of things, I know. I'm not saying I just jump into my closet and, snap, in ten minutes I've got it all pared down. This is where a friend actually can be very helpful. When you're teetering—"Oh, but I wore this to that party that was so fun and everyone said I looked so good. Do I have to give it up?"—your friend can be the hammer.

"Are you really going to wear it?" your friend might say. "That party was eight years ago and I haven't seen you in it since. Toss it!"

When I'm culling my clothes I use a method I call "give away, keep away, throw away." Give away is for the clothes you can pass on to friends or donate to Goodwill or other charities. Throw away is of course for things that not even Goodwill will want. Ha! When

I'm going through my kids' clothes, I get very sentimental. I see a little dress and I know my daughter's outgrown it, so can I at least give it to someone I know? Uh, no, not if it's stained and has a big hole! That's for the throw-away pile.

But my middle ground is "keep away." Some things you can't bear to part with, even if it isn't in current rotation. I understand very well that certain items carry special meaning, and you may even nourish the hope it might be worn by you or someone else someday. But don't fool yourself about what really belongs in there. At the very least have your friend stand guard at the keep-away pile!

Once I've pruned my wardrobe, it actually seems like I have more clothes than before. And they almost seem new! And what a sense of space and calm! It's like, *ah, I can breathe again.* Similar to the feeling you get when your car is freshly washed with a full tank of gas!

You can also get that feeling by organizing your closet really well. I'm not organized by nature, but when I arrange my clothes by color and try to coordinate them with the items I wear with them, I can walk in and say, "Oh, what do we have here?" instead of panicking because I have nothing to wear. It's more relaxing. And when you're short on time, it really helps to have outfits partially put together, or at least ready to be easily assembled. Not to mention when you're totally

late and completely frantic and *oh my God what am I gonna wear?* and *will I ever get out the door?* You know those times!

While I weed out clothes on a regular basis, I do keep clothes around that may not fit me at the moment—but do fit me when I'm a little heavier or a little skinnier. Some people say you should never keep your "fat" clothes around but I disagree. I definitely have my uniforms, like the go-to outfits for days when I'm feeling bloated. I know I can still feel okay and reasonably confident in them. Do you really think that by getting rid of "fat" clothes it will keep you from gaining weight? I'm a realist. My weight goes up and down, and I want to have clothes that make me feel good at every phase, whether it's a skinny day or a chub day!

Part of being a realist is also recognizing when you really have gotten past the stage of ever wearing something again. You have to be honest with yourself. Truly, are you going to wear that short, tight dress you used to go clubbing in fifteen years ago? If you've still got the body for it, you go girl! But don't kid yourself. Maybe it's time to give it to your daughter or niece!

I believe in age-appropriate dressing. I know with hair I said forget about the age-appropriate thing, but I think it's different for your body and clothes. I'm often tempted to buy things I shouldn't. I might be dying to wear a cute short skirt I see, but then I have to face

the fact that it may not be age-appropriate. The skirt's probably better for my daughter—so I buy it for her instead.

Also, you really shouldn't wear a short dress and a low-cut top. Especially if it's short *and* tight. That's my biggest no-no. I don't think that look is great at *any* age, to tell you the truth, but when you're younger you can get away with it. Otherwise, choose one—short, tight, or boobs. Same goes for tight and sexy—you can be tight and sexy on the top, or on the bottom. Not both.

I don't wear very short skirts anymore. Unless you're young, it's just not a good look to me. And I'm not generally a big fan of too much cleavage. I think you have to leave a little to the imagination.

When you're in doubt about wearing something for *any* reason, you should probably go with your doubts. That may sound inconsistent with being a confident woman; and obviously a lot of people say you should take risks. When I was younger I used to get dressed and think, *Hmm. I'm not sure if this looks good but I'm gonna try it.* But I've since learned that when it comes to fashion, obey my rule, "when in doubt, leave it out." That theory seems to work best for me. Try it and see if it works for you too.

My personal style, as you may realize by now, tends to be a little bit conservative. I like a classic look that's

not too flashy. I don't like rhinestones. I think they can look cheap and tacky and ruin an otherwise elegant piece of clothing. I do love sequins though.

I also prefer to dress in a way that makes me look

My Fashion Icons

Audrey Hepburn

I wish there were women now who were chic and elegant the way she was. I've shown my girls *Breakfast at Tiffany's* and we have a lot of pictures of her in the girls' rooms because we all just love her.

Madonna

As I mentioned, she was a real inspiration to me when I was a kid! But I think she's still got a great sense of fashion and style.

Jennifer Lopez

I am a huge fan of the way this woman dresses and how put-together she always is. Her skin is glowing, her hair is beautiful, her lip gloss is perfect, and her outfit always matches her nail polish. I really appreciate when someone makes that much effort to look good.

feminine but not too sexy. Mauricio likes a soft look. If I want to be sexy for him I don't wear a tiny, tight dress with my boobs hanging out—unless maybe we're going out for a night on the town in Vegas.

A big part of being fashion-savvy is knowing how to dress appropriately for the occasion. For a glitzy night in Vegas, okay, go sexy. But for a charity event, you want to be feminine and sophisticated.

Clothes can really set the tone of your experience. Obviously mood and personality affect what you wear, but it goes the other way too. To use an example that still makes me cringe, I will refer again to the episode in season 1 where I screamed at my sister in the limo. That night I wore a short black dress. Just the fact it was black made it kind of assertive; wearing color can often be much more feminine. (I swear, I can put on an ugly, frumpy dress but if it's red my husband will say it's gorgeous!)

Also not typical for me was the dress's length that night—or lack thereof, I should say. Usually I don't like anything coming up that high; I think it's unflattering. But the sleeves were long and had these interesting cut-outs, so I thought they kind of balanced out the short-ness of the dress. But the dress was just not me; I even said in the episode that I thought maybe I should give it to Farrah.

After the episode aired I read in a blog, "Kyle was so

aggressive that night. Even her dress was aggressive!"
Oh my God, it was true! Yeah, it was the dress's fault,
not mine! Ha-ha! It made me realize how much clothes
can set the tone—or at least reflect one's state of mind.
The next time I put on something like that, I better
watch myself!

Normally when I make a fashion statement it's with
the tops that I wear. I love certain kinds of tops, ones
that are flowing, with interesting detail, blousy, frilly
styles, tops that are flowy or skim my body. (Things
that don't cling to my stomach.)

I'm really drawn to tops with unusual sleeves. It's
hard to describe the exact style, but now other people
seem to know it when they see it. My friends will say
to me, "Oh, this top is so you!" I never knew before
that I had something that stood out as being—well, so
me. It's nice though. If you wear a particular kind of
garment or have a signature look that you're known
for, go with it. Play it up! If not, don't be afraid to ex-
periment with possibilities. You can develop your own
special look. As long as it's based on what truly flatters
you and makes you feel fantastic, it can really enhance
your style profile.

Of course, all this advice is useless unless you can
actually afford to buy the clothes. I feel very strongly
that you can be stylish without devoting your entire
paycheck to it. I honestly cannot afford to buy all the

things I would love to buy; I have to pick and choose. That's why I mix it up. I reserve my big expenditures for high-quality staples that will serve as the backbone of my wardrobe for years rather than things that are "in" for just one season.

Some people assume, just because I'm on the show, that everything I have is expensive. So not true. I buy a ton of inexpensive things. I really do mix it up.

For instance, some people will go out and spend $80 on a pair of black leggings. Why? Why spend $80 for something you can get for $15? As long as it fits correctly, what's the difference? Like I said, I prefer to spend my serious money on bags and shoes (which naturally we'll talk more about later!). Other things I can find cheaper.

I'm a huge fan of this designer, Matthew Williamson, but if you buy a top from him it's probably a thousand dollars! He did some designs for H&M, though, and I got this gorgeous cap-sleeve blouse for $60. I wore it on the show. It looks exactly like the ones that cost hundreds of dollars!

H&M is a great place to shop for cheap but fabulous stuff. They have lots of stores on the East Coast and the West Coast, and some in the Midwest. But sometimes you can only get the best deals if you're really determined. One time I knew the store was going to start selling Matthew Williamson for H&M. But I knew

that the store on Sunset Boulevard, which isn't very far from me, would be overrun with stylists and people in the business. So I drove out to Woodland Hills (which is *not* very close to me) and got there way before opening time to stand in line. Even there, at a store pretty far out in the Valley, as soon as the door opened it was like a horse race. Everyone was off and running! I'd never seen anything like it. The store staff kept yelling, "Only two pieces per person! Two pieces per person!" So I just kept snatching things in twos and twos.

Another good place for nice, inexpensive stuff is Zara. It's a great place to buy blouses that range from $30 or so to something like $79. Don't get me wrong. I love Saks, Barneys, and Neiman's, I try to find things that are beautiful but not crazy expensive. And not trendy.

I shop online for some things, like shoes and even tops and dresses if they're loose-fitting and I know my size. But I don't really recommend going online to buy fitted clothing.

Fit is really important overall. (Not just when the clothing is so form-hugging it's practically plastered to your body—I wouldn't want to wear something like that anyway!) The proper fit in a pair of pants or a jacket, a skirt, a dress, even some blouses, can literally make all the difference between walking around like a schlub or knocking 'em dead. I'm serious. Good

My Glamorous Nighttime Attire

You don't want to know what I wear to bed at night. But I'll tell you anyway.

I make such an effort trying to look good when I go out, and trying to look beautiful and sexy for my husband. And then at home I have the scariest pajama situation! Basically I wear whatever feels the softest against my body. It doesn't matter if the tops or bottoms match. They might be from Target, or they may have been lurking in the back of my drawer forever. I have gorgeous pajamas hanging in my closet, but, sadly, I never wear them. They're just not my style. I need comfortable. If I try to wear all the fancy nightgowns I get claustrophobic. My legs get twisted and tangled!

They make it look so easy in the movies!

tailoring will absolutely set you apart from the crowd. Look at anyone you think has great style and I bet you anything their clothing is tailored flawlessly. Proper tailoring is so worth it, and it's almost a necessity when you're short like me, or have other characteristics that make it almost impossible to find a perfect fit off the rack. You might be able to find a good tailor by word-of-mouth.

Oh my God. We haven't even gotten to shoes yet!

And they're my favorites! Along with handbags, of course, which are also coming up.

I love, love, love, love shoes. I can put on a pair of shoes and feel like a totally different person. The higher the better, because I'm short, okay, petite. Shoes have this almost supernatural power to make you feel incredibly good.

And you know, you can always tell someone by their shoes. I've thought that forever about men, but it's true for women too. If their shoes are falling apart what does that say about them?

I have a real pet peeve about when the bottom part of a woman's heel comes off, but she just keeps walking around on the heel with the naked metal shaft sticking out and you hear the "click, click" every time she takes a step. What is she thinking? She's not thinking! Doesn't she realize how she's presenting herself to the world? If she's walking around like that, what does her home look like?

Little things like that can mean a lot. If your shoes are in need of repair, do not wear them until you fix them. Period. End of story.

It's worth your while to seek out a trustworthy shoe repair place. I don't like spending a lot of money on flats, because I am so addicted to heels. But you have to wear them sometimes with jeans and capri pants. The only flats I wear are Chanel. I have a few differ-

ent colors always. I take care of them by taking them to the shoe repair shop and having them resoled. I've been wearing Chanel flats since I was pregnant with Farrah. 1988!

I am very hard on my shoes, so not only do I need a good shoe guy; I also need one who's affordable. Everyone in Beverly Hills goes to Arturo's Shoe Fixx, and I do go to him, but I also have someone in the Valley who's not at all expensive and equally good. He's just not known as "The Shoe Guy" of Beverly Hills!

I have to admit that as much as I love high heels, it's getting harder and harder to do. What can I say? Sometimes you have to suffer for beauty! I do plan to wear heels until the day I die. I don't ever want to feel like I threw in the towel! So I certainly can't tell you to stop wearing heels. Your doctor can tell you that, and he's probably right, but you won't hear that advice from me! Ha-ha! I was at dinner in New York recently and a fan of the show came over to me and said, "I love your show! Look, I'm wearing my 'Kyle heels'!" She lifted her pants to reveal a three-inch heel. My eleven-year-old Sophia said, "My mom wouldn't wear a heel that low!"

You may not like heels, of course. Shoes are pretty much like the rest of your clothing—you have to find what works best for you. You have to figure out what lifts your spirits, not just your heels. And when you

do find a shoe you love, buy multiples. I found these Prada peek-toe platforms in black leather that I just love. Every time I put them on, I don't know what it is, I just feel so much better (although nobody even sees them half the time because I wear my jeans so long—Ha!). I realized I should try to find the shoes in some other colors, and I've been looking. A good trick for that is after you buy the shoe in person, go online to find other pairs in different colors or other fabrics. You may even find them cheaper!

And now, handbags. If you watch the show, you know how crazy I am about handbags. Lisa from the show always says that every time I get a new handbag I'm so excited it's like I found the cure for cancer. Ha! Maybe that's because I don't get them very often, and it's a treat for me. Every time I see a handbag I think I have to have, I remember I have four kids and educations to pay for. So I will either save up to buy the bag (and maybe by that time it will even be on sale!) or wait until my birthday and say to my husband, "Can I get this? Pretty please?" I do a little finagling! And sometimes my friends will all chip in and buy me a bag for my birthday too. They really are so expensive! It takes a lot of friends!

That's why I wanted to design handbags that are beautiful and hip but that you don't have to go into debt to buy. You know, you leaf through magazines like

Vogue and you see something you like and it's $5,000! Who spends that much? The handbag line I've created will not be like that. People deserve to have things they love that don't cost them a lot.

It was fun picking the fabrics and the hardware and the designs and saying things like, "No, absolutely no rhinestones!" Not on my bags! I like sequins, though, so we went with that instead. All of the bags are ones I would definitely carry myself. The process came very naturally to me. (Someday I'm hoping to branch out and design a line of tops. Stay tuned!)

Accessories are important, and it doesn't end with handbags, of course. The little details they add can raise an outfit from the mundane to the sublime. Or they can turn a generic outfit into something that's truly *you*. You know that Gucci jacket of my mother's I was telling you about? The night I wore it, Mauricio and I were taking our daughters to a concert—the kind of concert where I didn't know half the names of the performers. So I wore the jacket but rolled up the sleeves, put it on with jeans, and mixed my jewelry in with it all. The rolled sleeves and jeans made it appropriate for the event, but my jewelry made it *me*.

If I put on an outfit that looks kind of dull, I then think of it as a canvas and start adding long chains and other things to spice it up. Gold hoops are a staple of mine; I often wear them when I'm wearing a necklace.

I also like diamond studs. But sometimes I switch it up and play with different earrings and bangles, trying to find just the right balance. You have to be careful about going too far when you're adding things, because it's easy to go past the point of perfection. Use some restraint and look for balance. For example, I would never wear bangles on both arms—on one I wear a watch.

My jewelry is just like everything else—a mix of high and low, half costume / half real. I love some of my costume pieces even more than the pricier ones! There's definitely no need to go broke on jewelry.

And don't forget sunglasses. They're not jewelry but I kind of think of them that way, because they can change up your outfit just like jewelry. I have a lot pairs in a lot of different styles and colors, because I *love* to wear them—especially big ones. You have to buy the shapes that are best for your face, though. I have a square face so I can get away with wearing the big ones. I've got my huge Jackie O sunglasses in black, tortoise, and pink!

I'm also big on belts because I like to wear flowing blouses, and pairing a beautiful wide belt with a flowing top not only creates a waistline, but also creates a statement: now it's not just a blouse, it's a put-together look. Sometimes I'll use a really long chain necklace as a belt. Don't be afraid to play around and do unexpected things. It's all part of developing your personal style!

You'll see me in hats a lot too. I think hats are very underrated. A hat can almost be like a wig when you're not having a great hair day or you want to be a little more private. But they can also be a great addition to your outfit. I like a black fedora with a blazer and jeans. Sometimes I'll wear a cowboy hat or a straw hat in the sun. A lot of people tell me, "Oh, I can't wear hats, they don't look good on me." But I bet they really haven't tried. It can feel funny to have something on your head when you're not used to it! But give it a shot. Sample different styles and give yourself time. This is one of those occasions when taking a friend to shop can be a good thing, because she might see how it flatters before you do.

Finally, don't forget one of your most important accessories—your hair. It's a crucial part of your look. When designers show their new collections, they spend a lot of time making sure each hairdo is just right for the clothes they're sending down the runway.

For example, I wouldn't want to wear a big, long gown and then wear my hair long too, because that would be overwhelming. Too much dress plus too much hair equals too, too much! I would pull my hair back for that, and that style has the advantage of letting you show off your face and your earrings, which can be quite elegant.

On the other hand, if your silhouette is pared down or your outfit is more minimalist, hair that's long or

has a lot of volume can balance it out. Balance—there it is again! Obviously a style staple!

Some hairdos can work with almost anything though, and we love those, don't we? A ponytail is great because you can just as easily wear it to the market as to a black-tie event.

Well, I've told you just about all the style secrets I know. Now all you have to do is go out and deploy them in your own individual way. Because individuality is the true essence of style!

Mi Casa Es Su Casa

Everyone says that my husband and I are the best entertainers, because when people come to our house they never want to leave. That's exactly the way we want people to feel. We want them to be welcome and comfortable and so happy in our home they feel like it's their home too. That, to me, is the essence of entertaining.

You may have seen the episodes of the show where Mauricio and I throw our annual White Party. It's a tradition we've had for a long time. We usually do it right around Mauricio's birthday in June, and each

year beginning in May, people start asking us, "When are you having the party? You are having it this year, aren't you?" I love that everyone looks forward to it so much that they start getting antsy about it. To me that's a huge compliment.

I never say, "Oh, don't worry, your invitation is in the mail," because I hardly ever send invitations. Ha! I know it's more fun to get an actual proper invitation in

My Tips for Being the Hostess with the Mostest

» Always start preparing for a party by making a detailed master list of what you need. Then break it down by what you already have, what you'll have to get, and where it will come from.

» Make a list of what you have to do. Try not to panic!

» Don't stress about sending invitations. Being spontaneous puts people (and yourself) at ease.

» Enlist your friends to help, and make it fun.

» Have the stage set when your guests arrive: candles lit, flowers arranged, music on, fireplace lit (if you have one), and bathrooms polished to a high shine, with candles and fresh towels and flowers. Don't forget the bathrooms!

the mail, but I'm just not organized enough to do that. Since that's not the way I roll, I usually send emails instead. Look, I've decided to do a party two days in advance and somehow managed to pull it together. Mauricio and I are good at doing things last-minute. If I had a bunch of time to plan my parties, I would drive myself crazy worrying about all the details!

And besides, when people know you've been plan-

> » Do as much work as you can ahead of time and keep things simple so you can enjoy your guests and they can enjoy you.

> » However, do make sure that dirty plates and ashtrays are picked up and whisked out of sight on a regular basis.

> » For a big party, hire help if you can.

> » When the party's over, or you wish it were over because you want to go to bed, turn off the music. If people don't get the hint, blow out the candles. If that fails, you may have to go upstairs and change into your jammies and come downstairs yawning. To tell you the truth, my problem isn't so much getting the guests to go home; it's getting my husband to leave the party and come upstairs. I burn out no later than 1:00 or 1:30 but he's happy to keep things going until 4:00 A.M.!

ning a party for two months, that puts more pressure on. That is exactly what I don't want. Mauricio and I strive for guests in our home to feel welcome in every way.

Making people feel welcome—it's the whole point of entertaining, isn't it? And yet I've been to gatherings where I definitely did not get the sense of being welcomed. I bet you've had the same kind of experience. Like when you go to someone's house and there's only a little bit of food, so you feel scared to eat. It makes you uncomfortable and nervous.

To me it's the most basic of all the rules of entertaining: when your guests arrive, have candles lit and music on and flowers around the house. Provide an instant welcome. Make people feel that you've been eagerly anticipating their presence.

Last night Mauricio and I had a bunch of friends over and we all cooked in the kitchen together. We had pasta with shrimp, garlic, and olive oil, as well as chicken and a cheese platter. Then we watched movies and had popcorn. We hung out. That's what I want my home to be: a place where people hang out—and not just my kids and their friends, but everyone.

At my daughter's birthday party I had a petting zoo and a moon bounce and princesses walking around, and sang "Happy Birthday" in Spanish. People had a good time.

Adults are just the same as kids, let me tell you. They

want an environment where they can just let their hair down, be themselves, and feel free to have fun. If you use that as your guiding principle, no matter what kind of entertaining you're doing, your guests will almost surely have a great time.

With entertaining, it's all about the vibe. Or really I should say vibes, because, no matter what, you want people to feel relaxed and comfortable, but you also want something to create atmosphere and energy specific to the kind of gathering you're hosting.

For example, with our White Parties, especially when we lived in our old house, which was very modern and had a huge backyard, we liked to go for a hip Miami club vibe. I love theme parties and I think other people do too; they're a license to live it up.

We make everyone wear white to the White Party. At first people are a little bit annoyed at being told they have to dress a certain way, but next thing you know everyone's running around having fun looking for their outfit. It actually creates anticipation and excitement. And I've found that everyone looks beautiful in white!

Then we set out a sea of white tablecloths and flowers and candles, with lights in the trees and a dance floor. The first year we even had mattresses and cabanas. We try to find that balance where it's elegant, but people can still let loose.

I also like to have a Halloween party every year, because that's my daughter Farrah's birthday. We do an open house, and all our friends come over with their kids and we all march out to go trick-or-treating at some point. I make macaroni and cheese and chicken fingers for the kids and lasagna and salad for the adults. And of course I always tell people to come in costume!

Decor is just as important with a Halloween party as it is with something like the White Party. I would decorate for Halloween anyway! I start on October 1 and bring out these little sparkly beaded pumpkins I have and put them out all around the house. I have a witch with a cauldron, and I put dry ice in it so it looks like something's brewing! I do a graveyard in front of the house with skeletons and tombstones. My older kids have begun making fun of me, but the younger ones still like it—and I know the adults do too! Grown-ups like having permission to feel like a kid again. That's another secret to keep in mind.

People appreciate when you've gone to a lot of effort for them. You want everything to be fabulous, ready and waiting for your guests when they arrive. You don't want them to see you running around, panting and sweating, huffing and puffing, working to get things right. That's liable to make them feel uncomfortable. They want you to be enjoying the festivities with them.

Entertaining is a *lot* of work. Especially if you cook. I am not one of those people that finds cooking relaxing. Cooking for a party is a huge job. My God, all the chopping and prepping. (And as you know, I almost always fail to heed my mother's advice about cleaning up as I go and end up with every pot and pan I own dirtied and strewn all over the kitchen!) NOT GOOD!

But food is such a critical element at a party. Never underestimate it. The absolute worst thing is not having enough food. Nothing kills a sense of celebration like running out of food—or putting out so little to begin with that people feel they're not even supposed to eat it. Mauricio and I always have tons and tons of it. There's something so pleasurable about knowing, even on a subconscious level, that you can eat to your heart's content all through the night. Or is that just me?

The kind of food you serve matters too, of course, especially if people are going to be roaming around, maybe holding a drink in one hand and eating with the other. You don't want people struggling with messy food or huge pieces they have to try to choke down in one bite! Women in particular will feel awkward and self-conscious about eating if there's a chance something's going to be hanging out of their mouth or crumbling everywhere. That is especially true if the cameras are filming you eat; take it from me!

French Country Flea Market

When we bought our new house, we just moved around the corner. I had driven by the house many times and always wanted it. When it came on the market, it was like a dream come true! We spent a lot of time renovating it. My friend Faye Resnick, who's an architectural and interior designer, helped us decorate it, and I learned a lot from her. I still have a lot to learn, but I'm getting there.

It's funny. People ask me for advice on decorating their house and I say, "Have a husband with a good eye and a friend who's an interior designer!" My husband works with high-end real estate, so he's very good about identifying a house's assets and flaws. He knows when it has good "bones," and he can see all the possibilities of what you can do with it.

Our old house was great, in a kind of Balinese modern style. But we sold it furnished, so we had to start all over with this house and replace everything, down to the forks. This house is truly everything I've ever wanted. It's done in a French country style, with distressed wood floors and whitewashed furniture. I wanted it all to be elegant but casual and cozy, kind of like something you'd see in the Hamptons, very fresh and clean. The walls had to be just right. White walls and stark white light bulbs are not conducive to feeling relaxed and comfortable. So I ended up changing the color of the paint on the walls three times. Faye and I drove my husband crazy! But we finally got it right: they have just a bit of a blush tone to them.

I wanted to pick up on the blush and the grayish lavender, so we used touches of purple and blue as accent colors. I put out a lot of flowers in those colors, and I have a gorgeous purple crystal geode on my dining table—it's supposed to be good energy.

I'm not a professional like my friend Faye, but I do have my own decorating moments. I love to go the flea market and buy old things. My favorite pieces come from flea markets, because it's so much fun shopping at them. I usually bring my girls, and I'm so proud and excited when I find treasures!

One of the best things about flea markets is that you can get beautiful, stunning things for a fraction of what you'd pay at a store! Going to the flea market is a great, cost-effective way to decorate your house.

You have to get up really early, usually on a Sunday, and spend the whole day shopping. We meet our friends and have lunch there, and then at the end of the day I leave with a truckload of stuff. My kids laugh because they've never seen somebody squeeze as much into a car as I can.

During one of my recent flea market adventures I accumu-lated so much stuff that the kids were already laughing at me, and then I found a beauti-ful chandelier that was a real steal. By the time I got to it I looked like something the cat dragged in. I tripped and fell as I was trying to wheel all of my things to the car and flew over my cart! I actually think I broke a bone in my leg, because it's still not normal. It's my flea market injury. But I saved my chandelier!

My kids said, "Let's go and take care of your leg. Leave the chandelier and we'll get it later!"

I said, "No! No! Forget about my leg, I need instant gratifica-tion!" So I got the chandelier home.

Buying stuff at a flea market really can save you money. But what I love most about it is bringing home things that have a memory attached, of fun times I've spent with my kids.

No spinach to stick in people's teeth, please. No chicken wings, either—they look unattractive, for one thing, and your food should always look elegant. But wings are also messy. You need to have little delicious bites that people can pop in their mouths, like shrimp

Holidays

We celebrate both Christmas and Hanukkah at our house. We'd be happy to celebrate Kwanzaa too, because I love holidays! We always say, twice the holidays, twice the fun! But it can be challenging, especially when they fall close together on the calendar. I always decorate for both holidays, the red and green and Santas for Christmas, and the menorahs and lots of silver and blue for Hanukkah. One time a teacher from my kids' Jewish school called and wanted to stop by. My kids were running around, "Mom! Oh no! Hide the Santas!" We couldn't stop laughing!

I believe it's important for kids to grow up in a home that truly celebrates the holidays and creates traditions. I am a fanatic about Christmas. I listen to Christmas music from the minute they start playing it on the radio until the minute they take it off—to the point that my husband and kids are ready to kill me!

I also totally do up the house. My mom always made a big deal about Christmas. My sister Kathy inspired me with all of her decorations too. She puts out so much stuff. I mean, she has a life-size Mr. and Mrs. Santa Claus! You just walk in the door ofher house and instantly feel festive.

with sauce, small pieces of sushi, tiny meatballs on a toothpick, little goat-cheese pastries, sausage bites with Dijon mustard. And everything has to be really good! Oh my, that's nonnegotiable! If you're having a big party I also think it's nice to pass the food on

I have a Santa figure reading to a little girl. And of course we get a big tree, and decorate with the family every year.

At Christmastime, candles are especially important. They create a warm glow, both literally and figuratively, that makes it feel like the holidays. It's the same feeling you want to give guests any time they're in your home. You want them to feel *at* home in your home.

We have family over for Christmas Eve either at Kim's or at my house, and then Kathy does the big dinner on Christmas night. And in between, Kim and Kathy and I each do the huge present-opening ritual with our families. On Christmas morning we make a big breakfast. No holding back on calories during the holidays! I mean, that's the time to have fun. So we have an omelet or scrambled eggs and cinnamon rolls. And bacon, of course! We're Jewish but we do like to have crispy bacon—I'm not gonna lie! Normally I don't eat pork, but at the holidays, all the rules go out the window!

Holidays are special because of family. Family is part of what you celebrate.

And that's what entertaining is too. At least for me. It's about sharing and celebrating with people you care about. Opening your home and honoring your friends and making them happy.

platters, because it makes people feel special and taken care of. They're being *served*. If you can hire someone to help, you'll not only be giving your guests the royal treatment, you'll also free yourself up to swan around looking like the calm, collected hostess—and that makes your guests feel good!

For drinks, it's fun to create one special cocktail for the occasion that's passed around, in addition to the wine and spirits you have set up as your bar. It's another way to make the event special.

At the holidays, for instance, I might do apple martinis with the glasses dipped in red sugar. It adds to the festive mood!

Nothing does more to set the mood, though, than the lighting and the music. Mauricio and I went to a party the other night that was just boring. I asked Mauricio, "What was the problem there?" And then we figured it out: the lighting was too high and the music was too low. For a successful party, you've got to do it the other way around: low lights, which will be flattering to people, and music cranked up just high enough that it sends the message through your guests' ears into their brains: it's party time!

Bright lights make people feel self-conscious, as if everything they do is being watched. In low lights, they have a little more freedom to enjoy themselves. For me, candles are everything! I cannot have people over with-

out a million candles being lit. They give off the perfect light—low, flattering, romantic, dramatic, intriguing, and welcoming all at the same time. And put flowers out in as many spots as you can. Flowers make people feel cared for, and they bring freshness and life to a room. I always go to the wholesaler's flower market in downtown L.A. to get flowers for my parties, because they're much cheaper there, so if you have a similar market in your area, take advantage of it.

I generally like to have fun, upbeat music that you can dance to, like Britney Spears, Michael Jackson, and old-school stuff like disco. Whatever you want to say about disco, it's great to dance to, and I think in some ways it's people's guilty pleasure. But for particular themed parties I might do something different. Maybe Latin music for a Cinco de Mayo party. I have also had mariachis perform at one of my Cinco de Mayo parties.

If it's possible, I try to have one extra entertainment going on in some quiet room of the house, like a psychic or a magician. People enjoy going from the music and people and laughter off to another little world for a whole different experience in the middle of the party.

I've given so many parties that one day I decided it was silly for me to be renting tables and tablecloths and chairs and dishes and glasses all the time. So I bought everything I need. I researched everything pretty thor-

oughly first, and found places, mostly online, where I could find party essentials pretty cheap. I had to order my tablecloths, though, because you just can't find them big enough to cover 120-inch tables and fall to the floor. Since I was going to spend more on them, I chose two basic colors: white for all-purpose and summer, and burgundy for fall, winter, and holiday. Sticking to a few basic colors will help you stretch your entertaining budget.

Here's another idea I came up with that I'm rather proud of. I got together with a couple of friends of mine and we bought a bunch of the same kind of plates, plain white with a silver border. And we did the same thing with silverware. So now, if I'm having a huge party, I can call them and say, "Bring it on over!" Or they can call me. It works perfectly.

You have to call on your friends when you're having a party. I couldn't throw my big parties without their help. My friends Faye and Pauline always help with decorating and flowers and I'm so crunched for time I can't do it all on my own. Everyone actually likes getting involved. They get excited and say, "Okay, what can I do?" It's fun. It's like the party before the party!

That's what it's all about—friends having fun. That is the holy grail of entertaining. If you nail that, you've got it made.

A Real Housewife

When I was first approached to do *Real Housewives,* my closest friends were very skeptical. They're not in show business and in fact won't even let themselves be seen on the show. I'm like, nice friends! Ha! They were always very supportive of my acting career, and they wanted me to stick with that.

But the acting business has changed so much. I took off a lot of years to have kids, and when I went back, there were huge stars in little guest roles on TV and I just basically felt like I'd been pushed way down the totem pole.

I never wanted to do a reality show or a soap opera. But eventually I agreed.

Real Housewives has been quite an education! I never would have put this job in the category of being "difficult"—until I started doing it! It's not the backbreaking or heart-wrenching kind of difficult—of course not. But it takes up a lot of time, and because there's a lot of stress, it can be psychologically difficult! I think all of us on the show quit a couple of times apiece before we finally finished season 1.

Over the course of doing the show I got to know the other girls better, and I learned a lot from them. I even learned about myself! Camille and I clashed big-time in season 1. The dinner-party-from-hell episode with the psychic was just the tip of that iceberg, and the issues between us lingered long after filming ended. But I eventually came to understand Camille as a person, and we became friends.

In some ways the show goes against everything I try to teach my kids. I don't want them arguing with people, being catty with their friends. I want them to learn how to deal with conflict in a constructive way.

But on the other hand, the show is everything I try to teach them. I want them to be honest and speak up for themselves. Avoiding drama is good advice to give to my girls, but in life, you can't always avoid it. Drama happens! And you have to get through it. Ulti-

mately, I try to teach my kids that they have to accept their friends' flaws. That's what friends are all about. As long as they aren't toxic friends.

My daughters find *Real Housewives* entertaining. They know that what I'm like on the show—a bit of a fighter, I guess you'd say!—is just a small part of my personality. They like my strength, but they know a much softer, light-hearted, funnier side of me at home.

By now I don't have to tell you what really matters to me: my daughters, my family, being a good mom, being a good partner to Mauricio, and being a good friend too.

I'm grateful that I have a great husband and a great marriage, but my mom didn't—and she was still happy. I have single friends who are happy. And I have some single friends who worry, and ask me, "What do I do if I never get married?"

I say, "Well, if you don't, it's okay, because you can have a great life without being married."

Women are very important in my life. I'd be lost without my friends. Thank God for the telephone! It's impossible to spend as much time with your friends as you'd like, but that phone is a lifesaver. It drives my husband crazy. I say to him, "But this is my time to spend with my friends, don't you see?"

It all comes down to the concept of family—whether family means you have a bunch of children or a bunch

of sisters or a bunch of friends. Cherish the people you love. That's the very best advice I can give you.

People ask me what I'll do when I finish the show, whenever *Real Housewives* is over.

My honest answer is this: "I'm going to go back to the way I was—being a *real* housewife again!"

ACKNOWLEDGMENTS

I want to thank my dad, Ken Richards, for being the most kind and loving father. I love and miss you.

I want to thank everyone who made this book possible. My publisher, HarperOne, for making me an author! My editor Nancy Hancock and my publicist Susan Wickman. Robin Micheli, I couldn't have done this book without you. My manager, Bette Smith . . . Dahling! Thank you for always being there for me 24/7.

Doug Ross, the crew of *Real Housewives of Beverly Hills,* my Housewives co-stars/friends, Adrienne, Camille, Lisa, and Taylor, Alex Baskin . . . for keeping me somewhat sane and making me laugh along the way. All my friends at Bravo, The Lady Sitter Justin Sylvester . . . my right hand during all the craziness! Rick Hilton, Dr. Estella Sneider, Eduardo Umansky, and the Benton clan for being the best in-laws/family a girl could ask for! The Wiederhorn family, the Sneider family, and the Moghavem family.

My nieces and nephews who I love with all my heart . . . Paris Hilton, Nicky Hilton, Brooke Brinson,

Barron Hilton, Whitney Davis, Chad Davis, Conrad Hilton, and Kimberly Jackson.

To all of you who loved and supported me along the way, Lorene, Tina, Faye, Pauline, Jana, Michele (aka Tiny Dancer), Chris, Barbara, Tiffany, Christine, Brooke, Tracy, Wendy, Roxane, Sue. I love you all. Thank you for being the best friends in the world!

My sisters, Kim Richards and Kathy Hilton. I love you both so much!!

To my daughters, Farrah, Alexia, Sophia, and Portia. Thank you for showing me what life is all about. You are my greatest accomplishments. I love you all so much it hurts.

To my husband, Mauricio, my soul mate, my best friend, and my biggest supporter. It's official . . . I LOVE YOU MORE!!!!!!!!

ABOUT THE AUTHOR

Kyle Richards

This sassy California native was born in Hollywood, into an acting family. She landed her first role at age four in Disney's *Escape to Witch Mountain*, where she played the younger version of her sister, child actress and fellow Housewife Kim Richards. Her other sister is Kathy Hilton, mother to Nicky and Paris Hilton. Kyle's TV credits include *Little House on the Prairie, Carter Country, Down to Earth,* and *E.R.* Film credits include *Halloween* and *The Watcher in the Woods*. Kyle is an avid advocate for the fight against cancer, even completing a sixty-eight-mile bike marathon last year to raise money to help fight the disease. Kyle is married to the love of her life, Mauricio Umansky, one of the nation's top Realtors. Kyle recently starred in the Lifetime original movie *Deadly Sibling Rivalry.*

Kyle is also developing her own handbag line, and developing her own affordable line of skin care. Her greatest passion, however, is being a mother to her four daughters: Farrah (22), Alexia (15), Sophia (11), and Portia (3). Kyle believes "If you obey all the rules, you'll miss all the fun."